ESSENTIAL

Modern Art

ESSENTIAL

Modern Art

Robin Blake

p

This is a Parragon Book
First published in 2001

Parragon
Queen Street House
4 Queen Street
Bath BA1 1HE, UK

ISBN: 0-75255-350-x

The author and publishers have made every reasonable
effort to contact all copyright holders. Any errors that
may have occurred are inadvertent and anyone who
for any reason has not been contacted is invited to
write to the publishers so that a full acknowledgement
may be made in subsequent editions of this work.

A copy of the CIP data for this book is available from
the British Library upon request.

The right of Robin Blake to be identified as the
author of this work has been asserted in accordance
with Section 77 of the Copyright, Designs and Patents
Act of 1988.

Editorial, design and layout by Essential Books,
7 Stucley Place, London NW1 8NS

Picture research: Image Select International

Printed and bound in China

CONTENTS

INTRODUCTION

Modern art is the art of almost the whole of the twentieth century, but it began in the nineteenth. During the 1880s, three very different pioneers, Paul Cézanne, Vincent van Gogh and Paul Gauguin, started to push beyond impressionism, trying to find for their painting a new moral and emotional framework. The impressionists had been content to look at nature with attention but without passion. They did not want to question it, or place themselves in it. The post-impressionists expected to get involved and in this way brought a renewed, almost righteous, ripple of feeling back into their work. In a short time the ripple became a tidal gush of vividly coloured emotions which inundated painting. For a time it became an artist's duty to fill the canvas with sensibility. This flowed unchecked for the first decade of the new century, until it provoked the reaction of cubism.

The parameters of cubism may be gauged by two remarks from its founders. 'For me painting is a dramatic action in the course of which reality finds itself split apart,' said Pablo Picasso flamboyantly. The quieter, subtler Georges Braque chose to emphasize a less percussive aspect of the new art when he disclosed: 'I don't believe in things. I believe in relationships.' This kind of talk, and more particularly the painting to which it referred, was met with blank incomprehension by 95 per cent of those who encountered it. They saw only the deranged product of two probable lunatics.

As we see now, cubism was no more insane than impressionism was in the 1870s, when it faced the same charge. In any case, the new painting was much more than just an expression of its leaders' creative force – although there was plenty of that in Picasso and Braque. It was an answer to the problem of unbridled emotion in the Nabis, the post-impressionists and the Fauves. That answer, so apparently extreme and contorted, was imbued with a very twentieth-century sense of paradox. The writer Karl Kraus described it as making 'a riddle out of a solution',

a formula that comes as close as six words can to expressing the spirit of cubism. Despite its inflammatory reputation, the discourse of this art was intellectual, its methods of composition deliberate and studious and the colouring of its pictures decidedly low-key.

Yet the word 'inflammatory' is just. Cubism lit the touchpaper for an explosion, the largest intellectual revolution in the visual arts since the Renaissance discovery of perspective. And its pioneers, closeted in their Montmartre studios, brooded on many of the central preoccupations of the twentieth century: the space-time continuum, the atom, the validity of sensory experience. They were not alone in this. It was the age of science, in which twentieth-century humanity suddenly caught hold of the suspicion that observable reality might be an illusion, or a confidence trick. And what if, instead of nobility and an immortal soul, we carried inside us only a snake pit of competing desires or, worse, a void? These are profoundly unsettling but, for some individuals, feverishly exciting thoughts which arrived along diverse channels. Einstein and Freud were two of the most important of these. Cubism was a third.

The post-impressionists declared that looking is not seeing. Braque and Picasso's first task, with their split-open multiple-aspect forms, was to show that seeing is not understanding. Their next task, a challenge that was taken up energetically by a host of offshoots, was to invent visual languages beyond seeing. Right at the front of what was beginning to be called the avant-garde of art – the metaphor is a military one, referring to those 'riding point' at the head of an army – cubism now began to fly above, or circle around or even pass through solid form. Its followers went on, like a victorious raiding party, to capture the essence of movement, expose misconception and root out the fundamentals of sensory truth. The consequences of all this activity, packed into a few momentous years just before the (differently shattering) upheaval of the First World War, were profound and irreversible. For all serious artists, cubism had broken through the wall of protective illusions about pictorial space. The breach was established

and the apparently ragged and disorganized forces of 'the new art' poured through, proclaiming liberation.

The artists themselves sometimes grasped the same liberty in their private lives, creating the stereotype of the penniless, hell-raising bohemian, always drunk on absinthe. Some, like Modigliani, really were like this. But most were profoundly serious people and occasionally too much so for their own good: Braque's reputation suffered to an extent because of his personal dullness next to the bravura of Picasso; Arshile Gorky and Jackson Pollock just suffered.

The absolute creative freedom claimed by modernism was bound to put it on a collision course with the new authoritarian politics which arose in the wake of the First World War. This, after all, was at least in part a reaction to the avant-garde in the arts, which was seen as symptomatic of an overall social sickness and disorder. Stalin's cultural apparatchiks called it 'formalism' and sent many artists to the Gulags. The Nazis condemned it as Degenerate Art and mounted a scathing exhibition of the stuff in Munich in 1937. At its opening Hitler, the failed watercolourist, declared: 'If artists do see fields blue, they are deranged and should go to an asylum. If they only pretend to see them blue, they are criminals and should go to prison.' Hitler and Stalin had some reason beyond their own prejudices to hate modern art, because many of its leading figures were sympathetic to, if not deeply involved in, left-wing revolutionary activity. Picasso's great protest painting *Guernica* rages against the rise of Franco and his use of terror bombing in the Spanish Civil War. Dada and surrealism were from the start aligned on the political left. And, in the 1960s, art and political subversion became in some quarters virtually interchangeable.

On the other hand there were spiritual (and spiritualist) dimensions to modernism that had little to do with politics, including the extraordinary rise and (by mid-century) fall of theosophy, an attempt to start a new religion mainly by two women, the Russian Madame Blavatsky and her English acolyte Annie Besant. Theosophy had little to

do with cubism but it left its imprint on modern art through four key *avant-gardistes*, Wassily Kandinsky, Constantin Brancusi, Piet Mondrian and Jackson Pollock. The vital constant here is the opposite of *Guernica*'s public howl. It is an intensely private and inner art, a dialogue with the soul. Pollock, one of its most intense practitioners, called all painting self-discovery. 'Every artist paints what he is,' he said, though he also insisted that what was created went on to live 'a life of its own'. The strong implication here is that the artist, as creator of 'living' works, bears a solemn responsibility that is unique among human activities.

From the first, modernism felt it should embrace new developments in natural science. For obvious reasons, optical physics and colour theory were to be of lasting importance, from Kandinsky onwards. There was also some input by mathematics into cubism; Einstein's physics found parallels in futurist notions of the fourth dimension; and the curious biomorphs of Miró and Klee may be related to creatures seen under the biologist's microscope. But it was in the human sciences – more tenuous but richer in suggestion – that modern art found both its philosophical courage and a fountainhead of source material. The most important of these soft sciences – which appear even softer today than they did at the time – were Freudian and Jungian psychology. The unconscious mind provided nothing less than a new world, a Prospero's island, in which artists could walk their imaginations and release their fantasies. The surrealist interest in dreams and automatism – writing, drawing and painting without the mediation of thought – cast an immensely long shadow over the whole culture of the twentieth century, while Jung's archetypes breathed new life into symbolism. The latter have persisted long after Jung the clinician has been consigned to the dustbin of history. They can be spotted, for example, in the later post-pop work of Peter Blake.

In more recent times it was not scientific ideas but technological hardware that stimulated the visual arts. While the result has undoubtedly been a preponderance of very ordinary and much bad art, this is beside

the point: oil on canvas is also mostly mediocre. Artists have grasped at the opportunities which technical advance gives them because that is their nature – to seek symbolic languages appropriate to their time and their vision. In some cases the languages used in the second half of the century were borrowed from those of the first, merely translated into contemporary terms. Much video-installation art, for example, looks like the kind of thing Dada would have been doing had they been lucky enough to possess DVD. On the other hand, because the material from which art can be made has become so radically different, there have been immense changes in what can be produced: stainless steel, plastics, fibreglass, polyester resin, neon, acrylic paints and NASA adhesives have all had their effects, as have airbrushes, aerosol sprays, Polaroid cameras, photocopiers and fax machines. Some of these would have delighted advanced practitioners like Malevich or Boccioni, but they would also have utterly changed their art, just as cheap computers and colour printers in the early 1960s would have transformed pop and op art.

The artist's orientation to the world became much more various in the modern era. At one extreme there were the depressives. Gloom-laden and angst-ridden, they contemplated modern society as one might a burnt-out church or a crashed car. Existentialism was the in-house religion of this branch of the avant-garde. It embraced freedom – spiritual, cultural and political – but this was not a particularly comfortable or comforting clinch. Released from irrational taboos, irrelevant religion and unthinking social obedience, the self became a pit in which exhilaration wrestled with boredom, liberty with fear. In life, anything was allowable, but existence was a cul-de-sac and personal extinction a certainty. In this perspective, art often became a desperate and driven activity but also a meaningless one.

In contrast to these intimations of the existential condition, much of modern art has been nothing but an expression of joy. Matisse, Balla, O'Keeffe, Brancusi, Klee, Moore and Johns are just a selection of the artists who felt no compulsion to make their works into public acts of

suffering. And one of the most attractive strands in modernist art has been its sense of humour. To spend an hour in a room with the solemn works of a Clyfford Still or a Ben Nicholson is perhaps thought-provoking. To do so with those of Magritte pays the same dividend, but you will also laugh in delight.

Twentieth-century art is a broad church, complex and fraught with contradictions. Here is an art that dealt in serene unities and hectic disjunctions, in the private meditations of Rothko and Mondrian and the public interventionism of Picasso's *Guernica*. It embraced the metal and machine age and at the same time hankered for the pre-colonial art of the black nations. It sanctioned the excesses of Dali and yet adored the monk-like dedication of Albers. It shouted against consumerism while lauding Warhol. And, if very often an art of movement, it was always one of movements, a forest tangled with an undergrowth of -isms.

No selection of art from such a period can hope to be complete. What follows is an attempt to trace a path loosely through the briery wood. At its centre may be found a castle and a sleeping beauty: but she is for each of us to discover for ourselves.

PAUL CÉZANNE *1839–1906*

THE CARD PLAYERS 1885–90

Musée d'Orsay, Paris/Courtesy of Scala

CÉZANNE was born in Aix-en-Provence, the son of a banker. One of his schoolfellows – and for many years an adult friend – was the future campaigning journalist and writer of realist novels Emile Zola, himself a figure of immense influence for the future development of French culture. In 1861 Cézanne went to Paris, where Zola was already established, to become a painter.

The impressionists, though not yet named as such, were soon to begin elaborating the theories and experiments in colour and out-of-doors painting whose results would in the 1870s so affront the rigidly traditional Académie de Peinture et de Sculpture, the official voice of French artistic taste. The young Cézanne met Manet, Monet and Pissarro, but his student work was marked less by these contacts than by post-adolescent fantasies, which resulted in a certain romanticism, and a frequent eroticism, in his darkly coloured canvases. It was not until he quit Paris to work closely with Pissarro at Auvers-sur-Oise in the early 1870s that his outlook changed. Learning from Pissarro the liberating impressionist brushwork and uncompromising attitude to colour, he now began to paint directly from nature.

Cézanne aimed above all else to shape the forms and harmonies of nature through impressionist colour techniques. But, as he observed ruefully, sensory observation is a confusing thing because 'light devours form, it eats up colour'. Instead of passively accepting that light confuses sensory experience, he struggled hard to use it as a glass through which one might discover the fundamental order and harmony in nature. He wanted to organize the perceptions of the senses in order to 'make impressionism something solid and durable like the old masters'.

Cézanne was therefore never quite a fully paid-up member of the impressionist fraternity, and exhibited at only the first and third of the eight impressionist exhibitions held in Paris between 1874 and 1886. Instead he increasingly developed his own philosophy of painting which was to be a powerful inspiration for twentieth-century artists, especially the cubists.

The Card Players is one of a series of paintings often cited in connection with Cézanne's famous remark that observed reality should be treated by the artist in terms of geometrical volumes: 'the cylinder, the sphere, the cone, everything in proper perspective so that each side of an object is directed towards a central point.' This is not a straightforward statement as it may seem: Cézanne's idea of 'proper perspective' was quite different from Renaissance ideas on the subject. But the sense of the volumes echoing and interlocking with each other does help reveal this great painting, so solid and so deliberately arrived at, yet never seeming contrived.

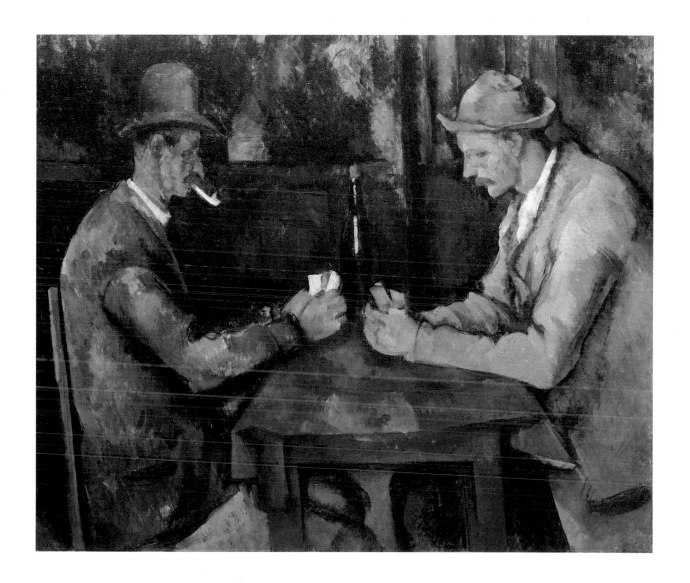

PAUL CÉZANNE *1839–1906*

THE BLUE VASE 1885–7

Musée d'Orsay, Paris / Courtesy of Scala

CÉZANNE was looking to stabilize impression, rather than to record its subtle transience. His pursuit of intellectual order is especially apparent in the still-life paintings, such as this luminous exercise in cool and warm colours. The painting is rightly titled since here it is not the arrangement of flowers that first takes the attention but the receptacle in which they stand. The ceramic is cool in contrast with the warmth of the apricot lying next to it: inorganic and organic proclaiming themselves in their own colours and shapes. There is a kind of hyper-realism about Cézanne's best paintings which at its best astonishes the eye.

The painting is typically idiosyncratic and even mysterious. This is seen in *The Card Players*, where some elements of the composition are difficult to read. The two visible parts of the blue-white plate, for example, divided visually by the vase, do not quite match and are, in fact, each looked at from a slightly different viewpoint. This is the sort of detail that misled the academics of his time into thinking Cézanne not just a misguided painter but also a bad one. In fact it shows that Cézanne's first concern as a painter is no longer for verisimilitude. He is not trying to give a single view of anything. The point he makes is that things can be clearly, if subtly, represented by more than one view. This emphasizes the activity of looking itself. Once the plate is split by an intervening object, it is no longer seen as whole. The eyes reconstruct, or deduct, the shape of the entire plate but they do not do so evenly since they are spaced apart. Nor do they perceive consistently from one occasion, one moment, to the next, because they move continually. Therefore since a single painting is the creation of thousands of these perceptions accumulating over time, it is bound to reflect their discontinuities as well as their consistencies.

The two apples and the ink pot on the right introduce another element of Cézanne's oil painting that worried his contemporaries a good deal more than it does anyone today. The canvas is left bare in some places and the objects do not look 'finished'. Cézanne here imports a technique from watercolour painting and the effect is to blur these objects and to emphasize the sharpness and solidity of the vase and the apricot at the centre.

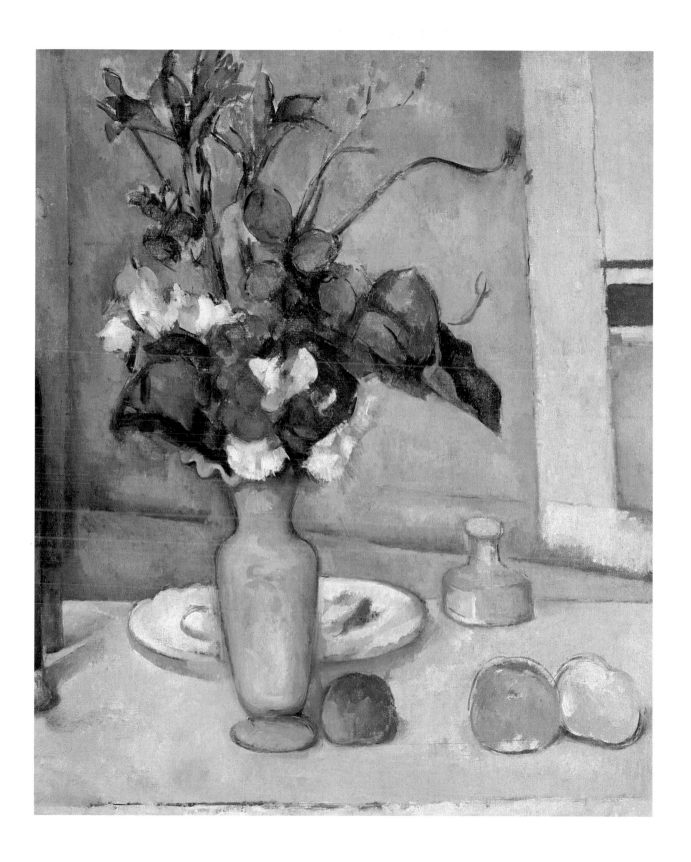

PAUL CÉZANNE *1839–1906*

THE BATHERS 1890–1900

Musée d'Orsay, Paris / Courtesy of Scala

BY the 1880s Cézanne was living back in the Provence of his childhood. Here he developed his mature style, living quietly and pursuing his art with a certain lonely dedication.

The motif of a group of bathers in a landscape enables the artist to tackle questions about the ideal of harmony between man and nature, of Paradise or the Golden Age, as against the actual disharmony which most of us experience most of the time. The vision usually offered on the subject by Cézanne – and at the end of his life it was one of his favourites – is paradisiac. His bathing pools are ideal places and his figures seem integrated into the land itself, appearing more mineral and vegetable than animal. It is possible that in old age he was thinking back with Wordsworthian nostalgia to times when he had joined in such bathing expeditions as a child, and when the distinction between nature and human society was less cruelly defined. The lack of Cézannean 'finish' in this sketch makes its surface all the more immediate and personal – rarely an important factor in his work.

This small sketch (22 x 33.5cm) of male bathers uses almost the same composition as that of a more 'finished' painting, also in the Musée d'Orsay, which is a little over twice the size and was completed in 1890-92. But Cézanne seems to have worked on the sketch even after he had finished with the larger painting and it cannot be dated more accurately than within the decade 1890-1900. Apart from the less finished, less solid figuration that you would expect from a sketch, there are significant differences in composition between this and the larger oil, in the landscape particularly. The sketch emphasizes the verticals of the trees while in the larger piece a mass of cloud frames the heads of the figures.

It is his recognition of visual confusion, differing viewpoints and the need to resolve them in the search for a new, yet almost classical sense of underlying form that makes Cézanne such a significant precursor of twentieth-century artists – of cubism first and then of the abstract painters. Matisse owned a small *Bathers* and found it a lifelong inspiration; and the large sculptural forms of Cézanne's three monumental late paintings of female bathers, known collectively as *Les Grandes Baigneuses*, seem to have been the most important influence on Picasso when, in the very year in which Cézanne died, he began work on *Les Demoiselles d'Avignon* (see page 94).

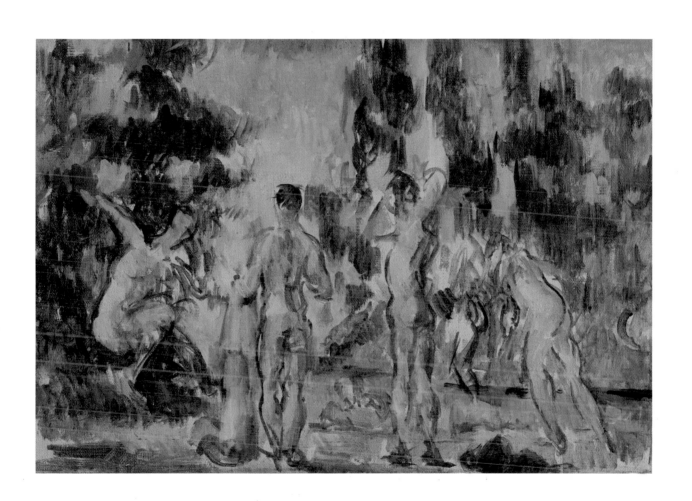

PAUL CÉZANNE *1839–1906*

THE PIPE SMOKER 1895

Hermitage Museum, St Petersburg / Courtesy of Scala

CÉZANNE was deeply offended when his friend Zola had portrayed him (or so he thought) as the feeble, untalented artist Claude Lentier in the novel *L'Oeuvre*, and he abruptly ended their friendship. This prickliness and isolation can be seen as another way in which, as an artist, Cézanne is distinctively modern: his insistence that he was accountable only to his own perceptions. In truth, the ties of friendship had never had that much effect on his methods, except during the period in which he was learning impressionism from Pissarro. But the elderly Cézanne became increasingly determined to pursue his vision in secluded independence.

Yet these traits belonged to Cézanne the man as well as the artist. He was of wealthy bourgeois stock, yet he grew to resemble the Provençal peasants he so often painted: suspicious, self-reliant, slow, private. Even his marriage was an oddly semidetached relationship, though not apparently an unhappy one.

Cézanne often expected his sitters to pose motionless for long hours, considerably annoying some of them, though this never shows in the finished portraits. This smoker appears as a young man of ruddy complexion and large hands: a working man in a dusty suit. The bottles provide dark verticals and the fruit bright circular forms to complement his clothing and his flesh. The composition is all about the interplay of diagonals. The sitter's body leans forward in such a way as to put him at ease with the facing edge of the table. Meanwhile his pipe juts downward at the same angle as the line of his breast pocket. In this way the composition can be read as a cascade of zigzagging diagonals from top to bottom.

The application of paint is also worthy of study, in particular Cézanne's method of achieving rounded forms. Instead of modelling the figure or object conventionally, with light and shade, he used 'colour modulation', whereby the juxtaposition of different colours, irrespective of lightness or darkness, gives the sensation of three-dimensionality. In the matter of highlights Cézanne was also idiosyncratic, partly because he was not interested in exploiting 'interesting' external light sources. The subjects of his mature paintings are always lit from within, which is the reason for one very striking aspect of Cézanne's portraiture, clearly and disturbingly evident here: there are no highlights in the pupils of the eyes.

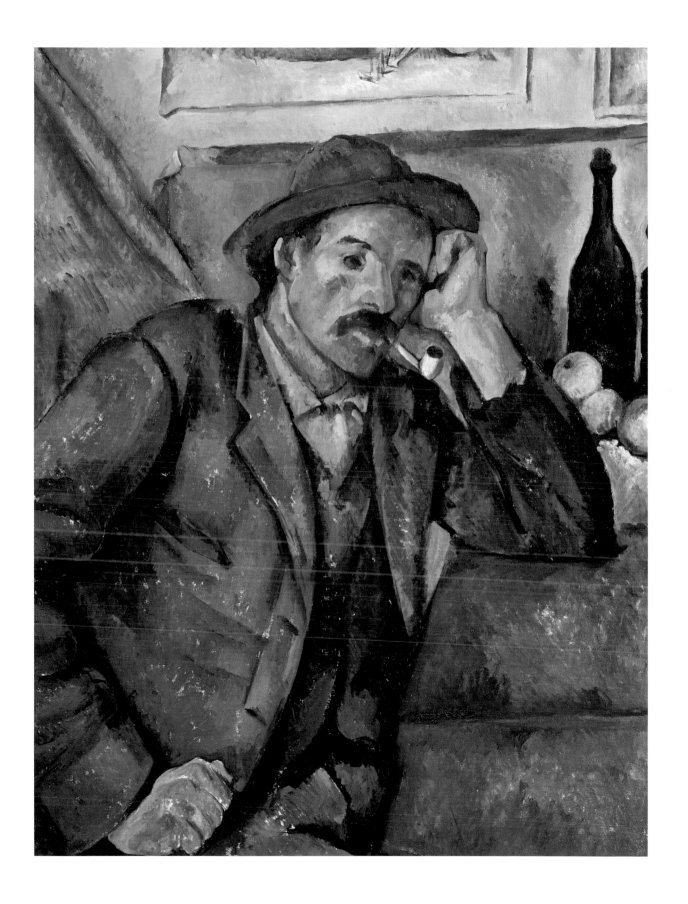

CLAUDE MONET *1840–1926*

ETRETAT AT SUNSET 1883

Pushkin Museum, Moscow/Courtesy of Scala

MONET was born in Paris, the son of a grocer. In his infancy, financial problems forced the family to leave the capital for Le Havre, where Monet's father set up a new business. The experience of living close to the sea, where the play of light on the ocean and in the sky changed so quickly and markedly, was to influence the painter all his life.

A precociously talented draughtsman, Monet began painting in his teens and came to Paris in 1862 after military service in North Africa. He fell in with the group of idealistic innovators who met in the Café Guerbois – painters who, in trying to find a deeper truth than academic realism, were rejecting the primacy of form in favour of colour. But it is Monet who must in a literal sense be considered the original impressionist. His painting *Impression: soleil levant* was exhibited at the group's initial exhibition of April 1874 in the premises of the photographer Nadar on Boulevard des Capuchines. This painting was noticed by the critic Louis Leroy, who wrote of it disparagingly: 'it is only too easy to attract attention by painting worse than anyone has hitherto dared to paint.' It was the indignant critic's attention to this one picture that led to the public label of impressionism, but it was one that was worn as an acceptable badge of identity by the painters themselves.

Monet was of course purposefully painting 'badly' (in the academic sense) but Leroy was quite wrong about one detail. It wasn't fame that motivated the artist but a strong personal vocation, which saw him through some extremely lean years, especially in the 1870s.

Etretat is twelve miles along the coast from Monet's childhood home of Le Havre and its dramatic cliffs and rock formations remain a powerful draw for tourists as well as artists. Monet painted there several times – the Museum of Modern Art, New York, has a beautiful close-up of the same natural rock bridge or arch that is in the distant centre of this glowing sunset view. The painting demonstrates the technique of Monet. He accumulates a large number of small brushstrokes in carefully selected colours to build up the forms and light effects, but without any regard for detail or superficial polish. The glow of perception is more important to him than palpable surfaces and hard edges.

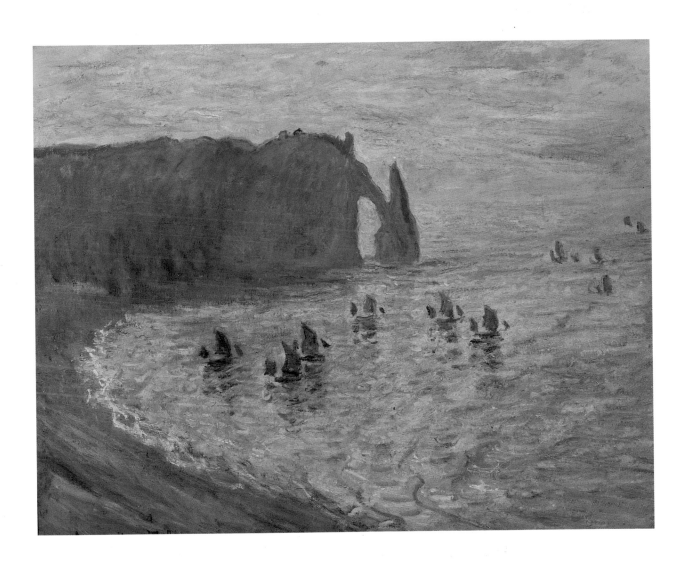

CLAUDE MONET *1840–1926*

ROUEN CATHEDRAL IN FULL SUNLIGHT 1892–3

Musée d'Orsay, Paris / Courtesy of Scala

THE fact that the impressionists originally got their name from a work by Monet is very appropriate. He was the most characteristic of the impressionists. 'Monet is an eye, but only an eye,' said Gauguin. This is substantially true. Monet said that the subject of his paintings was not a view but the act of viewing. This accords with the central discovery of impressionism, which was that the eye of the person looking at a painting can reconstruct the detail 'left out' by the painter, though this will be done more or less successfully depending on the painter's skill at persuading the eye towards the desired effect. This insistence on the participation of the viewer – previously thought of as passive and neutral – in the creative process is one of the elements of impressionism that make it look forward directly towards modernism.

Monet had no wish to judge or to arrange what he saw. He had nothing to 'say', no social message or critical commentary, and in this sense he refused to play the role of the oppositional, quasi-political, individualist creator that had been written for the artist by romanticism.

Yet in another way Monet played that role very well. In the 1880s he became disillusioned with impressionism as a movement because he saw the beginning of the process that was to turn the impressionist method into a greetings-card cliché. Monet wanted to show that the artist's eye could break through the surface of perception and the method he chose almost required that he turn into an obsessive and a semi-recluse: both are familiar characteristics of a certain type of modern artist.

Monet's idea was to paint subjects in long series to show the way in which the perception of light changes the subject through time. The first of these, fifteen views of a field of Normandy haystacks, were shown in 1891, with each canvas recording the light and colour effects on the same view at different hours. The next year he rented a room opposite the façade of the cathedral at Rouen, capital city of Normandy, and made a series of twenty views of the great building, with exactly the same purpose.

Monet's attitude to colour was that colour transmits light, rather than the other way around. The paintings in the *Rouen Cathedral* series are keyed according to the particular which the artist sees as dominant: brown, blue-and-gold, blue or white. The fact that this view is painted 'in full sunlight' makes it one of the sharper, less shimmering in the series.

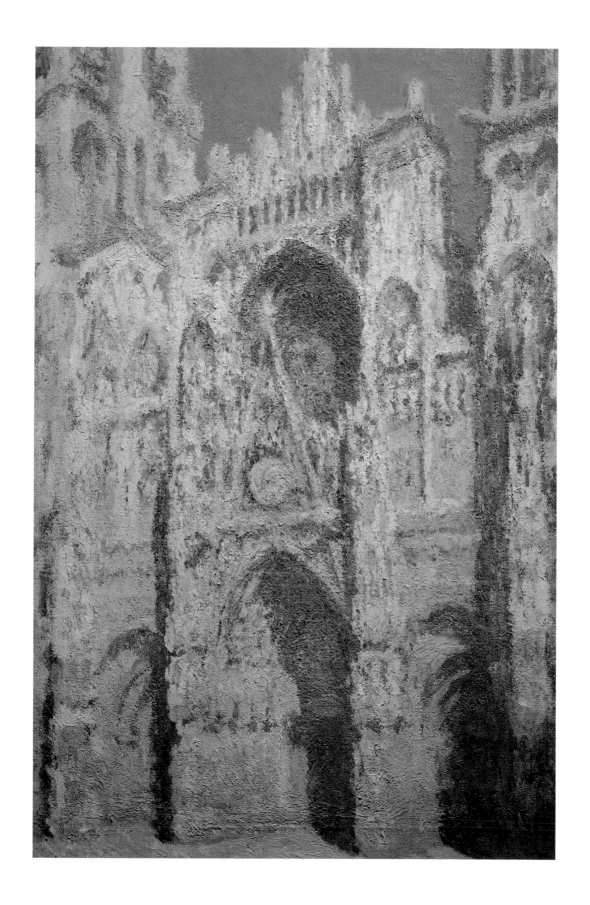

CLAUDE MONET *1840–1926*

WHITE WATER LILIES 1899

Pushkin Museum, Moscow / Courtesy of Scala

BRIDGES and spans were among Monet's most consistent interests all his life. At Argenteuil, Normandy, he painted the river bridge many times; and in his great series on Gare Saint-Lazare, carried out in 1877, the angular pitched roof of the engine shed and the smoke-shrouded bridge across the tracks, Pont de l'Europe, are vital elements. And when he was sixty he began a series of Thames bridges – 100 paintings which required three consecutive winters staying at the Savoy Hotel, from where his room looked out at Westminster and Waterloo bridges.

This is a view of Monet's garden at his last home, Giverny, outside Paris, where he lived for the last 44 years of his life. There is probably no acre of ground in the world that has been more thoroughly scrutinized by an artist. As most people are aware, there was a lily pond in the garden, crossed by this ornamental 'Japanese' bridge. In fact what Monet had was a substantial water garden with a small lake, all of which he created himself, across the road from his house. He began it in 1893 and had to get permission to divert the River Ru, a tributary of the Seine, in order to get the necessary flow of water. This garden then became his painting place, his constant motif for the great series of water-lily studies, including the eight large curved murals created specifically for the Musée de l'Orangerie (Jeu de Paume) in Paris.

Monet was a highly disciplined, dedicated painter whose temperament was calm and methodical. He generally had several paintings on the go, because he felt he could work on a particular canvas for no more than fifteen minutes at a time. As cloud conditions and the position of the sun changed in relation to the view, he would put down his brushes and return on another day at the same time, when light conditions were comparable.

The creation of Monet's paintings of his Giverny water garden was an activity not unlike the act of gardening itself, and a substantial part of Monet's pleasure as a artist must have been akin to the gardener's own enjoyment. Both are engaged in an activity that is part design and part chance, gives a deeply sensual pleasure but is, on any utilitarian scale, completely useless. But the uselessness of art is another theme which became a powerful cultural determinant in the twentieth century.

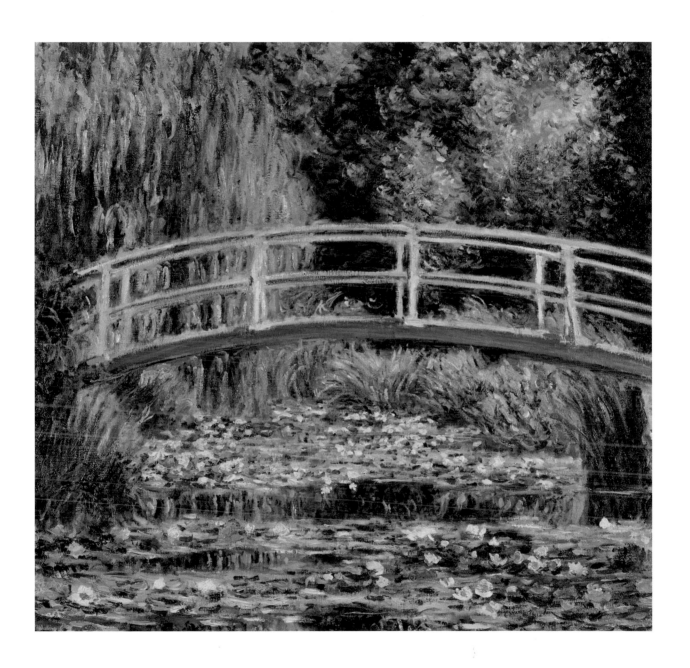

PAUL GAUGUIN *1848–1903*

NAVE NAVE MOE (THE MIRACULOUS SOURCE/SWEET DREAMS) 1891

Hermitage Museum, St Petersburg/Courtesy of Scala

GAUGUIN'S father was a journalist from Orléans, who died when Paul was three, after which he lived for four years with his half-Peruvian mother on her uncle's estate near Lima. Back in France, Gauguin went to school in Paris but, at seventeen, he signed on as a sailor in Le Havre and worked on the South American route. By 1871 he was again in Paris, now working as a stockbroker. From this he was soon earning a healthy income and he married, fathered five children and developed his passion for art as a Sunday painter. He also began to collect works of early impressionism through his friendship with Camille Pissarro, and formed a special regard for the work of Cézanne.

It was not until he was 35, following a stock-market crash in 1882, that Gauguin gave up business to become a painter. He had already known modest amateur success, having had a conventional landscape accepted at the Salon – the official show of the Academy – in 1876. But as now he settled down to paint professionally, commercial success eluded him and his savings drained away. Finally his wife left him, he lost contact with his children and he began to go hungry: he had set out on the road to his own personal Calvary.

Gauguin spent two periods in Brittany, living at Pont-Aven in a colony of artists of whom he became the acknowledged leader. His impressionism had always been weak and was now behind him. The impressionists, he said, 'seek around the eye but not at the mysterious centre of thought'. To get painting into the centre of thought, Gauguin and his associates were proud to call themselves symbolists, not only in form and subject but also, more importantly, in colour. Vibrant and bright, their colour world (which would be Gauguin's to the end of his life) is like that of no other artistic movement of the time. They meant it to resonate with deep imaginative realities, in a vague anticipation of the Freudian unconscious mind. In practice, colours were applied in flat, almost patchwork style, their juxtapositions intended to create harmonies which, by analogy with music, would evoke particular emotions and moods.

Gauguin was enough of a romantic to believe that pre-industrial society was at heart more truthful than Western civilization. Such truth, he thought, came through myth and the imagination rather than rational thought and it was in search of the same truth that he eventually travelled to the French colony of Tahiti in the Pacific, which he imagined to be akin to Paradise. The long series of works he painted of the Polynesian islanders are those by which he is best known.

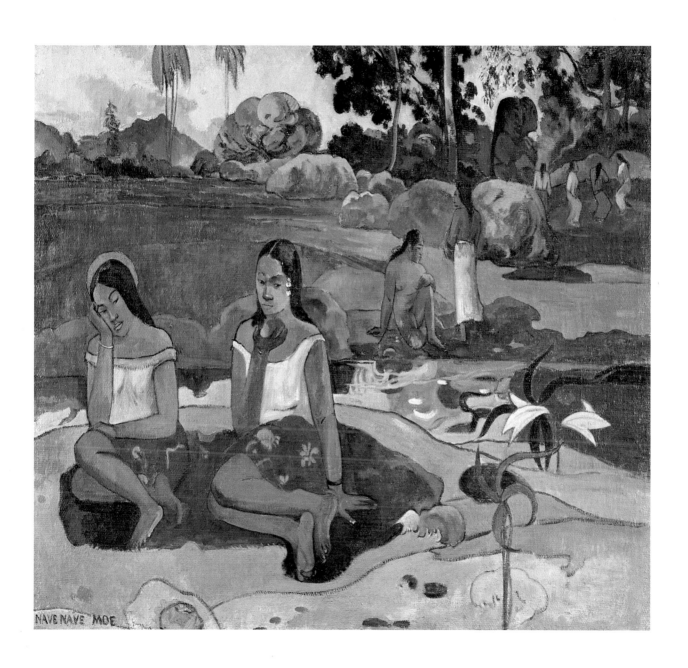

PAUL GAUGUIN *1848–1903*

SPIRIT OF THE DEAD WATCHING (MANAO TUPAPAU) 1892

Goodyear Collection, USA / Courtesy of Scala

IN Brittany, Gauguin had painted religious allegories and scenes of peasant life into the same canvas, in order to demonstrate his belief that the perceptions of the imagination are more 'real' than those of the eye. This famous painting, done during his residence on the island of Tahiti and painted on burlap because he could not afford regulation canvas, has its own spiritual context. Indeed it has a story. Gauguin came back to his hut late one night and found his girlfriend lying in their bed, squeaking and trembling from fear of the dark. She had imagined an old woman dressed in black squatting beside her.

Gauguin painted the scene as an illumination of darkness. In a commentary on the painting, he said that he put yellow decorations on the black pareu – used as the bed's undersheet – both to surprise the viewer and to create the illusion of lamplight, because he had no intention of simulating actual lamplight. The background is purple, which he explained was the colour of the girl's fear, but it is scattered with flowers like sparks of fire bursting from it. All these elements combine to suggest something more fundamentally disturbing than the alluring daytime sexuality of *Et l'Or de leur corps*.

It seems that Gauguin, despite his declared love of the people, was not entirely at ease with the Tahitian psyche. For that matter he had never quite felt included in the spirituality of the Breton peasants, but in Polynesia the contrasts were enlarged by the cultural distance he had had to travel. Alienation of the white man among black people – and vice versa – is a profoundly modern notion but it was a heresy in the 1890s, when the 'primitive' world was being enthusiastically carved up by European colonial powers. Gauguin did not believe in the white man's burden. He hated the arrogance of colonialism so much that he never represented it except obliquely, when one or two of his Polynesian paintings (like this one) wear a melancholy aspect, which hints at the emptiness, and sometimes the horror, of life under the imperial masters.

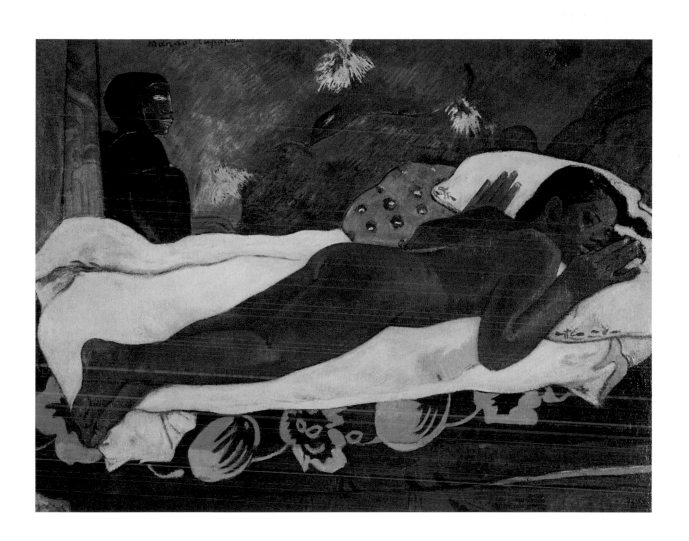

PAUL GAUGUIN *1848–1903*

ET L'OR DE LEUR CORPS 1901

Musée d'Orsay, Paris / Courtesy of Scala

THE restless and turbulent course of Gauguin's life was very much a function of his personality. He suffered from mood swings and could be a difficult companion. At certain times he would be extraordinarily selfless. At others, he was angry, withdrawn, even suicidal. He dressed flamboyantly, in utter disregard for convention – floppy felt hat, blue frock coat, yellow trousers – and thereby both attracted attention and, in some quarters, repelled it. When he was in the South Seas, his paintings, dispatched back to Paris in the hope of sales, had the same effect. Although these had their admirers, they were most often deplored by the critics for what was supposed to be their demented crudity. The public turned up at a Gauguin exhibition largely out of curiosity towards the exotic world he portrayed, or else to scoff at his crazy colouring and distortions of space.

The miracle of Gauguin is that, although dogged all his life by poverty, depression and disappointment, he almost never allowed his delight in the bright colours of his fancy to be dimmed. The truth was that Paradise in these islands had long since been squashed by colonialism (if it had ever existed) but Gauguin continued to represent it as if it endured. The great difference between his Breton paintings and those made in Tahiti is the new sensuality he found in his islander subjects. He had always preferred painting women and girls, but his Bretonnes, in their traditional black dresses and white, winged coifs, were severe, nun-like figures. These island women, either nude or wearing startling prints and surrounded by vivid blooms, radiated health and sexuality.

As its title tells us, this painting of two girls posing together on the ground, freely but not unselfconsciously nude, is a celebration of physical beauty, in particular that of their 'golden' skin. But with the red blossom backlighting the girls' heads like a halo there is also a religious element here, a reminder that Gauguin had once painted unorthodox representations of Christ that had shocked Catholic France. The artist's suggestion here that there is goodness in sexuality was revolutionary in its time and is one reason why Gauguin is a figure of such significance far beyond the discipline of painting. For it was not just in the twentieth-century plastic arts that sex became a persistent theme: its representation and discussion has permeated the whole of modern culture.

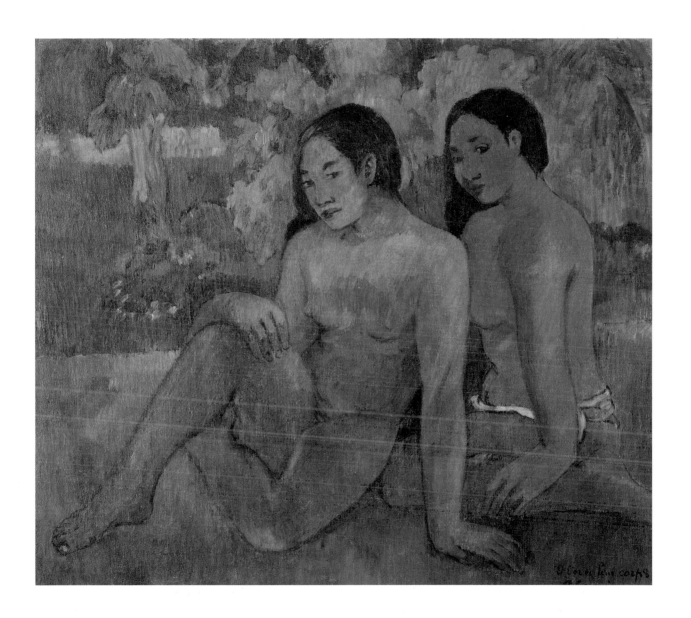

VINCENT VAN GOGH *1853–90*

SUNFLOWERS 1888

Neue Pinakotek, Munich / Courtesy of Scala

'NOW to get up heat enough to melt that gold, those flower-tones, it isn't any old person who can do it, it needs the force and concentration of a single individual whole and entire.' The quotation is from one of Vincent's letters to Theo van Gogh. No artist has left a more complete documentary legacy than van Gogh: there are 860 letters, most of them to Theo, which form a vivid and garrulous running catalogue of his works in progress. This is fortunate because, especially in Arles, van Gogh became astonishingly prolific, turning out one unsaleable canvas after another on an almost daily schedule.

In late summer 1888 he painted four still lives of the celebrated vase of sunflowers, intended specifically to decorate his brightly painted house at Arles. Gauguin was due, and van Gogh was excitedly preparing for the visit, wanting to make the house, and specifically the studio, splendid with flowers and pictures of flowers: 'Nothing but big flowers . . . If I carry out this idea there will be a dozen panels. So the whole thing will be a symphony in blue and yellow.'

He retained a special regard for the sunflower paintings and, when he sent them to Paris, he dared to hope that they might one day be worth as much as 500 francs. This was not only because they expressed his love for the southern sun and the colour yellow in general, but also for their sheer decorative quality. 'Next door to your shop,' he wrote to Theo in Paris, 'in the restaurant, you know, there is a lovely decoration of flowers. I always remember the big sunflowers in the window there.' This interest in art as decoration may seem to conflict with the passionate solemnity of van Gogh's attitude to painting, but it is perfectly consistent with his love of Japanese art and his sheer enjoyment of colour for its own sake.

The colours in the Arles paintings are preternaturally vibrant and the pigment, whether applied with brush or palette knife, is thicker and more squelchy than ever. At this time van Gogh began, like Gauguin, to experiment using unprimed (and therefore more absorbent) canvas, sometimes as cheap and loosely woven as hessian sacking. This may have been for a combination of aesthetic appeal and economic necessity, for in this period van Gogh remained grindingly poor and utterly dependent on the modestly salaried Theo.

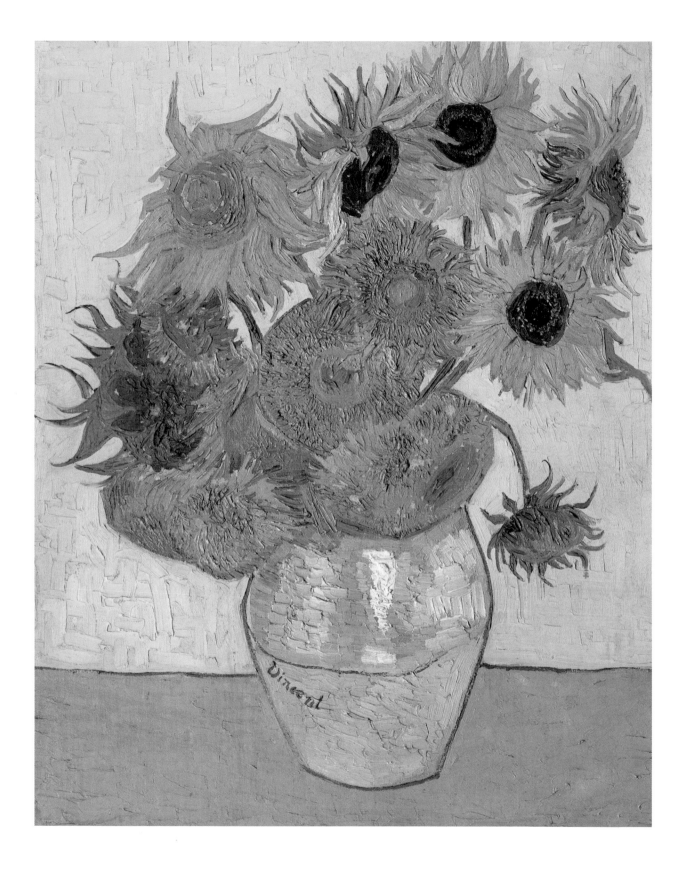

VINCENT VAN GOGH *1853–90*

THE RED VINE 1888

Pushkin Museum, Moscow/Courtesy of Scala

THIS was painted in November 1888, in the middle of Gauguin's visit. On 6 November, as the grape harvest was in full swing, van Gogh wrote to Theo of a walk he had taken with Gauguin: 'But if only you had been with us on Sunday, when we saw a red vineyard, all red like red wine. In the distance it turned to yellow, and then a green sky with the sun, the earth after the rain violet, sparkling yellow here and there where it caught the sun.'

It seems that both men painted a picture of this memorable scene, which van Gogh records, as he usually did, almost entirely in terms of its colours. As if in token of the awe in which he regarded Gauguin, van Gogh's landscape is slightly more Gauguin-like than his own usual manner. Seven months later he sent the painting to Paris with a consignment of canvases. Theo wrote back that the paintings had 'given me much food for thought on the state of your mind at the time you did them. In all of them there is a vigour in the colours which you have not achieved before – this in itself constitutes a rare quality – but you have gone further than that, and if there are some who try to find the symbolic by torturing the form, I find this in many of your canvases . . . But how your brain must have laboured, and how you have risked everything to the very limit, where vertigo is inevitable!' He adds: 'The red vine is very beautiful. I have hung it in one of our rooms.'

Perhaps its Gauguin quality is what gave this particular picture its unique commercial appeal: it became the only painting van Gogh sold during his lifetime.

Bolstered by the good opinion of the devoted Theo, van Gogh did not suffer a loss of self-respect for his lack of success. But to his horror, he did begin to lose his mind. Gauguin's stay, which lasted two months, was marked by much absinthe drinking and increasingly passionate arguments between the two self-taught men, whose ideas were by no means compatible. The visit culminated in van Gogh threatening Gauguin with a razor, before cutting off part of his own left ear as a gift for a local prostitute. Gauguin departed in alarm and van Gogh found himself in a local asylum.

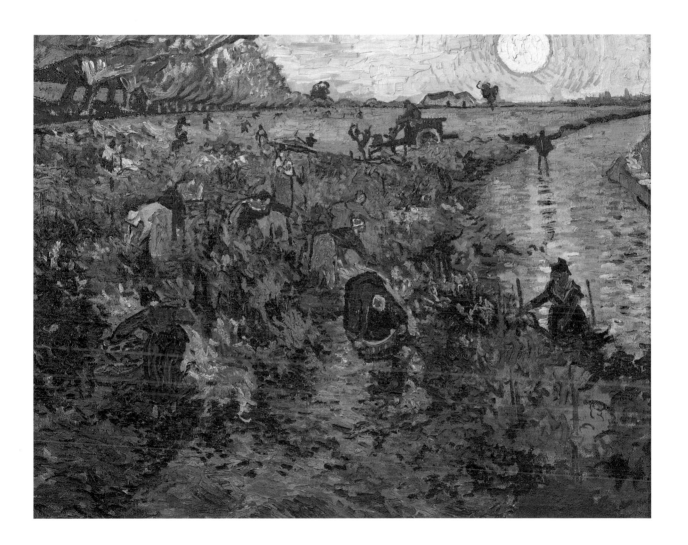

VINCENT VAN GOGH *1853–90*

SELF-PORTRAIT 1889

Musée d'Orsay, Paris / Courtesy of Scala

VAN Gogh was born at Groot-Zundert in Holland. Although his father was a Methodist pastor, his uncle had a senior position with the international art dealer Goupil at The Hague, and at the age of sixteen the young Vincent left his boarding school to work for his uncle. He stayed with the firm for six years and was posted to branches in London and Paris. But this raw, sensitive, passionate young man was not very interested in the kind of art he was handling daily and he left Goupil, first to study theology and then to become a lay missionary in the Borinage, Belgium's blackened and polluted coal-mining region. Here idealism and self-sacrifice led to his giving away all he had to the poor and living as one of them. This tendency to hurl himself into his work with total commitment, almost to the point of self-annihilation, remained typical of him.

In the Borinage, van Gogh began to draw the miners and their families, and gradually the ambition to serve humanity through art replaced his evangelical hopes. In 1880 he made a decision that ensured many more years of poverty: he would renounce his faith and become an artist. He studied in various places, notably Antwerp, and suffered his privations with neither consolation nor support from the unsympathetic and uncomprehending van Gogh family. The one shining exception was his younger brother Theo, who worked for the Goupil firm in Paris. Devoted to Vincent, Theo sent him money whenever he could and, in 1886, agreed that Vincent might come to live with him in Montmartre. At this stage a distinctive van Gogh painting technique, with its thick and energetic impasto, had already appeared, much influenced by the seventeenth-century master Frans Hals.

At first he revelled in contact with the Parisian *demi-monde* of artists, particularly the now relatively mature impressionists. He brightened his palette and made huge strides towards the painting style so well known today. But it wasn't until he tired of Paris two years later and travelled south to Arles, in Provence, that his development as a painter reached its height.

This self-portrait is characteristically intense, every brushstroke organized around the powerful stare of the eyes. 'When I compare myself to other fellows,' he once wrote, 'there is something stiff and awkward about me; I look as if I had been in prison for ten years.' The stiffness and awkwardness is here in full measure but it tends to turn up in all his self-portraits, which, seen as a series (there were 23 of them), form a programme of self-examination as searching as that of van Gogh's admired fellow countryman Rembrandt.

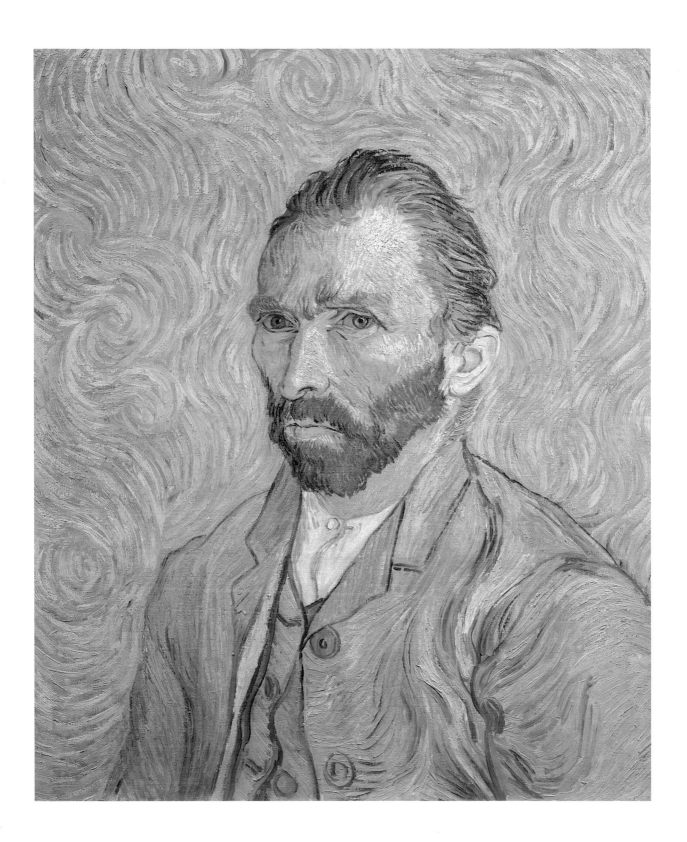

VINCENT VAN GOGH *1853–90*

THE CHURCH AT AUVERS 1890

Musée d'Orsay, Paris / Courtesy of Scala

VAN Gogh's doctors at the Saint-Rémy asylum twenty miles away, where he was admitted in May 1889, thought painting too excitable an activity for him. But the artist insisted that he would kill himself if he could not make art and the flow of finished canvases continued: audacious portraits, fierce, foaming landscapes and extraordinarily individual still lives. After a year the patient seemed much restored, although the ailment – perhaps a combination of epilepsy and tertiary syphilis – was chronic and incurable. Yet van Gogh seemed ready to start a new life away from Provence, and went to Auvers-sur-Oise, a town to the north of Paris where lived the sympathetic homoeopathic practitioner and art enthusiast Dr Gachet. It was to Gachet, the subject of several van Gogh portraits, that the artist gave this night view of the Auvers church.

Van Gogh was greatly influenced, as were other artists of the time, by prints from Japan by Hokusai, Hiroshige and others, now beginning to circulate round Europe. What particularly attracted him was their uncompromising colours, almost unshadowed depiction of nature and playful use of perspective. In this painting, the bright unseen moon inevitably casts a shadow under the church, but it is a rich green shadow lighter than the deep blue of the heavens, which inhabit the inside of the church as well as the sky. The design of this much celebrated painting both shows perspective and subverts it with the wavy outlines of the roof and the surrounding path. The effect is visionary, almost hallucinatory.

Van Gogh's was an expressionism in which Gauguin's allegorical ideas had no place, as had become clear during the older artist's visit. For van Gogh, symbolism was simply a way to exploit colour for emotional effect. And, as can be seen from his Auvers work, van Gogh was in a heightened state of emotion during much of the time there. In June and July 1890 he produced no fewer than 70 paintings. Then, on 27 July, he shot himself in the chest.

Van Gogh did not die at once and Dr Gachet sent for Theo, who rushed to his brother's bedside. He was still there two days later when Vincent died, apparently without complaint. As he himself had once written to his brother, he had found that 'it is hard to die but even harder to live'. He had been a professional artist for less than ten years.

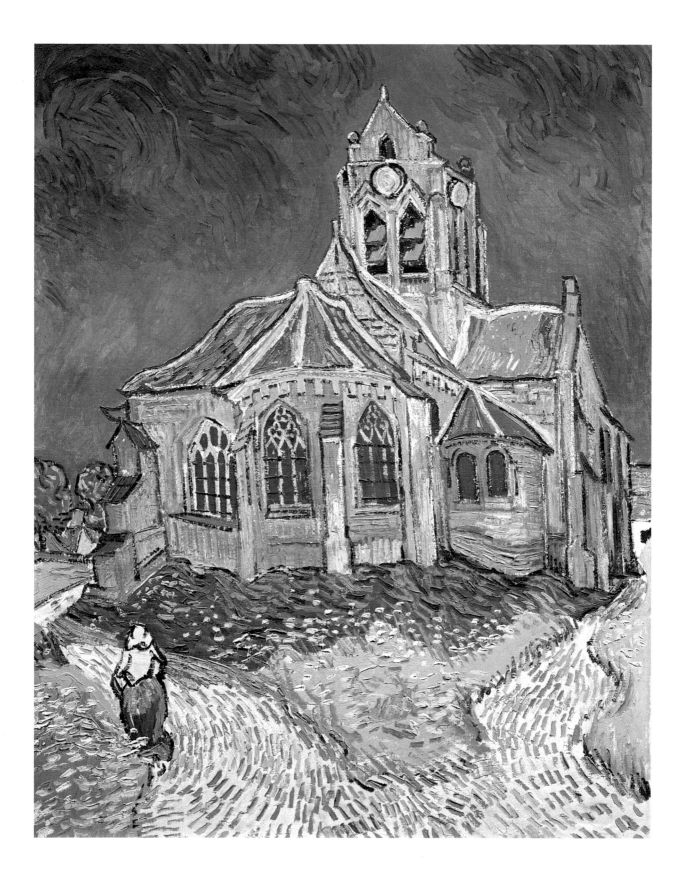

Georges Seurat *1859–91*

Model Seated in Profile 1886–7

Musée d'Orsay, Paris/Courtesy of Scala

AS a child Seurat hardly knew his father, a Parisian civil servant, but was devoted to his mother and went to her for his evening meals at 130 Boulevard de Magenta even in the last years of his life, when he was secretly living with his mistress Madeleine and their child.

His first professional teacher was Henri Lehmann, himself a pupil of the great classical painter Ingres, so that Seurat was grounded very early in the importance of sculptural form and harmonious composition. He was at this time also interested in Piero della Francesca and studied works by Murillo, Rubens and Delacroix in the Louvre.

In April 1879 Seurat attended the Fourth Impressionist Exhibition, and was struck especially by Monet and Pissarro whose works gave him 'an unexpected and profound shock'. But it was not until about 1883, after military service, that he met the impressionists themselves. He was also influenced by two of Whistler's portrait 'arrangements' – of the artist's mother and of Thomas Carlyle – which he saw exhibited in Paris in 1883 and 1884.

Although some impressionists either ignored the human figure or found it insignificant, Seurat delighted in it. His two best-known works, *The Bathers at Asnières* (1883–7) and *Sunday Afternoon on the Island of la Grande Jatte* (1884–5) are well-populated scenes of figures bathing, sunbathing or strolling on the banks of the Seine in summer, each conveying the popular holiday mood in a way which is detached (there is no sense of the artist as one of the crowd) but by no means unfeeling.

The *Model in Profile* is without any social context for she is a preparatory sketch for another large work, *Les Poseuses*. This playful work is one of Seurat's few intimate interior scenes. It shows three nude models – or perhaps one model in three poses – in the artist's studio at different stages of undress. This sketch is for the right-hand figure, who in the finished painting is removing her stockings. She exemplifies Seurat's preoccupation with figures in profile and (in this sketch especially) is strikingly similar to the central boy in *The Bathers at Asnières* – the young man seated on the riverbank dabbling his feet in the water.

Seurat declared that one of his aims was to show his figures monumentally, as if on a classical frieze. As a student he had made pencil studies of the Parthenon frieze and his mature interest in profiles may be traceable to this practice, as well as to the artist's exposure to the two Whistler portraits. He succeeds in the difficult feat of making many of them, including this, both natural and monumental at the same time.

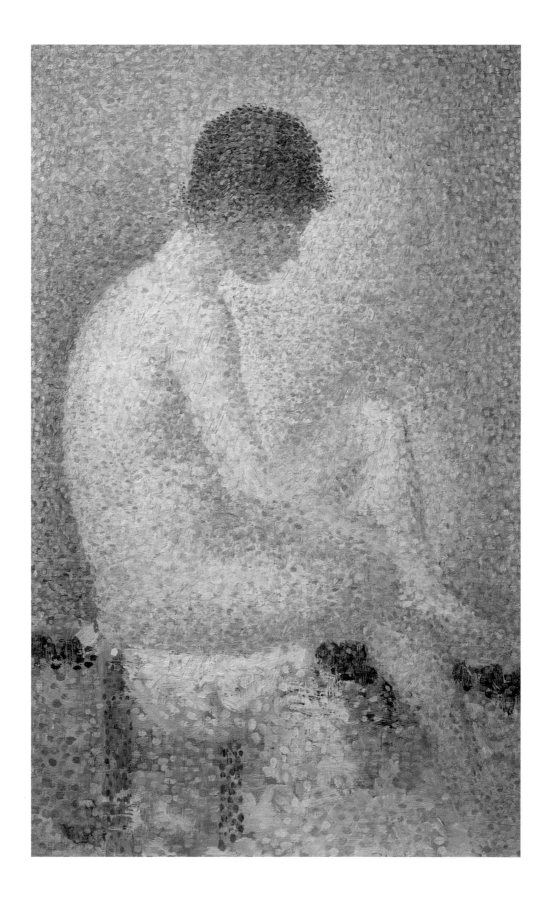

GEORGES SEURAT *1859–91*

PORT-EN-BESSIN: OUTER HARBOUR, HIGH TIDE 1888

Musée d'Orsay, Paris / Courtesy of Scala

SEURAT was a painter who instinctively wanted to arrange what his eye saw. So, although he had deeply imbibed the ideas of impressionism, he rejected the randomness of the impressionists' approach to the painted subject.

With the exception of 1887, when he was again on military service, Seurat spent his summers after 1886 in Normandy, painting marine landscapes. He spent his holidays successively at Honfleur (1886), Port-en-Bessin (1888), Le Crotoy (1889) and Gravelines (1890). Port-en-Bessin is a fishing village about midway along the stretch of coast which after 1944 would become famous as the site of the Allied landings.

Seurat was a great theorist and developed his pointillist style, which he preferred to call divisionism, as a dogmatic development of the impressionists' colour theories, informed by his reading of the scientific work of Eugène Chevreul, Ogden Rood, Charles Henry and others. Divisionism exploited the fact that small dots of different primary colours are merged in the eye to form a new area of unified colour. Its practitioners – Paul Signac was the most significant apart from Seurat himself – applied their pigments in tiny points next to each other in various proportions, allowing the retina to form for itself the shades and nuances of the colour field. But apart from the 'scientific' gloss, another distinctly modernist idea is at work here: the observer as a participant in the work of art, as a collaborator with the artist.

Seurat's 1888 composition is highly wrought and carefully arranged. The view is an image both timeless and naturalistic in which the rhythmic contours of the coastline, the curves of beach, road and sails, are interrupted by the lateral parallels of the breakwaters, leading the eye in towards the wooden harbour buildings and stone cottages of the village. The land mass seems to embrace the ocean and port while, in a complementary movement, the sea reaches possessively towards the land. It is an image of interpenetration and for this reason is as valid in a documentary way as it is aesthetically pleasing, for it sees that the life and economy of a fishing port is in essence a yoking of the land to the sea.

Seurat thought of the picture plane as if it were a 'hollowed-out space', a profoundly modern idea which later inspired twentieth-century painters from the Fauves and cubists onwards. The implication of it is that the painting does not reflect reality, or open a window to it: it appropriates elements of reality for its own purposes, using visual rhythms, contrasts, colours, lines and textures to guide and even instruct the observer's eye.

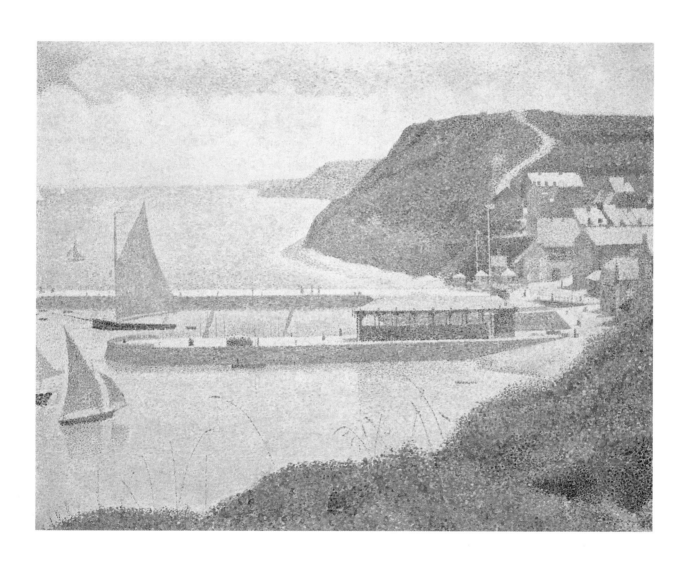

GEORGES SEURAT *1859–91*

THE CIRCUS 1890–91

Musée d'Orsay, Paris/Courtesy of Scala

SEURAT'S large paintings were produced slowly and deliberately, and were preceded by many outdoor compositional sketches and figure studies from life, which were reworked into the finished painting at his studio. Even after exhibition, Seurat might continue to work on them: both *The Bathers at Asnières* and *Sunday Afternoon on the Island of la Grande Jatte* were reworked for two or three further years. The genesis of *The Circus*, too, was slow.

In the mid-1880s, Seurat came under the influence of symbolist theoreticians – not fellow painters but writers like Charles Henry, Baron Huysmans and Jules Laforgue. Increasingly he saw himself as distinct from the impressionists, with artistic purposes which included the non-verbal communication of moral and social values.

Seurat loved public entertainments. *The Circus*, his last large-scale canvas, is based on his visits to the Cirque Fernando in the Boulevard Rochechouart. It completed a small set of scenes of public entertainment – the others are *The Parade* and *Le Chahut* (the cancan) – which set out deliberately to exploit Charles Henry's ideas of expression, while also responding to a new body of aesthetic theory inspired by the vogue for Richard Wagner's music. Seurat abandons all pretence of spontaneity here. Diagonals, at precisely calculated angles of 30, 45 and 60 degrees, are used because Henry relates these to particular colour tones. But if this seems over-cerebral, the artist's uses of disequilibrium and of interlocking ellipses are highly effective as celebrations of the curve of the circus space and the energy held within it. In this way they enhance the excitement and joy which Seurat seeks to convey. It is interesting to note that the horse appears in the traditional rocking-horse format which, thanks to the photographic research of Edward Muybridge in 1878-80, was known to be physiologically impossible. Seurat did not care. For him, the crescent curve made by the horse is an essential part of the rhythmical complexity of the composition.

Seurat was not a materially successful artist. He sold just two canvases in his lifetime and achieved no posthumous reputation for at least a decade. When *The Circus* was shown, still unfinished, at the Salon des Indépendants in 1891, the artist loitered near his painting for the appearance of a certain distinguished critic, hoping to witness an outburst of critical rapture or furious condemnation. But much to his chagrin the painting rated no more than a momentary glance before the critic moved silently on.

He was never to complete *The Circus*. On that day the hall had been cold and Seurat caught a chill. A week later he was dead, at the untimely age of 32.

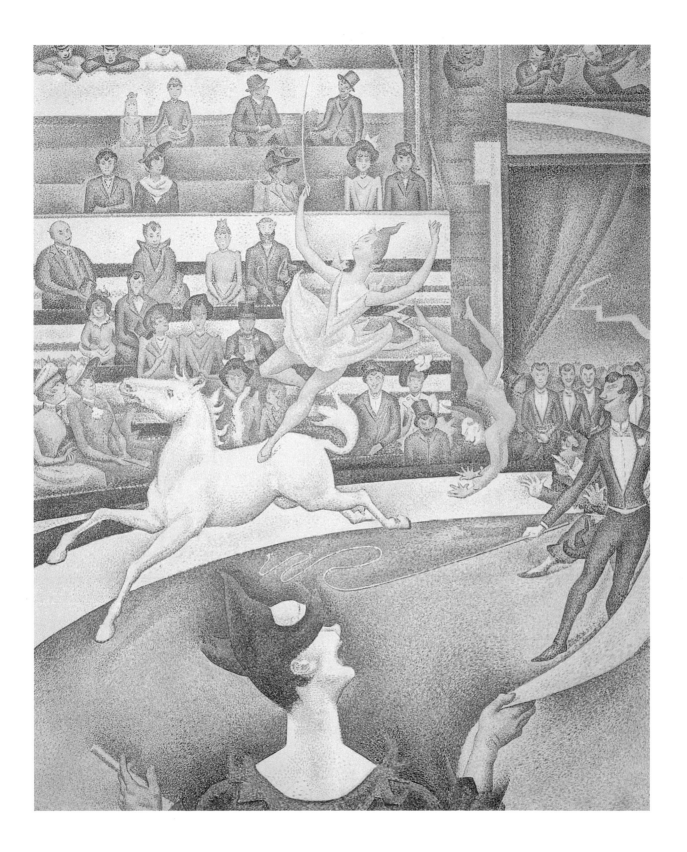

WASSILY KANDINSKY *1866–1944*

REMINISCENCE 1917

State Gallery, Moscow/Courtesy of Scala

KANDINSKY was born in Odessa, Russia, and had a relatively late vocation as an artist. For seven years in his twenties he was a law student and economist, with an interest in anthropology, but in 1896, at the age of 30, he abandoned these activities and went to study painting in Munich. Within five or six years he had established himself, exhibiting his work and teaching a painting class at the Akademie.

He was known for his figure studies in the *Jugendstil* (the German art nouveau), but he abandoned these as his travels increased his knowledge of the new French developments in painting, in particular the advances made by Gauguin and Matisse in landscape and figure painting. His work looked back in these years obsessively to Russia. But in 1908–9 his landscape work developed quickly in the direction of abstraction, with rapidly outlined contours and colour applied in broad contrasting patches. He had had a revelation, he said, on coming into his studio and seeing one of his paintings turned on its side. At first he had not recognized it, seeing instead an abstract painting made of bright colour patches which he found indescribably beautiful. From then on he dropped 'the depiction of objects' as something harmful to his art because it interfered with this direct communication of spiritual beauty.

By 1909 Kandinsky had begun to experiment with pure abstraction and two years later he abandoned overtly representational art. At the same time he was taking inspiration from religious motifs and ideas: he was attracted to the fashionable quasi-religion of theosophy and certainly believed that art was a religious activity, revealing higher truths and deeper experiences. He associated colours, as did Paul Klee, with musical notes and regarded painting and musical composition as essentially the same activity.

In Munich Kandinsky had become one of the leading lights of the Blaue Reiter (Blue Rider) group, with Klee, but the outbreak of war between Germany and Russia in 1914 meant he had to leave Germany. In 1917 in Russia, the Revolution forced further changes to his life and he worked on the administration of a succession of revolutionary cultural projects. Although he worked for the Marxist regime, and found the cultural ferment that came in the wake of the Revolution stimulating, the materialism of the new ideology was at variance with his spiritual ideas and he left Russia in 1921 to work for Walter Gropius at the Bauhaus in Germany.

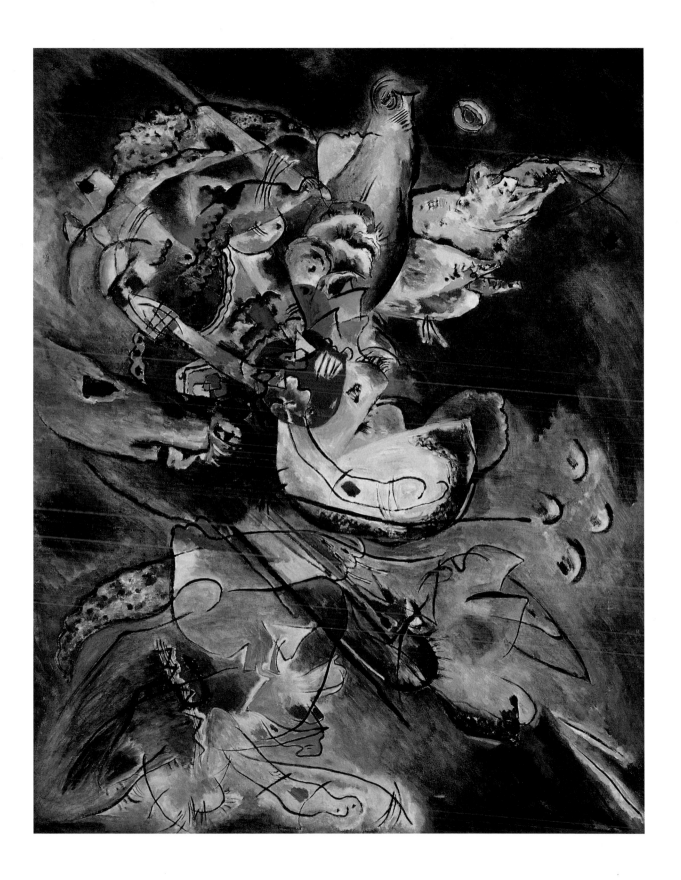

WASSILY KANDINSKY *1866–1944*

COMPOSITION IN RED AND BLACK 1920

State Museum, Tashkent / Courtesy of Scala

FROM 1910 Kandinsky increasingly assigned neutral or purely functional titles to his work, often with numbers. Yet his compositions were characterized by enormous vitality as if, in striving to reveal spiritual reality, they were delving into some subatomic world of hurtling particles and sparks of explosive energy. This continued to characterize his painting during the Bauhaus years.

Kandinsky once described his creative process by using a fusion of scientific and musical metaphors: 'Each work arises technically in a way similar to that in which the cosmos arose – through catastrophes, which from the chaotic roaring of instruments, finally created a symphony, the music of the spheres.' In fact he planned his paintings carefully, by first making various trials on paper. In this way he fixed the identity and defined the impact of the pictorial elements that interested him before he began to paint. He would then take his prepared canvas and draw charcoal outlines for the main colour patches, which he blocked in with the chosen pigments. Only after this was the linear structure painted in with black brushed lines over the colour. The linear and colour relationships were arrived at separately and were complementary rather than interdependent.

Like Klee, Kandinsky became a victim of Nazi ideology soon after Hitler's takeover of power in 1933. The Bauhaus came under close political scrutiny and its director was told he could keep it in existence only if Kandinsky was dismissed. In the end he left Germany, with the help of Marcel Duchamp, finding refuge and an apartment in Paris. The Paris art scene was wildly multicultural but Kandinsky never quite integrated with it, remaining an outsider looking in.

In his Paris years Kandinsky, again like Klee, began to paint forms that looked like micro-organisms, and he hunted through biology books for inspiration, searching for examples of the correspondence between art and nature. He never renounced his belief in art as a spiritual force for the regeneration of life along theosophist lines.

The Nazis caught up with him again in 1940, with their occupation of Paris. Kandinsky stayed quietly where he was and remained unmolested. An anxious moment came with the mass burning of modernist paintings outside the Tuileries in May 1943 but none of his works was included, possibly because he was perceived as being now out of the main current. At this time canvas and oil paints became unobtainable and his last works were in gouache on small sheets of paper and card. He died in December 1944, a few months after the liberation of Paris.

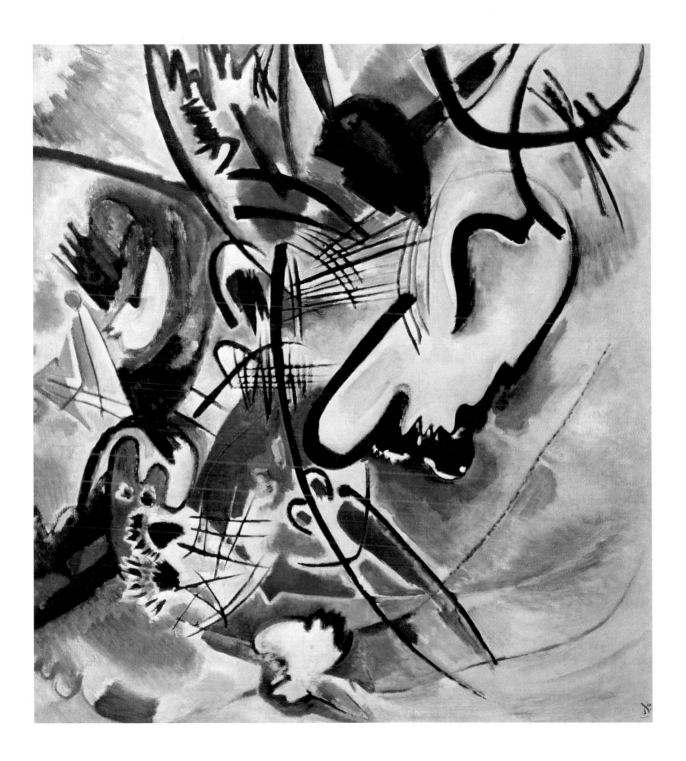

PIERRE BONNARD *1867–1947*

THE TERRASSE FAMILY: A BOURGEOIS AFTERNOON 1900

Musée d'Orsay, Paris / Courtesy of Scala

AS a young man Bonnard followed his father's wishes and studied the law but, unlike Cézanne in the same situation, he was actually called to the Bar before deciding to paint instead. While still a law student he had enrolled in 1887 at a Paris art school, where he met Maurice Denis and Paul Sérusier, who with Edouard Vuillard and Paul Gauguin would form the group with which the young Bonnard most identified, the Nabis painters.

The young Bonnard had been particularly inspired by Gauguin and by Japanese prints (he was known for a while as 'the Japanese Nabis'), drawing from both models a new sense of bold outlined forms, fluency in line and colour and unexpected viewpoints. At this stage he designed stained-glass windows, pottery, furniture and screens in a style influenced by the Japanese prints and art nouveau. He also designed publicity posters, including a successful one for champagne which was seen all around Paris and inspired Bonnard's acquaintance Toulouse-Lautrec to try his hand in the same market. Bonnard's champagne advertisement earned him 100 francs. He immediately gave up the law and rented a studio with Denis, Vuillard and Sérusier.

Several of Bonnard's more ambitious early paintings portray outdoor family scenes. This one was exhibited at the Salon d'Automne in 1903 and is a half-amused treatment of a family he knew well, since his favourite sister, Andrée, was married to the composer Claude Terrasse. Bonnard's concern for order in life is seen here, with the viewpoint manipulated to emphasize balance, security and sanity, making a kind of modern conversation piece, complete with its built-in joke: the Terrasse family is sitting on a terrace.

But this kind of thing is not really the best of Bonnard, to whom an ironic idiom was and would remain fundamentally alien. As he gradually distanced himself from the Nabis, with their earnestness and symbolism, he fell under the ever-potent influence of Cézanne on his way to coming, late indeed, to an appreciation of impressionism in general. His best work even in the Nabis period and certainly after it was both intimate and overflowing with feeling. His adaptation of the insights of impressionism enabled him to create a type of work completely in his own idiom (a Bonnard is always instantly recognizable) while adhering more or less to impressionist ideas about light, movement, transience and feeling.

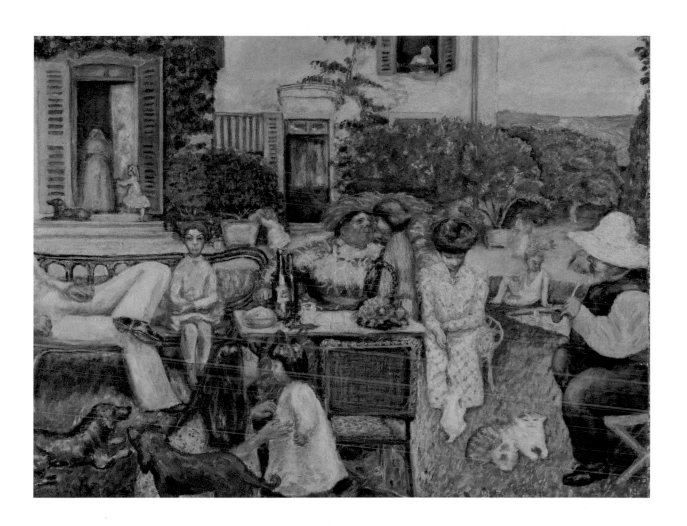

PIERRE BONNARD *1867–1947*

THE NUDE IN THE BATH 1917

Collection Beller, Paris / Courtesy of Scala

IN 1894 Bonnard's life was changed for ever when he met Marie Boursin, known as Marthe, with whom he began a liaison that became his main artistic preoccupation for the 47 years of their relationship. He celebrated Marthe in paint over and over again with obsessive intensity until her death in 1942, never allowing her to age but always presenting the desirable young body he first remembered. Usually painted nude, Marthe is seen around the house, stretching, combing, brushing, sleeping, perfuming, stroking a cat, putting on stockings and, above all, bathing. The unrelenting, voyeuristic interest Bonnard showed in his wife's intimate rituals of dressing and cleansing represent a classic statement of the artist as obsessive and of art as neurotic repetition, even of addiction, which has had many parallels throughout all the arts of modernism.

But Bonnard's compulsions are neither unmitigated nor instinctual. This pose is based on his studies of classical nudes in the Louvre and the arrangement of the forms, exploiting the curve of the bath inside the rectangle of the canvas, provides a new interpretation of Cézanne's ideas on composition, while employing a quite un-Cézanne-like brush technique.

After Marthe's death in 1942 Bonnard, with another five years left to him, painted more still life and landscape than before. On one occasion when a model did present herself, he did not ask her to pose in a still position but rather to move around and please herself as to what she did. Almost a quarter of a century of painting Marthe going about her daily life had made it impossible for him to study a figure in anything but movement.

Early historians of modern painting often consigned Bonnard to a few mentions here and there, as a minor and late efflorescence of impressionism, whose career was an artistic cul-de-sac. Picasso, for example, called him a 'pot-pourri of indecisiveness'. But Bonnard has since come to be seen as one of the most magical painters of the twentieth century. His greatness lies to a great extent in his ability to make light shimmer and glitter in a fantastically powerful flux, making the interior of an ordinary bathroom, kitchen, living room or bedroom into a heady, almost ecstatic space. As the painter himself put it, painting for Bonnard was 'the transcription of the adventures of the optic nerve'.

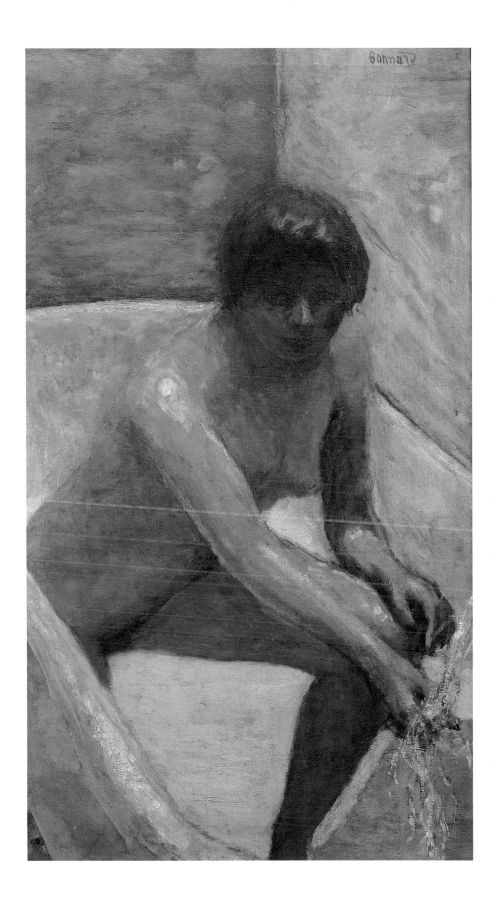

HENRI MATISSE *1869–1954*

NUDE STUDY IN BLUE 1899–1900

Tate Gallery, London

MATISSE was born at La Cateau in France and moved to Paris as a young man to study law. In the 1890s he had already started to work as a legal clerk when, convalescing after appendicitis, he took up drawing and painting. Soon he had decided to be an artist and abandoned the law to study with the outstanding teacher Gustave Moreau. In the first years of the century Matisse, who eventually became known for the graceful beauty of his line and the harmony of his colours, was the leader of the fauvist, or 'wild beast', group of painters, which flourished in Paris during the first decade of the twentieth century. The name Fauve was applied sardonically by a critic when he saw the display of these artists – Matisse, Derain, Vlaminck, Dufy and others – at the 1905 Salon d'Automne.

The name stuck because it had a certain validity at a time when, to academic critics, the paintings' non-naturalistic array of colours and headlong brushwork seemed a deliberate and violent affront to civilized values. Yet it is not at all an adequate name for Matisse, about whom there was nothing in the least violent or savage. He apparently had no strong political convictions and was pleasingly free of overt neurosis. His consistent subject throughout 60 years as a professional artist was pleasure in all its manifestations: in women, wine, food, landscape, rooms, colour and the very act of painting itself. He strove for an art which was, as he put it, 'of balance, purity, cheerfulness, comfort to the soul – something like a good armchair'. The contrast with the moody, sometimes angry, often politically engaged Pablo Picasso is marked.

All his professional life he was preoccupied with how art could join the actual beauty of things, as it is perceived and enjoyed (transiently and imperfectly) by the senses, to the timeless aesthetic principles which underlie all things. His studies of the human body are key to this inquiry. This early example is an academic exercise, carried out at the Académie Carrière, in Paris's Rue de Rennes, which the young Matisse frequented for several months. Here, nude models were available and artists and students were able to draw and paint in a particularly free and tolerant atmosphere. Although it would be five years before Matisse found his own distinctive style, this nude is organized into the ideal pattern known as the 'arabesque' – a spiralling form around a vertical axis – which was to interest him throughout his life.

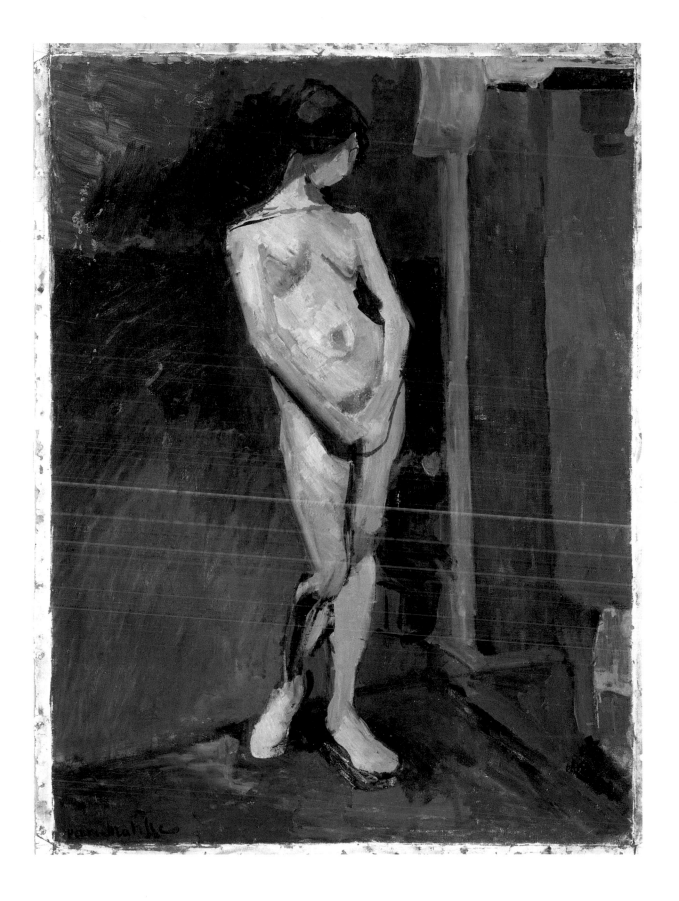

HENRI MATISSE *1869–1954*

THE PINK STUDIO 1911

Pushkin Museum, Moscow/Courtesy of Scala

MATISSE had long ago rejected Seurat's pointillist experiments, which had been continued into the next century by his friend Alfred Signac whom Matisse also knew well. The fauvists came to regard this branch of post-impressionism as dull and lacking in dynamism, with the separation of colours sapping the strength of the colour field. All the Fauves were deeply impressed by van Gogh but, unlike his friends, Matisse preferred Gauguin's less visibly anguished technique. Above all he revered Cézanne, one of whose *Bathers* he bought at a time when he had to make real sacrifices to raise the cash. He never regretted it, and said of the painting years later: 'It has sustained me spiritually in the critical moments of my career as an artist; I have drawn from it my faith and my perseverance.'

What Matisse found inspiring in Cézanne was the relationship between colour and structure. Cézanne's colours were always built into the foundations of his work, making an art that was vigorous, endlessly renewable and pursued with inexhaustible concentration. So it formed a model of exactly the kind of integrity Matisse himself wanted to develop as he sought out the colours and combinations that would express his feelings. He never felt that these colours were rationally worked out: they emerged by intuition, almost by instinct, in what for this artist was the essence of the creative process.

By 1911 he had already distanced himself from the other fauvists and he was reacting too against the new enthusiasm in Parisian art circles for the cubism of Picasso and Braque. He now embarked on four big paintings, each of an interior and known collectively as his 'symphonic interiors'. *The Pink Studio* – the first of the series – shows Matisse's studio at Issy in south-east Paris. The harmony of colour and of the rectilinear forms invite the musical comparison, but why is the piece compared to a symphony? The analogy is appropriate, if only because it indicates that these are, despite their domestic subject matter, works of considerable ambition. Large and invitingly accessible, they are anything but intimate. Instead they make a frank public avowal of Matisse's pleasure in his job and in the room in which he works at it.

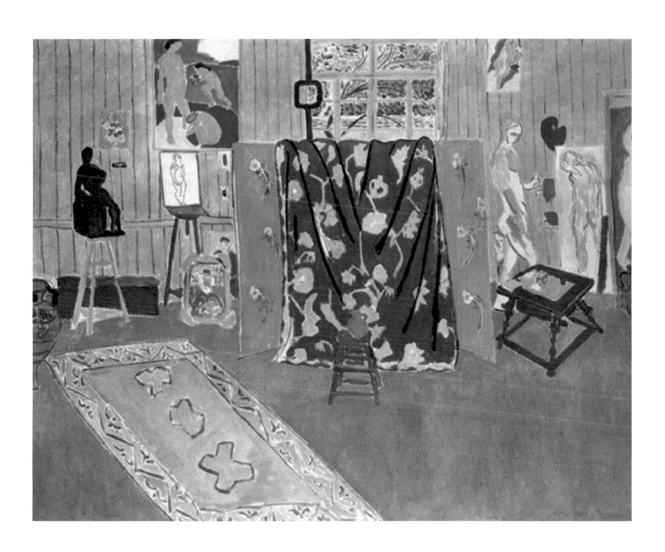

HENRI MATISSE *1869–1954*

READING WOMAN WITH A PARASOL 1921

Tate Gallery, London

MATISSE was late hitting his stride as an artist. An extremely thoughtful, intelligent and articulate man, he spent his twenties in preparation for the life of a professional painter by making deep studies not only of the impressionists and neo-impressionists but also of the old masters, taking from them what he needed and rejecting all that was inessential. This process of identifying the essential and discarding everything else was, in fact, central to his approach to composition.

'The whole arrangement of my picture is expressive. The place occupied by figures or objects, the empty spaces around them, the proportions, everything plays a part. Composition is the art of arranging, in a decorative way, the various elements at the painter's disposal for the expression of his feelings ... All that is not useful in the picture is detrimental. A work of art must be harmonious as a whole; unnecessary detail would, in the viewer's mind, only interfere with the essential elements.'

Reading Woman with a Parasol was painted at Pont du Loup, near Nice, three years after Matisse had moved south from Paris. Despite his insistence that composition is an intuitive process, the canvas is organized with all the care of a still life, to create an almost flawless display of the confident brush strokes, the irrefutable colours and the bold design of Matisse's mature work.

This is not a naturalistic portrait and, in fact, the woman was a professional model named Henriette. So, while Matisse's representation of her is absolutely convincing as that of a real person absorbed in a private activity, it is also universal in theme and composition. As if to underline this, the array of objects on the table resembles a set of symbolic attributes such as were often included in old portraits. It is as if Matisse were concerned as much with connecting to the tradition of western art since the Renaissance as he was with 'modernity'. Analysis alone cannot comprehend the genius of Matisse. His paintings have an extraordinary, very particular presence, which reminds us that he was the greatest French-born artist at work in the twentieth century.

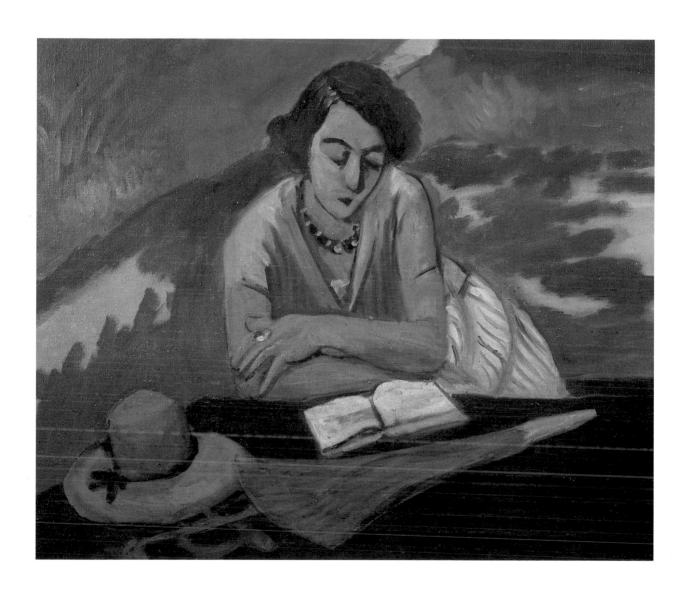

GIACOMO BALLA *1871–1958*

FORM, NOISE, MOTORCYCLIST 1912

Palazzoli Collection, Milan/Courtesy of Scala

BALLA was one of the most inventive and energetic Italian painters and designers of the modern era. His long career covered much the same span of time as Matisse's, though the two were very different in their objectives, not to say in temperament.

Balla, who had no academic training, set up as a painter in Turin, where he worked until 1895. Moving to Rome, he immediately showed an analytical approach to his work, practising the divisionism (or pointillism) pioneered in France by Seurat. Balla worked on portraits, landscapes and scenes of the Roman streets, while keeping up with neo-impressionist developments in Paris. He was a man with strong, left-leaning political views but as an artist he adhered to objectivity, allowing neither symbolist nor propagandist overtones to encroach on his work. In this, he was content methodically to explore the representation of light in paint.

Balla had worked since the turn of the century with two much younger painters, Umberto Boccioni and Gino Severini. In 1909 Boccioni composed his two futurist manifestos and Balla became one of the first signatories, a departure which led him to explore with fascinating results how he might capture, in two dimensions, three-dimensional movement, particularly (in keeping with the futurists' obsession) when it is at speed. The futurist 'discovery' that the space through which bodies move is never straight but is curved, or even circular, chimed with his own growing rejection of the static universe. The theory also happened to resemble Einstein's special theory of relativity which, with its demonstration that space-time is indeed curved, was published in 1905.

With wit as well as skill Balla now turned out canvases whose effect resembled that of movement when photographed at a slow shutter speed. He also became interested in the attempts by some futurists to produce a visual equivalent of noise. This is the subject of the painting illustrated.

The sequence of the title words is significant: two abstract words and then the clinching concrete signifier: motorcyclist. Balla's design achieves its effect by exploiting the wheels of the machine, its tyres, cogs and flying chain, unravelling them and feeding them into a vortex, while fire or electricity sparks between them. The reverberant quality of noise is also there, as Balla's various moving coils echo each other. This is not really representational painting, but rather abstraction of a kind that, though it owed much to cubism, had not previously been seen in painting.

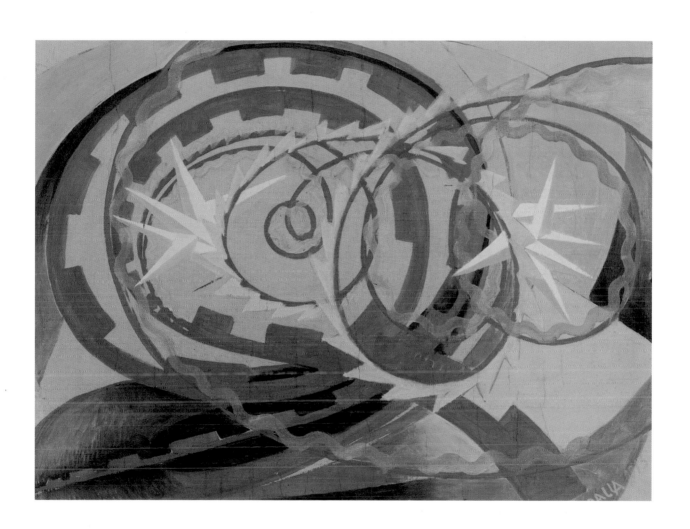

GIACOMO BALLA *1871–1958*

SKETCH FOR FIREWORKS 1915

Theatrical Museum, La Scala, Milan / Courtesy of Scala

BALLA was too old to fight in the First World War and so he observed Italy's entry from the sidelines, making a number of works that expressed his patriotism without degenerating into jingoism. He also began to become involved in the theatre, designing stage sets and lighting and even appearing as an actor. This was partly under the influence of a new member of the futurist circle, Fortunato Deprero (1892–1960), who was particularly close to Balla and was fascinated by theatre.

The push by Deprero and Balla into the world of the performing arts was stimulated when the two artists met Sergei Diaghilev. Diaghilev's Russian Ballet company had had sensational success in Paris, with the dancer Nijinsky and the composer Igor Stravinsky, from 1910 onwards. But as the war dragged on, they began to travel further afield, including making a tour to Italy. In keeping with his policy of seeking set designs from the best available avant-garde artists, the impresario commissioned both Balla and Deprero to design scenery and costumes. The sketch illustrated refers to an early piece of music by Stravinsky, his symphonic fantasy *Fireworks* (Opus 4) of 1908, which was subsequently choreographed for Diaghilev. *Fireworks* was to be danced at Milan's La Scala theatre and this is one of several sketches for proposed set designs. The set is unmistakably futurist but it is heavily simplified compared to Balla's paintings. Here Balla's normally exuberant creative impetus is restrained by the importance of not upstaging the dancers. The richly but simply coloured design has solid faceted forms which seem to be a mixture of urban buildings and rural landscape. They are topped by effervescent striped areas which call to mind pyrotechnics with their transitory explosions of fire and light.

As well as taking up the challenge of depciting scenery, Balla tried his hand at many diverse activities. He designed concrete poems and musical instruments. He worked on typography and advertising posters. He produced luminous ties, fancy waistcoats, children's furniture and brightly coloured toys.

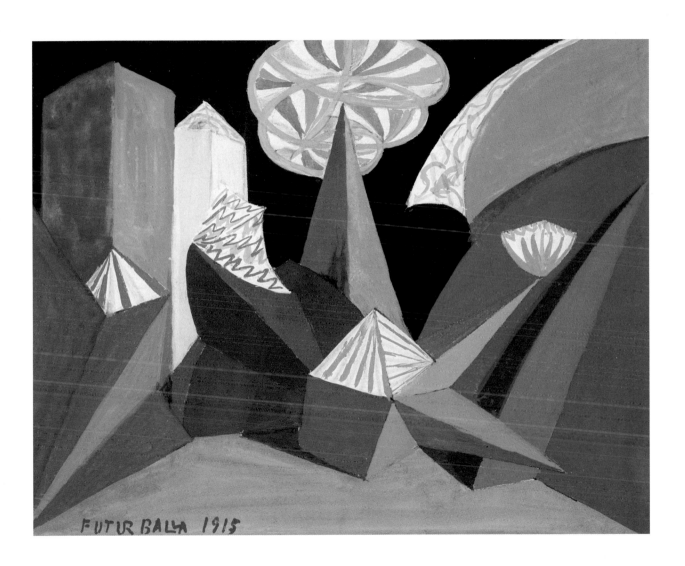

PIET MONDRIAN *1872–1944*

COMPOSITION 1921

Kunsthalle, Basle / Courtesy of Scala

MONDRIAN was born in Amersfoort, the Netherlands, into a strict Calvinist family. He built his career patiently from his early training in academic realism, through impressionism and, in Paris before the First World War, cubism. But he is best known – indeed, instantly recognizable – for his mathematically exact, primary-coloured abstractions.

It is surprising to discover that the man who produced this apparently cool, cerebral piece (and hundreds like it) was interested in spiritualism and theosophy. Mondrian was neither deeply nor widely intellectual, but his ideas acquired a definite, lifelong philosophical basis from his meeting with the Dutch philosopher M. H. J. Schoenmakers in 1916. Schoenmakers, also a theosophist, had developed a system called positive mysticism or 'plastic mathematics' which, he explained, meant 'true and methodical thinking from the point of view of the creator'. Schoenmakers would expound his ideas as follows: 'We now learn to translate reality in our imagination into constructions which can be controlled by reason, in order to recover these same constructions later in "given" natural reality, thus penetrating nature by means of plastic vision.' This muggy verbiage seems to be from a separate universe to the pristine clarity of Mondrian's paintings of the 1920s and 1930s, yet they gave the Dutchman courage to develop the approach that made him famous, which was, again in Schoenmakers's words, the attempt 'to penetrate nature in such a way that the inner construction of reality is revealed to us'.

Mondrian's theosophy – the belief that matter, and its superficial presentation, was the greatest stumbling block to enlightenment – was what enabled him to believe that through his art he could peel away layer upon layer of subjectivity and reveal the objective essence of reality. The paintings thus become icons for a religion that was so new it had no pre-existing iconography. They are objects of meditation, mantras for the contemplation of deep structure which are spun from the voluntary abandonment of all expression, emotion and materialism.

Mondrian's paintings, before he redefined himself as an abstract artist, were symbolist works moving into cubism. Later he would regard these paintings as merely sentimental, but they were often impressive, sometimes with surprising echoes of van Gogh's passionate vision and certainly without a hint of the exquisite realm of emotional detachment into which Mondrian moved after 1912. The purest products of that process are these grid paintings, in which rectangles are established by broad black lines on a white ground, selectively coloured in with primary colours.

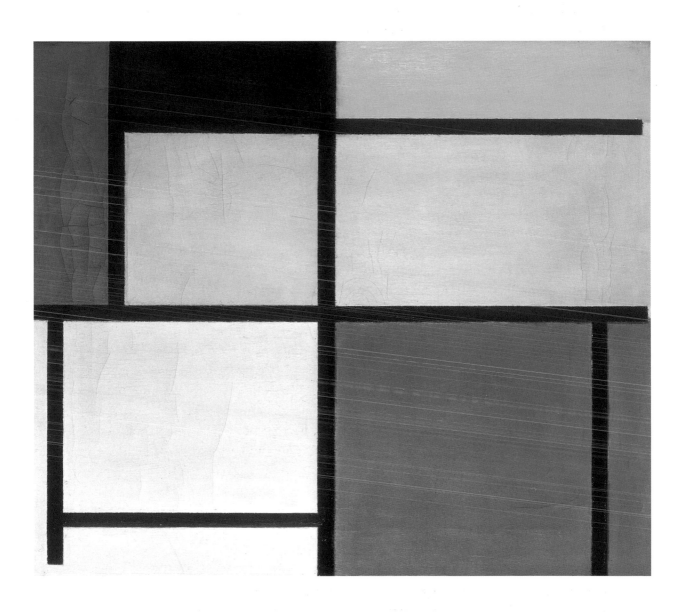

PIET MONDRIAN *1872–1944*

COMPOSITION II 1929

National Museum, Belgrade / Courtesy of Scala

MONDRIAN sought neither to analyse nor to synthesize matter – as, for example, Braque did – but instead to transcend it. He therefore found pure cubism too urban and too rooted in the observation of inessential things. His response was to leave the city and look for more elemental subjects. In an early, fascinating attempt to transform nature into pure art, he made a particularly brilliant series of seascapes (1912–15) in which the play of water is reduced to a geometric pattern of thin crosses and intersecting vertical and horizontal strokes of paint.

Until 1924 Mondrian's professional loyalty was to a group of Dutch abstractionist colleagues, the most talented of whom was Theo van Doesburg, who edited the Dutch utopian art and design magazine *De Stijl*. Mondrian himself liked to call his position neo-plasticist. His geometric vertical and horizontal lines and simple colours were intended, as he said (drawing on his guru Schoenmakers) to reflect the 'primordial relation' in nature which governs all other relations, and this is a relation of opposites: black/white, male/female, vertical/horizontal. The rectilinear grid seemed to him for almost twenty years a perfect expression of this structural principle. Its spareness accorded well with the ideas of De Stijl, a movement so austere that it sometimes made the Bauhaus look unprincipled by comparison.

In the late 1930s, fearful of Nazism, Mondrian lived for a time in London, but the outbreak of war, and then a Luftwaffe bombing near his studio, prompted him to leave for the USA. Here he became in his last years something of a cultural sage, attracting many visitors to his New York studio and expounding his theories in print. Their theosophical loopiness in no way prevented him from gaining American star status. At the same time his vision loosened in a way best exemplified by his last finished painting, *Broadway Boogie-Woogie* (1942–3). As the title – unlikely for a Mondrian – indicates, it is inspired by jazz and the streets and motor cars of Manhattan, as viewed from a skyscraper.

In his austerity and doggedness and patient attention to spatial relationships, there is something of his countryman Vermeer in Mondrian. Both men have a similar capacity for inspiring a real but intangible awe, leaving many enthusiasts groping for words to express what his paintings mean to them. But Mondrian's brilliance had a much wider immediate impact than that of the master of Delft and he can justly now be called one of the most influential image-makers of the twentieth century.

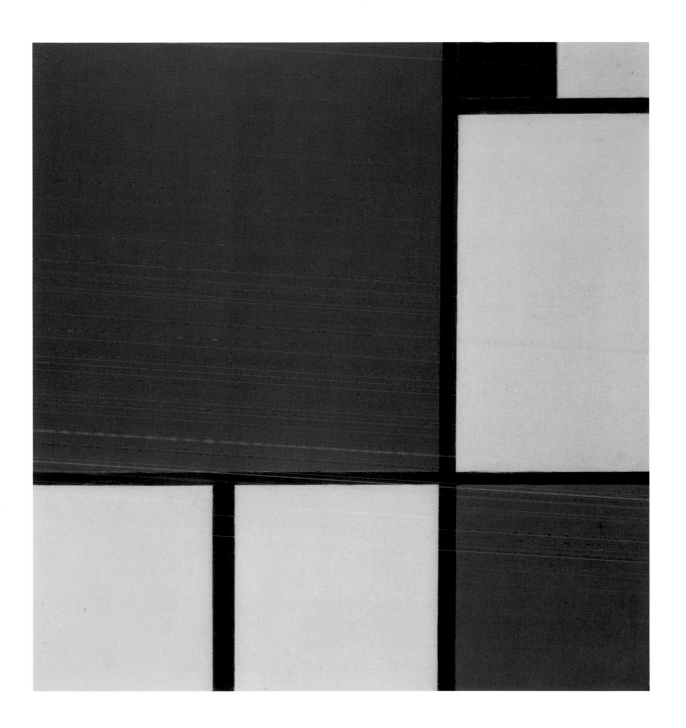

CONSTANTIN BRANCUSI *1876–1957*

THE SORCERESS 1916–24

Courtesy of the Guggenheim Museum, New York

BRANCUSI'S family were well-to-do peasants in Romania. He left them in their remote village at the age of about eleven, enrolling at the art school of his provincial capital and later studying in Bucharest. Here he began to make sculptures but soon realized he needed to travel further afield and set off to walk to Paris, taking two years over the journey before finally arriving in 1905. There he supported himself by washing dishes while studying at the Académie des Beaux Arts. In the next year bronze pieces by him were exhibited at the Salon d'Automne and he began to practise direct carving.

Brancusi became one of the most influential sculptors of the century. The central idea that drove him was that 'what is real is not the external form but the essence of things'. His search for the essence of a subject meant that life-likeness was far from his mind. The appearance of a thing was just a starting point: its essence had to be striven for in the making of the piece.

Like others of his generation, he had particular respect for Buddhist and Hindu philosophies, with their emphasis on the oneness of things, the possibility of transcendence and the practice of meditation. And like other artists of his time, he was drawn to theosophy, conceiving his three-dimensional pieces (like Mondrian his canvases) not as monuments of any kind but as objects of meditation.

Brancusi drew his inspiration from three sources: from the rough village carving he had known as a child; from industrial forms; and finally – in common with Picasso and almost every artist in Paris just before the First World War – from tribal sculpture, especially that of Africa. All these influences are to be seen in *The Sorceress*. Just 100 cm high, it is carved from three contrasting woods which seem initially hardly to belong together. It is especially the forward thrust of the smooth, cleanly turned upper section, the Sorceress herself, in contrast to the roughly chopped-out folk-style base, that gives this piece its force.

In the late 1930s, Brancusi completed one of his most ambitious works. He had for some time been designing interiors, including furniture. Now he built the Tirgu Jiu complex in his native Romania, an assemblage of symbolic furniture and a war-memorial piece, *Endless Column*, which formed on a small scale the kind of 'temple of love' which Brancusi had for many years dreamt of building.

RAOUL DUFY *1877–1953*

THE FOURTEENTH OF JULY AT DEAUVILLE 1933

Pushkin Museum, Moscow / Courtesy of Scala

DUFY was already an office worker at the age of fourteen but studied art in the evening at Le Havre's Ecole des Beaux Arts, a school which later produced Georges Braque, five years Dufy's junior. Early influences were Delacroix and the impressionists but it was not until five years after Dufy had gone to Paris, at the age of 23, that he found his direction. He discovered the painting *Luxe, Calme et Volupté* by Matisse, which was exhibited at the Salon des Indépendants in 1905, and, as he wrote, he suddenly 'understood all the new principles of painting, and impressionist realism lost its charm for me as I contemplated this miracle of the imagination introduced into design and colour. I immediately understood the new pictorial mechanics.'

Dufy adopted the style of the artists who would become known as the fauvists after their own collective show in the Salon d'Automne the same year. Dufy described his painting method at that time: 'I drew the contours of each object in black mixed with white, each time leaving in the middle a blank space which I then coloured in with a specific and quite intense tone. What did I have? Blue, green, ochre, not many colours. But the result really surprised me. I had discovered what I was really looking for.'

The liberation felt by the Fauve artists, under the pioneering influence of Matisse, was from all obligations to observe or record objective reality. Of course they were subject painters but their first loyalty was to their own vision, and Dufy's vision is a delightful one. He rejoiced in colour and in the very direct, rapid transcription of landscape. He especially enjoyed scenes of public holiday and celebration, as in *The Fourteenth of July at Deauville*, which shows the ships flying pennants for Bastille Day. Note the outline of the ships and houses crudely brushed in with black paint – a trademark of Dufy's style.

Dufy's professional life lasted more than half a century and his work is easily recognizable. Although he is popular with the card- and print-buying public, Dufy has often been underrated by critics, partly perhaps because of the lack of agony in his life and work. As well as a particularly sunny and optimistic painter, he was a prolific decorative and stage designer and an acclaimed illustrator. He was also a fanatical lover of music and admirer of musicians, an interest he also celebrated in his work, particularly towards the end of his long life.

KASIMIR MALEVICH *1878–1935*

THE AVIATOR 1911

Russian State Museum, St Petersburg / Courtesy of Scala

MALEVICH was a designer, printmaker and painter born in the Ukraine of a working-class family. He struggled to find the cash to study art while working on the railways and by 1904 was an art student in Moscow. His work developed quickly, in an art environment which spawned and disposed of new groups and movements with a bewilderingly rapid turnover. Malevich exhibited with Kandinsky in 1907, then became associated successively with the Jack of Diamonds, Donkey's Tail and Target groups. The last-named, influenced by cubism, Orphism and futurism, developed the concept of rayism (or luchism) as a fusion of all three, but Malevich quarrelled with its leader Larionov and joined another grouping, based in St Petersburg, known as the Union of Youth.

Through the private collections of rich men with advanced tastes, like Sergey Shchukin and Ivan Morozov, he was increasingly exposed to the Paris school of modernist painters, at first favouring particularly Matisse. These private collections were an important conduit for the dissemination of modernist ideas in pre-revolutionary Russia. Shchukin's Moscow palace, to which favoured artists could get access, displayed 37 Matisses, 29 Gauguins, 26 Cézannes and no less than 54 Picassos. The effect of this cornucopia of visual experiment and iconoclasm on excitable men like Malevich was electric.

The Aviator is in the cubo-futurist style that Malevich embraced around 1912-13, moving away from the plain primary colouring he got from Matisse to the more subdued and complex palette of the cubists. Several typical cubist mannerisms can be noted here: the playing card, the stencilled lettering and the elision and overlapping of flat surfaces. The aviator himself, in his tubular metallic suit and strangely unsuitable hat, represents a figure who was seen by all modernists at this period as metaphorically as well as spatially above ordinary mortals. In fact Picasso and Braque, during their pioneering cubist phase, used to refer to each other as Wilbur and Orville, after the Wright brothers.

KASIMIR MALEVICH *1878–1935*

HEAD OF A WOMAN C.1920

Russian State Museum, St Petersburg / Courtesy of Scala

FOR years Malevich had gone the rounds of avant-garde art movements until, with suprematism, he founded one of his own. Suprematism was about the absolute emotional value of colour and for a while Malevich became a pure abstract artist, rejecting all representation as a distraction and anxious only to celebrate the material uselessness of art. In this phase Malevich's work involved arranging plain-coloured geometrical shapes on the canvas, of which the most important shape according to him was the square. This generally appears in a dominant colour among the distribution of other rectangles, trapeziums and parallelograms in his compositions. But it was not long before he rejected even colour itself, producing two notorious works that came to be regarded as central to the suprematist thesis. The first was *Black Square* (1915), which is simply that, in the centre of a plain white ground, while the second, *White on White* (1918), is a tilted white square whose outline can just be seen against the equally white ground.

Malevich, not untypically of avant-garde artists, was given to outbursts of revolutionary enthusiasm, and this generated a good deal of rhetoric and hot air. 'I have broken the blue boundary of colour,' he declared. 'I have emerged into white. Beside me, comrade pilots, swim in this infinity. I have produced the semaphore of Suprematism. Swim! The free, white sea of infinity lies before you!' This reads like claptrap, and to a great extent it is, but Malevich's idea of the artist as an aviator derives partly from the way in which the flying eye, looking down, reduces the earth to a flat, abstract design, which is precisely what suprematism was supposed to do.

The *Head of a Woman* was painted after he gave up suprematism but his taste for abstraction is strongly represented in it. The canvas is divided strictly into two halves along the horizon line. To the earth, whose vegetation or cultivation is represented in horizontal coloured strips, belongs the woman's body, while her featureless egg-head seems to inhabit the white sky, the limitless realm of the aviator, in the middle of which Malevich the suprematist had invited his fellow artists to join him. The colours here have a similar appearance to those in certain pop-art works, for example those of the English artist Peter Blake.

KASIMIR MALEVICH *1878–1935*

THE ADVANCE OF THE RED CAVALRY 1930

Russian State Museum, St Petersburg/Courtesy of Scala

AFTER the Revolution Malevich realized the personal as well as the professional advantages in becoming an enthusiastic apparatchik of art. He threw himself into all the revolutionary government's programmes to raise the cultural awareness of the masses, which brought art into factories and generated modernist street decorations. In 1919 he joined the teaching staff of the Vitebsk art school, whose director was Marc Chagall. But to be a mere staff member was not to Malevich's liking and he organized a coup, which effectively ousted Chagall so that Malevich could replace him.

Later Malevich became interested in utopian schemes, which he expressed by getting his students to make architectural models after his designs. Some of his ideas ran parallel to those of Germany's Bauhaus, where an old acquaintance of Malevich, Wassily Kandinsky, was working.

Although he also busied himself (again like the Bauhaus) with the design of everyday objects such as teacups, Malevich's ideas began to seem unacceptably 'formalist' in the changed cultural environment after Lenin's death in 1924. Now Joseph Stalin was tightening his grip on the government and Stalin's taste was far from modernist. He liked his art folksy and conservative.

Gradually, Malevich was deprived of all his teaching posts and committee positions. He tried desperately to adapt by abandoning the appearance of suprematism and returning to painting in a figurative style. *The Advance of the Red Cavalry* looks like the kind of subject that might appeal to Stalin. But for those in tune with the new Party boss's mind, there was not enough detail in it, nothing to authenticate the image as genuinely revolutionary or heroic, for one cannot tell from internal evidence if the red cavalry is truly advancing or in fact running away. Unless you are a secret policeman, the greatest sin in totalitarian society, and the greatest intellectual danger, is to be this ambiguous.

Malevich was now neglected, impoverished and reduced to teaching in amateur painting clubs. When he was last allowed to exhibit, on the fifteenth anniversary of the Revolution, his work was hung merely as an object lesson in the despised school of formalist art, with damning labels affixed to it. After he died of cancer in 1935, Malevich's name was forgotten for two decades, until a major collection of his work was acquired in the mid-1950s by the Stedelijk Museum, Amsterdam. His suprematist ideas then had an effect on abstractionists such as Ad Reinhardt and later on minimalists.

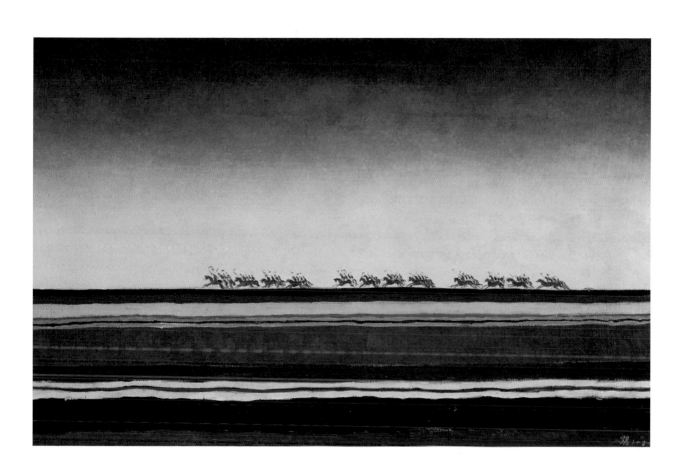

PAUL KLEE *1879–1940*

SMALL PICTURE WITH A PINE TREE 1922

Kunsthalle, Basle/Courtesy of Scala

KLEE was born in Berne, Switzerland, where his father taught music. He himself was a talented violinist but from an early age showed even more facility at drawing. He went to Munich to train as an artist and lived much of his adult life in Germany. Before the First World War he was a member of the expressionist group that took its name from a booklet accompanying one of their exhibitions, Der Blaue Reiter (the Blue Rider), a whimsically chosen title of no particular significance. The leaders of this group were Franz Marc and Wassily Kandinsky. Marc's death in 1917, killed in the war, was to affected Klee deeply.

Klee had seen work by the Italian futurists in Germany but, like artists all over the world, he looked at this time to Paris, the source of every revolutionary artistic development over the past 50 years and the seeding ground of the new cubism and Orphism. Klee visited Paris in 1912. Among the Parisians, he found cubism somewhat dour in appearance and was most enthusiastic about Delaunay and Orphism. For Klee Delaunay's vibrant glowing colours conveyed a poetic quality which many cubist works lacked, and he translated Delaunay's Orphist manifesto *La Lumière* into German. Hitherto primarily a draughtsman-illustrator and printmaker, he now turned increasingly to painting.

In *Small Picture of a Pine Tree* Klee's tone is perhaps uncharacteristically dark and a little foreboding. 'The more terrifying this world as it is today,' he wrote in 1915, 'the more abstract the art.' As so often with Klee, abstraction is never complete and the pattern resolves into one or more images. In this case the most obvious is that we see a window looking out at a bare, isolated pine tree over which is poised a red disc, which might be the sun. In this way the painting can be related to Klee's admiration for Delaunay and his *Window* series (see page 126).

There is a subtler resonance at work here also. The painting shows, in fact, two trees. The pine is reduced to the barest and most childlike representation but up the vertical beside it is a structure that is also a tree: an arrangement of squares and rectangles around a spine. The correspondence between the stick-tree in the background and the abstract tree of colours to the fore is opaque, however, leaving a question hovering: which is a better tree, the child's scrawl or the vision of the expensively educated artist?

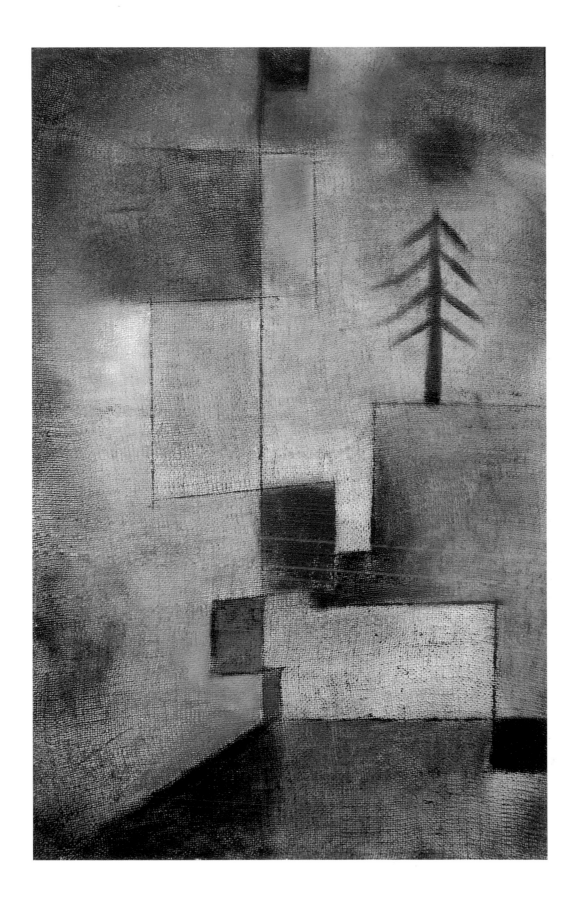

PAUL KLEE *1879–1940*

AD MARGINEM (ON THE MARGIN) 1930–36

Kunsthalle, Basle/Courtesy of Scala

FROM 1920 to 1933 Klee was a teacher at Walter Gropius's Bauhaus, the influential and idealistic school of architecture, art and design founded in Weimar before moving in 1925 to Dessau. The Bauhaus was set up under the banner of German expressionism but graduated to its own distinctive form of minimalism. While teaching there, Klee wrote *The Thinking Eye*, a book which it would seem did little to serve Gropius's vision of a unified culture of arts and crafts. Instead it made a schematic examination of the colours, identifying in each case their spiritual equivalents. 'Art,' he wrote, 'is not for reproducing the visible, but making things visible.' His ethereal, almost monastic apartness in this period earned him the nickname the 'Bauhaus Buddha'.

In the early 1930s Klee became a target for the Nazis, who came to power in 1933. He lost his teaching job and his home was searched. In December 1933 he left Germany for Switzerland. Meanwhile the Nazis held him up as a prime example of degenerate art and hung seventeen of his paintings in their cautionary exhibition of Degenerate Art in July 1937. Klee's works were deliberately mixed up with paintings from an insane asylum in case members of the public missed their point. Klee, however, watching these proceeding from a distance, was probably delighted. He often praised the drawing and painting of children and the mentally ill, saying that they were 'to be taken very seriously, more seriously than all the public galleries, when it comes to reforming today's art'. There is, as often with Klee, an element of teasing here. But his world is bizarre and illogical enough to take jokes seriously while at the same time jesting about serious matters.

Klee developed a keen sense of lyricism and wit in his painting, as well as a distinctly off-beat metaphysics. He often used objects and colours symbolically, not as Jungian universals but as part of his own particular language of significance and, as here, he sometimes populated his pictures with invented life-forms. The composition of *Ad Marginem* is inextricable from its subject. The living things flourish all around the edge while the sun sits in the middle of all, making it a weird inside-out version of the solar system. The colours and figures are tapestry-like but because they are directed by Klee's own idiosyncratic ideas they are instantly recognizable as his own.

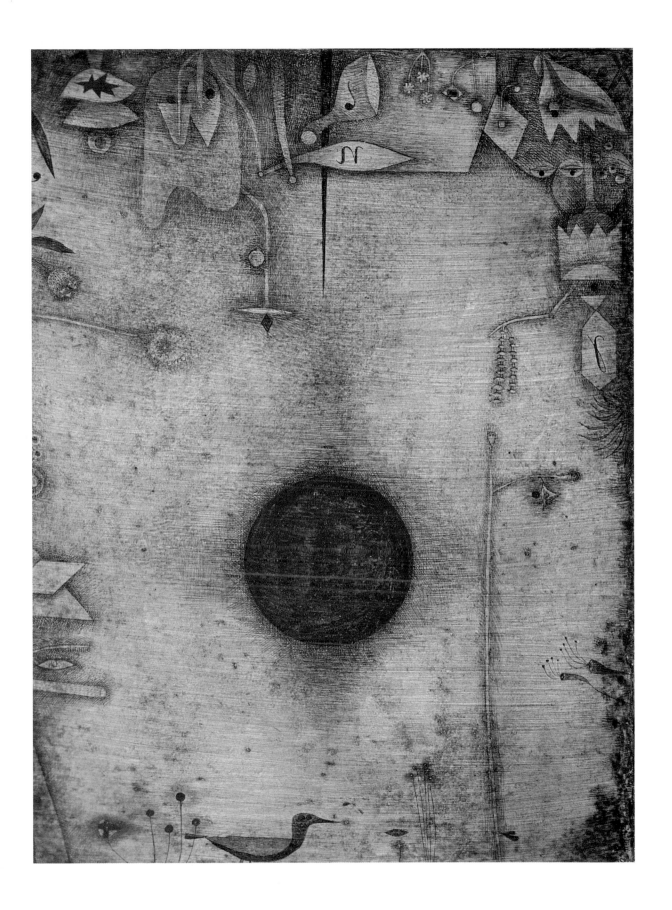

Paul Klee *1879–1940*

Still Life with a Die 1923

Thyssen-Bornemisza Museum, Madrid / Courtesy of Scala

DURING the First World War, Klee was drafted into the army but was posted to a clerical job in a flying school, where he had little to do and could draw at his desk – scenes of an escapist world of his own imagination. Klee was at this time primarily an expressionist but before long, in the 1920s, he came to the attention of the surrealists in Paris. They were enthusiastic and included him in their first exhibition in Paris, in 1925. Joan Miró, in particular, was deeply influenced by Klee.

Klee's sense of humour pointed to affinities with Dada and the surrealists, though these did not extend so far as to make him into a surrealist himself. His concern was to tap hidden realities, as in this still life of three potted plants. The decorated ceramic pots and their plant life resemble a triptych, which recalls icons and other religious painting. The die is small but obtrusive, introducing a random mathematical element into the scheme. The four objects and their relationship cannot be rationally construed but are best seen as poetic images seen with an almost childlike vision. Klee was not one to despise the art of children. In personal check lists of his work he catalogued drawings made when he himself was three or four.

Klee worked restlessly across a wide range of media and painted on many different kinds of support, from muslin and canvas to burlap sacking. He was quite capable of mixing oils, tempera and watercolours on one canvas and used many paints of his own devising. A set of particularly chalky colours is much in evidence during one phase of his career, and an especially thick, pasty oil medium appears in his last years in Berne

Klee usually worked on a small scale and was always interested in forms, shapes and creatures that look as if they belong on a microscope slide. At the same time he elaborated a large personal system of pictorial signs. These gave his work a mythic, coded primitivism that did not endear him to totalitarian minds, with their suspicion of ambiguity, wit and the internal landscapes of the mind. Klee's theories about colour, which he thought to be the principal and perhaps the only dynamic element in painting, were elaborately worked out in his writings and lectures. He constantly used the metaphor of music, like Braque, though in Klee's case colour, not form, provided the equivalents of harmony and melody.

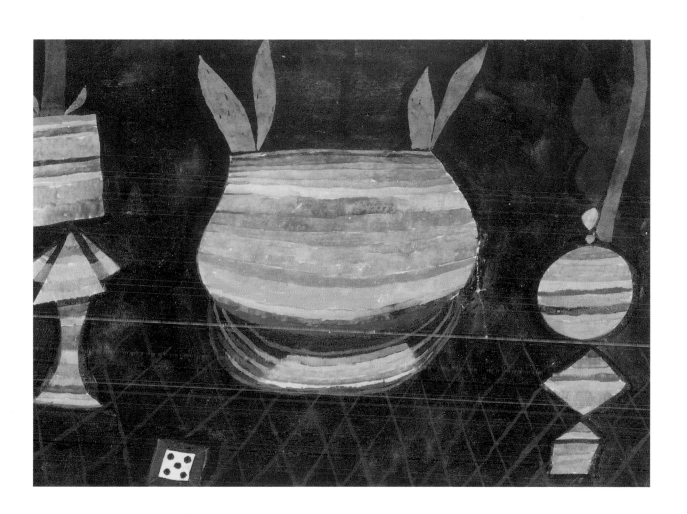

FERNAND LÉGER *1881–1955*

CONTRAST OF FORMS 1913

Rosengart Collection, Lucerne, Switzerland / Courtesy of Scala

LÉGER, who was born in Normandy, sometimes claimed to be of peasant stock but in fact his father was a wealthy cattle dealer. Léger himself had been a professional architect's draughtsman in Paris when, in the first decade of the twentieth century, he took up full-time painting. He passed through impressionist, neo-impressionist and fauvist stages (painting works that he later largely destroyed) while socializing with young painters such as Robert Delaunay, Marc Chagall and Chaïm Soutine, as well as many writers, including Guillaume Apollinaire. In 1909 he showed work at the avant-garde Salon d'Automne alongside Marcel Duchamp and other modernist painters and, from 1910, became committed to the style of cubism.

He made rapid progress towards his own cubist vision and created an individual style to go with it. His *Contrast of Forms* is one of a series of oil paintings and sketches in which tubular forms are contrasted with flat ones. Despite the bucket-like shape and metallic colouring of Léger's tubes, these are virtually abstract studies but they derive from the artist's awareness of the accelerating pace of life, of invention and of change. There was a part of Léger that wanted to celebrate this in futurist style. Yet he was beginning to understand that for most people, social and cultural change can be as unsettling as it is stimulating, setting up strong contrasts in every aspect of life – for example between tradition and innovation, or actuality and memory. Contrast became, for a time, the main preoccupation of Léger's art and, in a lecture roughly contemporary with these paintings, he dared to convert it from a current obsession into a general rule: 'Pictorial contrasts used in their purest sense – complementary colours, lines and forms – are henceforth the structural basis of modern pictures.' But contrast was not just a structural principle, it was an expressive one. 'Contrast = dissonance, and hence a maximum expressive effect.'

In the series *Contrast of Forms* Léger used similar forms and colour relationships in each picture, but varied the design. The abstraction is not complete because the forms are recognizable and seem to occupy three-dimensional space. In this variation there is the appearance of a contest between blue tubular forms and red angular ones, with the blue jostling the red out of the way to occupy the foreground and centre of the picture space.

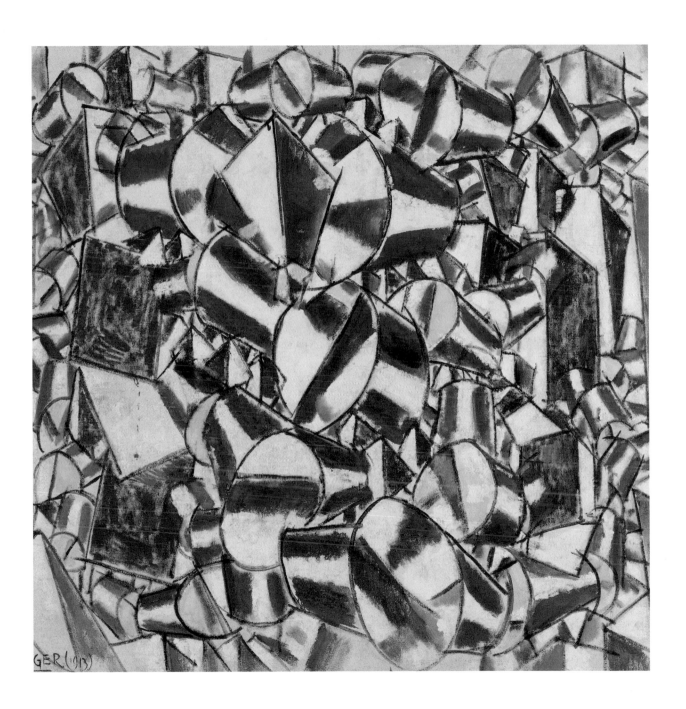

FERNAND LÉGER *1881–1955*

THE ACROBATS: COMPOSITION WITH TWO PARROTS 1935–9

Musée Nationale de l'Art Moderne, Paris/Courtesy of Scala

LÉGER was drafted into the French army's engineering corps and served on the western front in the First World War, most notably in the terrible Battle of Verdun (1916), where he was gassed. Throughout his war service he recorded the experience by continually drawing; and through the contact with private soldiers, he developed a much greater understanding of the lives of the mass of people. 'I found them poets, inventors of everyday poetic images – I am thinking of their colourful and adaptable use of slang. Once I got my teeth into that sort of reality I never let go of objects again.'

His liking for the poilu, the French footsoldier, awoke Léger's instinctive socialism and he now abandoned the abstruse, intellectualized cubism of the pre-war years. His art became steadily more accessible so that from the 1920s he was consistently working with figures and the representation of objects.

The circus was one of his favourite themes for many years. He had become committed to painting in the working-class environment 'with its aspects of crudeness and harshness, of tragedy and comedy, always hyperactive'. *The Acrobats: Composition with Two Parrots* celebrates circus acrobats who are seen performing leaps and balancing acts, with their apparatus of ropes and ladders strewn around them. The figures appear sculptural, with a strong suggestion of tribal art. There is little sense of flight or movement of the kind that Seurat or the futurists put into their visions of the circus. But if Léger's acrobats seem oddly earthbound, they provide a very Légerian contrast with the two parrots, whose brightly coloured presence suggests a capacity for real flight.

The interlocking, resonating design testifies to the care with which Léger sought compositional harmony in his figure painting. A particular idea here is the curve of the arm, whose repetitive similarities speak of the acrobat troupe's dependence on each others' strength and of the way their performance plays variations on single themes – lifts, jumps, contortions – which they must all be able to perform interchangeably. The individuality of the troupe's members is submerged in their joint activity: an idea very commonly expressed in the left-inclined art of the 1930s. Léger himself became a strong supporter of the left-wing Popular Front in France, which formed the government from 1936.

There are a number of versions of this painting. In one, the figures are painted exactly as here, but the background is reduced to a single yellow plane and the colours are varied.

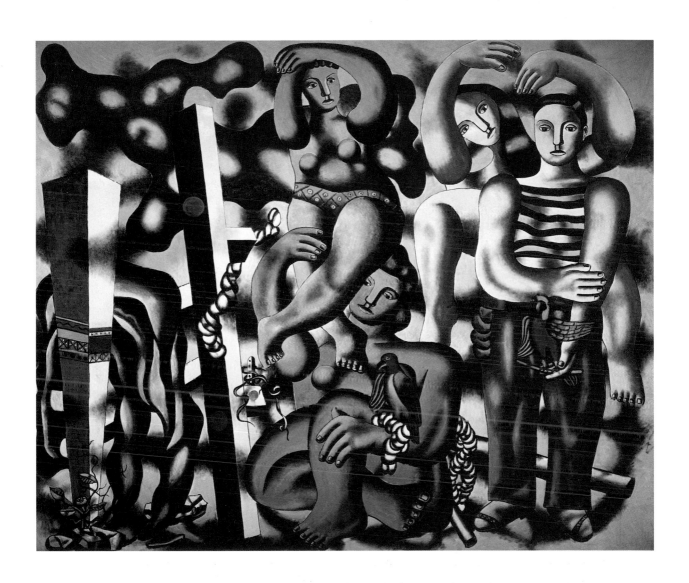

FERNAND LÉGER *1881–1955*

ADIEU NEW YORK 1945

Musée Nationale de l'Art Moderne, Paris / Courtesy of Scala

LÉGER was an exact contemporary of Picasso and, while he may not have been able to rival the Spaniard's infinite inventiveness, he was just as versatile, working in his time with oil paints, prints, stage sets, stained glass, tapestry and ceramics. As a draughtsman and illustrator he was also prolific and he was the first major artist to become involved in film-making. From 1915, when he first saw a Charlie Chaplin film, this actor and director was a strong influence, but he also worked with the Russian director Sergei Eisenstein, the Frenchman Abel Gance and the Hungarian Alexander Korda.

Léger made a number of visits to the USA; his longest was during the Second World War, when he took refuge there after leaving France in October 1940. He lived in New York, keeping a studio on West 40th Street, but travelled around the country and taught, notably at Yale University and Mills College, Oakland, California. He painted more than 120 paintings in America during the war, of which *Adieu New York* was his swan-song, a poster-like and unusually enigmatic work. Broad coloured shapes vie for the attention with meaningless sculptural shapes, either angular and hard-edged or rounded. None of these forms or colour blocks interlock; they seem laid over and under each other at random. At the same time a scroll with the picture's title and a crescent of simply drawn netting frame the left-hand side of the image.

The 'liberation' of colour into a mode of its own, contending with different forms and shapes, was suggested to Léger one night while walking down Broadway, as he observed the effect of the neon signs tacked on to buildings or strung between them. However, this is only a starting point for Léger's American work, in which many ideas mingle together. His series of paintings on divers, with the same liberated patches of colours drawn from those Broadway signs, are also reminiscences of swimmers glimpsed in the port at Marseille during Léger's escape from France.

The fact that there is no straightforward way of interpreting this painting suggests a certain irony in Léger's view of the USA. As no literal reading of the piece is possible, the painting is a teasing, intriguing message for a people proud of their straightforwardness and suspicion of intellectuals. Léger was not normally given to irony but contact with the Americans, a people for whom irony often seems a form of subversion, apparently released something gently mischievous in him.

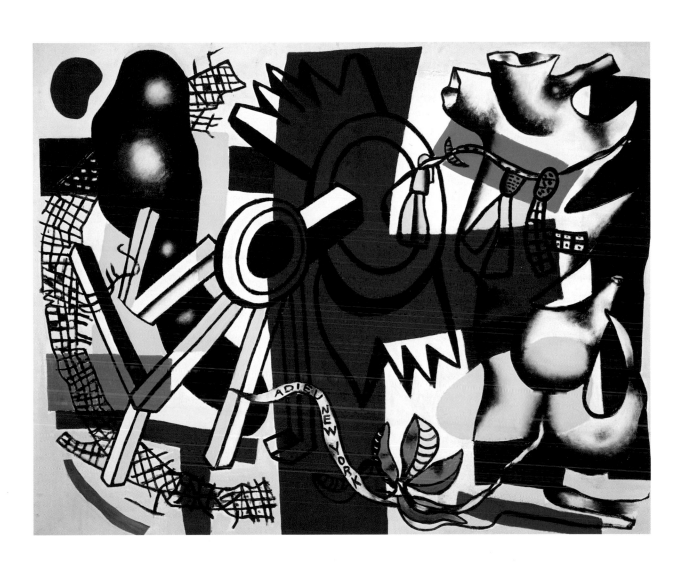

PABLO PICASSO *1881–1973*

PORTRAIT OF GERTRUDE STEIN 1906

Metropolitan Museum of Art, New York/Courtesy of Scala

PICASSO was more than a great draughtsman, painter, sculptor, printmaker, potter and illustrator. He was a public figurehead for the modern movement in art and his name has penetrated far beyond the art world into the consciousness of the mass of people who rarely think about art at all.

He was born in 1881 at Málaga, Spain, and, as his father was an art teacher, Picasso was quickly recognized as a prodigy. He attended art schools in Barcelona and Madrid but by the age of twenty could already exhibit and sell his work. He went to Paris to study the impressionists, Cézanne, Degas and Toulouse-Lautrec and his first figure paintings were of people marginalized by society such as beggars, buskers and prostitutes. In manner these works took as their starting point the minimalist drawing style at which he excelled. From 1901–4 his colouring favoured cool blues and greens and this is known as his 'blue period'.

In 1904 Picasso moved permanently to Paris. From 1904 to 1906, the 'pink period', he painted figures from the circus and the bohemian world of Montmartre. One of the latter was Gertrude Stein (1874–1946), whose portrait he completed in 1906, when the sitter was 32. Stein was an experimental American writer who lived in Paris and took a leading role in promoting the artistic avant-garde, which at this time was preoccupied with the so-called Fauve group – the 'wild beasts' of art – who included Matisse, Rouault, Derain and Vlaminck. Stein came be the first to chronicle the next new thing – cubism.

The origin of cubism is usually linked to Picasso's discovery of so-called primitive art, in particular tribal masks, after a visit to an ethnographic museum. Those forms certainly chimed with Picasso's own instincts towards simplification and even caricature as a draughtsman, and their influence is easily seen in this portrait. The flattened line, especially about the eyes and the brow, offers a frankly monumental reading of Stein's face, as if she were one of the Easter Island statues. At the same time her hands and dress are treated naturalistically, creating a disconcerting doubleness in the image. At one level, it might be that Picasso was expressing his own ambivalence towards Gertrude Stein: he did not know whether to worship or woo her. But on a very much more theoretical plane, one on which the intellectual Stein was very happy, the ambiguity of the portrait is also a statement of one of the future tenets of cubism. This claimed the right to look at anything from more than one point of view simultaneously.

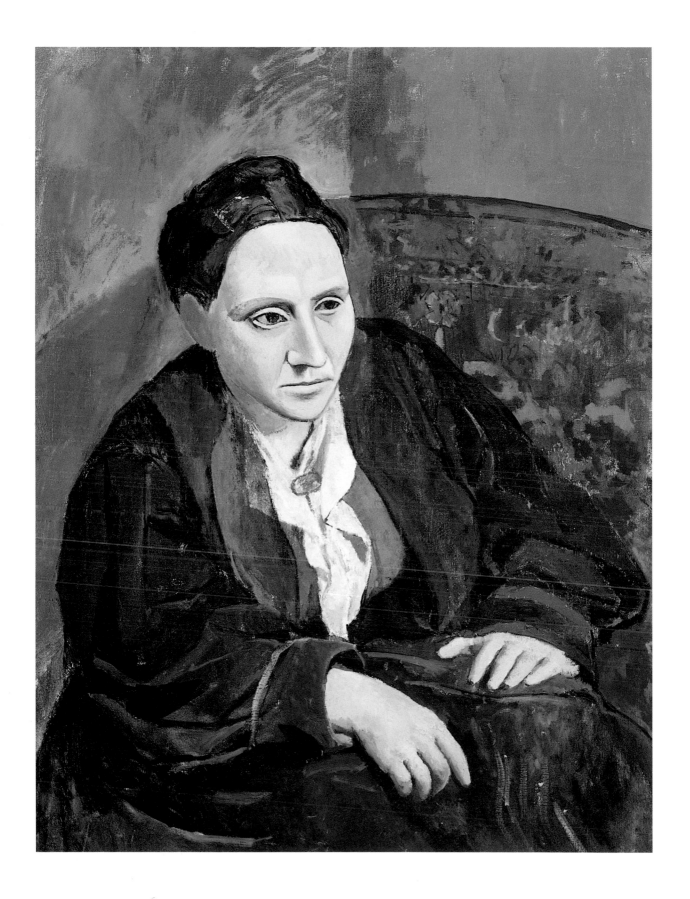

PABLO PICASSO *1881–1973*

LES DEMOISELLES D'AVIGNON 1907

Museum of Modern Art, New York/Courtesy of Scala

PICASSO undoubtedly intended to make a big statement with this painting. It was the largest canvas he had ever stretched and, before beginning to paint, he had its back protectively lined in anticipation of a great success. He was not wrong: *Les Demoiselles d'Avignon* is one of the turning points of European painting.

It was conceived as a scene inside a bordello and, in its original form, would have included among the prostitutes two fully clothed male figures, a sailor and a medical student, both drunk. These were eventually dropped after several sketches had been made, leaving the women to display themselves undisturbed to you, or me, or anyone looking at the picture.

It still disturbs and provokes discussion. Its influences and antecedents are in themselves a large debate. The early elimination of the clothed males from Picasso's design, with their perhaps unwanted echo of Edouard Manet's *Le Déjeuner sur l'herbe*, let him concentrate on the example of Cézanne, an artist he was more interested in. Cézanne's series of *Bathers* – especially his *Large Bathers* in the National Gallery, London – also glow fleshily against blue sky. The difference is that Cézanne's women turn inward to concentrate on their own pleasure while Picasso's look frankly out of the picture towards the viewer. This may be to invite, to question or to challenge – or perhaps, to an extent, all three.

A look at the five women suggests that they represent different stages in the progressive deformation of the face, picking up where Picasso left off with his portrait of Gertrude Stein. The tribal mask is particularly apparent in the standing figures to the left and right, while in the squatting figure it is distorted into parody. But, for all its formal contortion, the extraordinary force of the painting is generated from Picasso's particular brand of creativity. As if fighting his own artistic virtuosity, his supreme facility in drawing and painting from life and nature, he dares nothing less than to re-imagine the human body. Gauguin's universe was also an imaginative one: but he tried to rekindle primitive bliss as he thought it once had been. Picasso was not trying to cast backward glances. His use of African mask shapes had nothing to do with an attempt to inhabit the culture that had created them. It was about imagined futures, alternative realities, parallel universes.

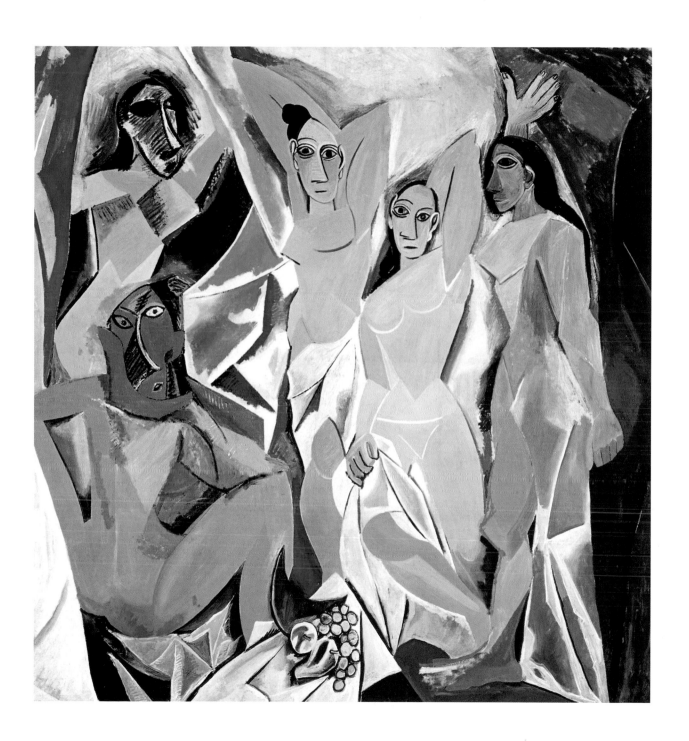

PABLO PICASSO *1881–1973*

STUDY FOR LAS MENINAS 1957

Picasso Museum, Barcelona / Courtesy of Scala

WHEN a painter of the stature of Picasso emulates a master such as Diego Velázquez, the result is of special interest. Originally painted in 1656, *Las Meninas* is in the Prado Museum, Madrid, where Picasso first saw it as a young man of eighteen. More than 50 years later, around the 300th anniversary of Velázquez's painting, he returned to it and this is one of at least 50 sketches, copies and versions he produced.

That enigmatic original – which the painter Giordano called 'the theology of painting' – records the room in which Velázquez himself, standing in front of his easel on the left, seems to be painting a portrait of the king and queen of Spain. Next to him are two *meninas*, or maids of honour, who fuss around the central doll-like figure of a royal princess, while dwarfs and other attendants complete the group to the right and in the background. The whole room is represented as if through the eyes of the artist's sitters – a role reversal which needed to be seen as playful and amusing if it was not to descend into an insolent, even dangerous theme in the hierarchical seventeenth-century Spanish court.

Picasso's reinterpretation, of great size and virtually monochromatic, retains all the figures of Velázquez's composition but transforms (or deforms) them in ways that are highly characteristic of Picasso himself. He is specially interested in the way in which the space has been divided up into rectangular areas and these he reproduces with emphasis. The small mirror on the wall, which is almost in the dead centre of Velázquez's canvas and carries the reflections of the otherwise unseen king and queen, is especially prominent in the Picasso, though it shows only one clear face – a livid, grinning one. The caped figure, observing the scene from the stairs beyond the doorway to the right, also comes into greater prominence as a looming peg-headed silhouette.

But the most important variation made by Picasso is in the figure of the working artist. He looms very much larger in this version, the great head almost up to the ceiling and the cross on his tunic, to denote the painter's knighthood, a dark gash which virtually carves him in half. At the same time the easel and painting paraphernalia have acquired a cobwebbed and ramshackle appearance. The ceiling in the Velázquez has a single fixing from which to hang a lamp. Picasso, in a sinister touch, replaces this with two gleaming butcher hooks, fixed directly over the heads of the two *meninas*.

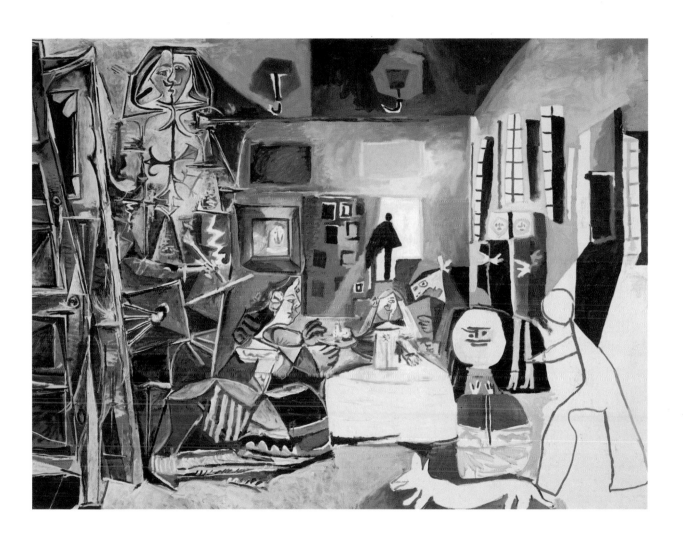

PABLO PICASSO *1881–1973*

JACQUELINE WITH A CAT 1964

Collection Picasso, Mougins / Courtesy of Scala

IN February 1964 Picasso began a long series of paintings and drawings of his second wife in various poses. Of this last phase in his career there has been much controversy. Some versions of the history of modernism suggest that, after the eruption of cubism, Picasso's creative powers gradually returned to earth like volcanic dust, until he was at last just another confused, lonely and sexually frustrated artist. One of his friends, Douglas Cooper, gave the opinion that his late works 'are incoherent doodles done by a frenetic dotard in the anteroom of death'.

Beside the view that late Picasso was bad in an artistic sense, there is another that says, whether good or bad as a painter, he was a very bad old man whose art, effectively, battered women. Picasso's favourite subject in the 1960s, as at other times in his career, was undoubtedly the female nude. It is also true that, growing older, he often treated it with a violent and dismembering coarseness which remains genuinely disquieting, even in the age when artists try ceaselessly to affront the viewer. To those who are offended by Picasso's women, with their crudely displayed sexual parts and insolent, sluttish ugliness, he may be, if not a woman-hater, then a sexist old lecher compensating for creeping impotence by lampoons and belittlements of women's bodies.

Perhaps neither of these is right. Picasso in his old age was a foxy character perfectly in possession of his faculties. When he himself said 'every day I get worse' he did not mean his powers were slipping. He meant he was deliberately painting 'worse', trying to get down to a level below or beyond appearance to where his own feelings were, for good or bad. That isn't 'senile doodling' and it might not be sexist filth either: it might simply be obsessive honesty. At the same time, as one glance at *Jacqueline with a Cat* shows, it is not the whole story.

Although Picasso's wife is subject to distortions hardly less extreme than those of *Les Demoiselles d'Avignon*, she displays none of the negative sexual typing seen elsewhere in the late paintings. Jacqueline appears as a woman facing intelligently three ways. Her head is formidable but her body, her sexuality, is played down: small breasts, concealed legs. Her control over the cat is total. We have to believe it is a portrait of a strong and respected personality.

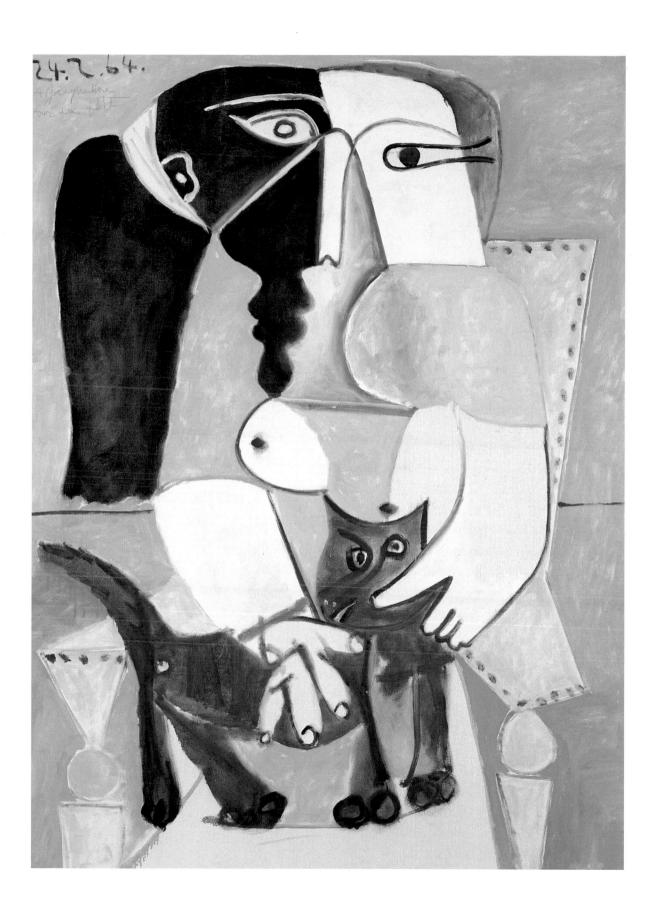

Umberto Boccioni *1882–1916*

Riot in the Gallery 1911

Pinacoteca di Brera, Milan / Courtesy of Scala

THE founder of the Italian school of futurist painters was born in Reggio Calabria in 1882. He lived in various parts of Italy during the course of childhood, but by 1899 he was in Rome, where, with his friend Gino Severini, he began to study painting with Giacomo Balla. A decade older, Balla became the young painters' mentor, encouraging them to experiment with pointillist and other advanced techniques. Boccioni had talent to burn and took up the life of the professional painter with alacrity.

In 1906 he went to Paris. The modernity of the city and the pace of its life galvanized him and the visit was a watershed. Returning home, he became disillusioned with neo-impressionism and began to experiment restlessly in various styles. But it wasn't until 1909-10 that he found a new direction, after reading a manifesto by the poet Filippo Tommaso Marinetti on what the author was calling *futurismo* – futurism. Marinetti's inspiration was, as he wrote, that 'the splendour of the world has been increased by a new beauty: the beauty of speed'.

Marinetti's words were stirring, even inflammatory. He wrote that the racing car was more beautiful than the Louvre's *Winged Victory*, that it was necessary to tear down museums, libraries and academies, that political struggle and human aggression were sublime. 'We shall sing,' he said, 'the great crowds excited by work, pleasure or rioting.' Boccioni enthusiastically set about reinventing Marinetti's futurism as a plastic art and swept Severini, Balla and other young painters along with him. A new manifesto addressed to Italy's young artists was publicly declaimed on 8 March 1910 by Boccioni from the stage of a packed Teatro Chiarella in Turin.

Like the second 'technical' manifesto which followed it, the *Manifesto of Futurist Painters* is filled with the kind of rebellion, counter-culturalism and iconoclasm that would subsequently echo through every progressive artistic movement of the twentieth century. It declares that all forms of imitation are contemptible, harmony and good taste are a tyranny and critics are anathema. On the other hand, it glorifies any type of originality, especially if it celebrates the new universal dynamism of speed and machinery. In painting, said Boccioni, all the old subjects must be swept away in favour of representing 'the vortex of modern life: a life of steel, fever, pride and headlong speed'.

Riot at the Gallery certainly shows Marinetti's excited crowd, but at its centre is an old-fashioned scrap, a set-to between a pair of women outside a Milan café. The taste for human drama that many of the futurists had was not overwhelmed by their avant-garde ideas.

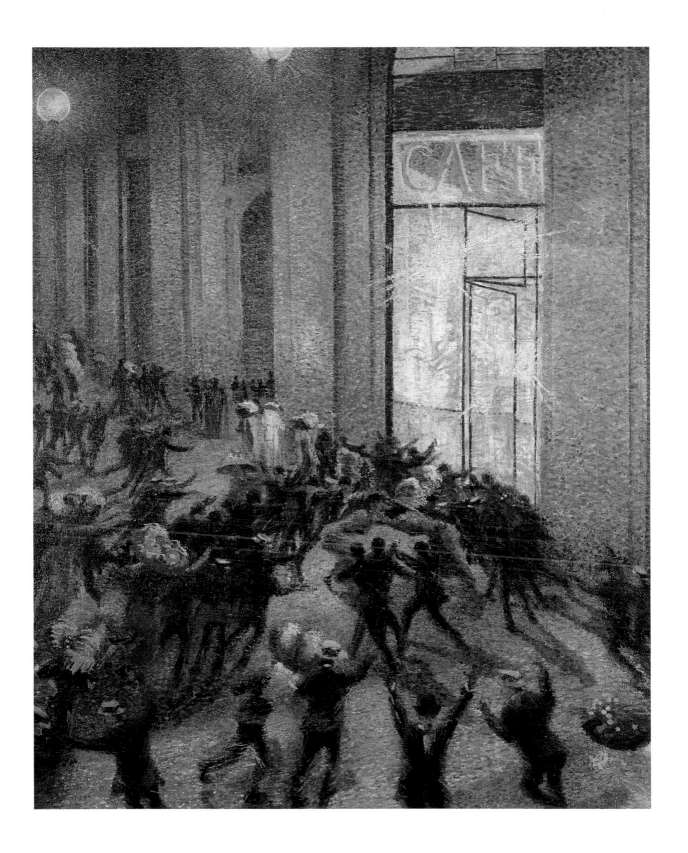

UMBERTO BOCCIONI *1882–1916*

STATES OF MIND 1: THE FAREWELLS 1911

Private collection, New York / Courtesy of Art Resource / Scala

FUTURISM was launched in 1910 but did not achieve any stylistic stability until 1911 when Boccioni and other members of the group went to Paris to meet Picasso and Braque, who were at the height of their cubist phase. They saw what the two Parisian artists were doing and returned to Italy deeply impressed, immediately seeking ways to adapt the methods of cubism – which they realized was primarily concerned with static objects – to their own interest in movement and speed.

The Farewells was the first of six paintings, entitled *States of Mind*, which collectively show how far Boccioni had now travelled in the short time since he painted *Laughter in the Gallery*. There are still traces in this new canvas of his old divisionist colouring methods – and the colours, as so often in Boccioni, are most delicately done – but now space is vigorously developed in the cubist manner. So is the idea of interpenetration, as the different planes of the visual field are pulled apart and reassembled in 'impossible' ways. The cab of a locomotive is seen from different points of view simultaneously, while human figures lie hidden like puzzle-pictures in the fragmented green landscape. The use of a railway as a device to express the explosive collision between machine and nature is entirely in keeping with the futurist programme. The steam locomotive is uncompromisingly mechanical, noisy, powerful and fast and it violates the innocent, age-old, timeless countryside without compunction. This is a perfect illustration of how unstoppable Boccioni considered futurism to be.

Struggling to express in words what he was trying to do, Boccioni wrote at this time that he aimed for a 'synthesis of what is remembered and what is seen', of 'that which moves and lives beyond the densities . . . that surround us left and right'. He was trying, so he said, to get a blend 'of the internal and the external, of space and movement in all directions'. If this is true, and it does seem to have been quite sincere, the futurists at a distance of almost 100 years still look like archetypal modernists, whose ideas are still heard echoed even in the era of Damien Hirst and Tracey Emin. The difference lies in Boccioni's passionate engagement: irony was alien to him.

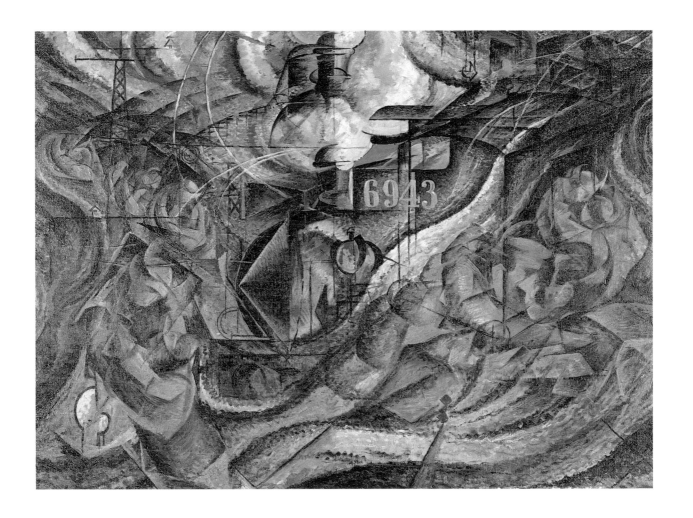

UMBERTO BOCCIONI *1882–1916*

ELASTICITY 1911

Private collection, Milan / Courtesy of Scala

FUTURISM was founded on the double notion of simultaneity and dynamism, laid out in 1910 by Boccioni himself. The published programmes – there were two, of which the second was described as a 'technical manifesto' – appeared at a time when Einstein's theories of relativity were becoming famous, theories which also destroyed the concept of linear extension in space and time. Meanwhile, far beyond the ken of Boccioni and his friends lay the discoveries in the 1920s of Heisenberg and others, about uncertainty in particle physics and the dynamic ambiguity which became known as quantum theory. But had he lived, Boccioni would not have been surprised by these. His futurist statements often read like anticipations, albeit entirely unscientific, of quantum physics.

Elasticity is similar in conception to *States of Mind* but pushes further in the direction of abstraction. Again the colour is delicately achieved in an overall scheme which sacrifices coherence to a flurry of forms and volumes shimmering on the edge of definition. Boccioni's muted pinks, reds and yellows spiral and billow around a few patches of greenery, to represent landscape, and from the flurry emerge a few uprights, the sparse tracery of pylons, telegraph poles and factory chimneys, standing for modernity. In the centre of the composition a dark, ambiguous shape is planted, which belongs not to either of these categories but to the imagination. It is a puzzling element in the painting, possibly to be taken as a suggestion that, in time, Boccioni might have come to terms with surrealism.

The painting comes closer to abstraction than was comfortable for Boccioni but such a tendency indicates the limitations of futurism in theory and practice. It proposes an inherently unstable form of painting, which was bound, in the end, to consume itself.

The popularity of futurism was short-lived but its name spread easily around Europe. It proved especially fruitful in Russia in the years before and just after the Revolution, when the poet Mayakovski and several painters adapted it to local needs. From 1912, Boccioni dabbled with some success in futurist sculpture, making objects that both contained and were embedded in aspects of their environment, so that fragments of horsehair, glass and tree bark would turn up in his plaster models.

War broke out in Europe in 1914 and, as Italy hesitated about becoming involved, Boccioni became increasingly political, joining in with the agitation for Italy to declare war on Austria. When this eventually occurred, he joined the Battaglione dei Volontari Ciclisti, and then the regular army. In 1916, while still a soldier, Boccioni was killed falling from a horse.

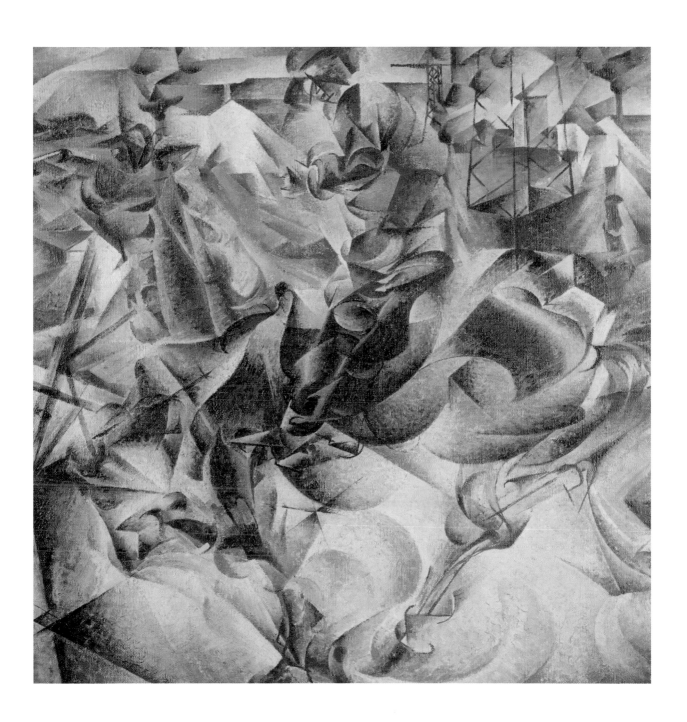

GEORGES BRAQUE *1882–1963*

DUET FOR FLUTE 1911

Mattioli Collection, Milan/Courtesy of Scala

THIS painting, like *Fruit Dish, Ace of Clubs*, belongs to the second, so-called 'synthetic' phase of cubism, which followed the 'analytical' first phase of 1910–12 and lasted until the outbreak of war in 1914. Neither of these terms, which imply a dialectic process being worked out in the development of the style, is particularly helpful in understanding what was happening, but it was now that Braque and Picasso began to use collage and letter stencilling in their pictures.

The placing of (apparently random) stencilled lettering on a cubist canvas helped to emphasize its flatness: an affirmation of cubism as a manipulative technique, which plays games with both reality and perception. This is a very modernist idea with overtones of 'alienation', the deliberate undeception of the viewer, which found equivalents in later twentieth-century theatre, literature and music.

Braque began at this time to paste wood-grain paper on to his canvases (*papier collé*) in a method not exactly like Picasso's contemporaneous experiments with collage. Whereas the Spaniard sought deliberately to create contrast, playing one material off against another, Braque looked for materials that would be in keeping with the brown colours of early cubism while acting as an integral part of the structure of his drawing. Braque particularly like wood-grain effects, and employed a decorator's comb – with reminiscences of his father's occupation – to simulate them in oil paint.

In this particular painting, the score for the eponymous *Flute Duet* is half seen on the left. Reference to music was a particular obsession of Braque's and, following his example, cubism produced a multiplicity of guitars, mandolins, keyboards and musical notes. The reason for the prominence of musical themes is not whimsical, however. The cubists insisted on the analogy between their paintings and the rhythms and tonal structures of music. The muted colouring of these early manifestations of cubism derive from this. The cubists wanted to concentrate their energies on the discovery of harmonious new forms and felt that bright colours were a distraction. Braque himself did not to return to the bright colours of his early Fauve period until the 1950s, when he painted a sparklingly bright ceiling at the Louvre.

Braque's oil paints were idiosyncratic to the end of his life and a further reminder of his early experience of house painting is his use of sand mixed with his pigment. He did not make preparatory drawings but worked out his ideas directly, if slowly and deliberately, on the canvas.

GEORGES BRAQUE *1882–1963*

FRUIT DISH, ACE OF CLUBS 1913

Musée National d'Art Moderne, Paris / Courtesy of Scala

BRAQUE was familiar with at least the smell of paint from childhood in Le Havre, where his father was a painter and decorator. In 1897 he enrolled in the local art school, becoming friendly with his fellow student Raoul Dufy. By 1902 Braque was living in Montmartre, Paris. He abandoned his academic training to concentrate on his own interests, which included the work of van Gogh and the fauvists Derain and Matisse. By 1906 he was exhibiting at the Salon des Indépendants, and in 1907 the poet Guillaume Apollinaire introduced him to Picasso, who showed him his work in progress *Les Demoiselles d'Avignon* (see page 94). This had a powerful impression, at first of repulsion ('Picasso has been drinking turpentine and spitting fire,' he remarked) and then, gradually, of admiration. Braque painted a response, his *Grand Nu* (1907–8), making his first cautious essay in the style which the two men would develop in partnership 'roped together like mountaineers', as Braque said. That style was cubism.

The term was not invented or even approved by them. Reference to the paintings' 'little cubes' was first made by the critic Louis Vauxcelles about a series of Braque landscapes in 1908. However inadequate it may be, the name stuck.

The essence of cubism is in its revolutionary transformation of objective reality. Braque's overwhelming enthusiasm, prior to Picasso, had been for the work of Cézanne, who, he now saw, clearly anticipated this new style not only by his interest in angles, overlapping planes and geometric volumes, but in the way he refused to employ the usual approach to modelling three-dimensional objects with light and shade. Cézanne used what he called colour modulation for this purpose. The cubists, searching for ways of making colour constructive rather than merely representational, did the same, playing games with space, flattening or skewing perspective and piling forms on top of each other to give that characteristically multifaceted appearance. Much of the experimental work was done by the analytical mind of Braque. Picasso had a Montmartre studio nearby and saw Braque daily, supplying the flashes of spontaneity, emotion and desire that ensured the style's vitality. The two men pushed cubism forward from figure painting through landscape to still life and made it the most sudden and startling advance in aesthetic perception the visual arts has ever seen.

Theo van Doesburg *1883–1931*

Composition IX, opus 18 1917

Haags Gemeentemuseum, Netherlands / Courtesy of the Bridgeman Art Library

VAN Doesburg, from Utrecht in the Netherlands, was a painter, architect, teacher and writer on style who shared Mondrian's interest in theosophy and many of his greater compatriot's aesthetic theories. Doesburg was brought to theosophy by several intersecting influences, especially his meeting with Mondrian in 1915 during the First World War. But there were other influences which led to his founding the journal *De Stijl* (the Style) – internationalism, disgust at the war, and (in Doesburg's case) contact with Dada.

The journal propounded utopian ideas through which the arts would become unified under a set of simple but unbreakable guiding principles, with the aim of nothing less than universal enlightenment. The starting point of all this was the question of how the purest spiritual harmony can be established through art and design. It was answered first of all in painting, but increasingly thereafter through architecture and a set of ideas about the whole environment of life. Comfort – at least in the conventional or sensual sense – was left out of its considerations, which put De Stijl furniture at a hefty commercial disadvantage when it was placed on the market. Doesburg was, however, a skilful and inspired designer of stained-glass windows.

Mondrian, ever the rectilinear purist, split with the group when Doesburg began to emphasize the diagonal in his paintings, though it seems unlikely he felt much sympathy either for Doesburg's links with the dadaist Jean (Hans) Arp. By the mid-1920s and until his death in 1931, Doesburg was increasingly absorbed in larger architectural and interior design schemes. In 1930 he coined a well-known but widely misunderstood term, 'concrete art', by which he meant an art free of pictorial representation and sentiment of any kind. 'I hate all that is temperament,' he said, 'inspiration, sacred fire, and all the attributes of genius that cover up the untidiness of the mind.'

His *Composition* of 1917 comes from a period of maximum intellectual ferment in Doesburg's career, shortly after the foundation of De Stijl. There is some surviving cubist influence in the shapes, white and coloured, which overlap as if they were flattened surfaces. However, the refined use of simplified colour is very De Stijl, as is the implication (which this painting shows very clearly) of an architectural drawing. Doesburg increasingly saw himself as primarily an architect and there is plenty of evidence here for the pleasure he took in the reduction of three-dimensional built space to the orderliness of a two-dimensional plan.

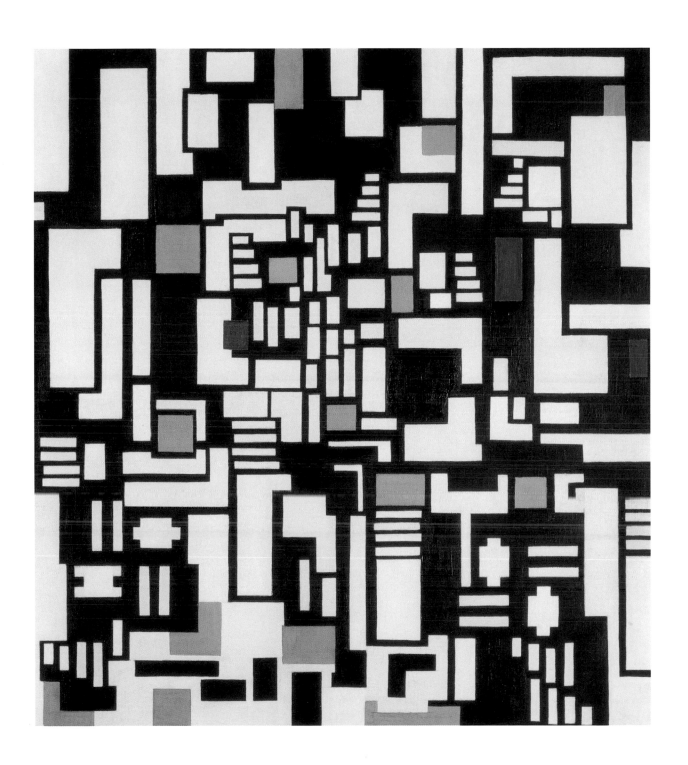

AMEDEO MODIGLIANI *1883–1920*

LOUISE 1915

Mazotta Collection, Milan / Courtesy of Scala

MODIGLIANI has claims to be considered the most accessible and immediately recognizable artist of the twentieth century. He was born in Livorno, Italy, the youngest of four children in a Jewish family. He fell frequently ill in childhood, which had the effect, as often happens, of intensifying his inner life and causing him to see himself as different from other children. At the age of thirteen he had already decided to become an artist.

In 1900, recovering from his most recent illness, he toured the major cities of Italy with his mother, herself an unconventional, politically radical parent. Together they reviewed 600 years of Italian art history, from Giotto onwards. Modigliani had already begun to learn to paint in Livorno with the impressionist master Guglielmo Micheli, but between 1902 and 1906 he moved on to study in Florence, Venice and finally Paris. Few early paintings by him survive, but in Paris he got to know the group of painters around the tenement known as Bateau Lavoir, who included Picasso (then at work on *Les Demoiselles d'Avignon*), and enrolled at the Académie Colarossi.

The year 1909 was an important one for Modigliani. Now based in the Parisian district of Montparnasse, he met the sculptor Constantin Brancusi, whose example persuaded him to try his hand at sculpture. Under Brancusi's tutelage he produced a series of elongated stone heads, which show the beginnings of the typical Modigliani face – flat *retroussé* nose, smooth surface and a very regular, elliptical outline. Brancusi also passed on his own proudly independent spirit, so that Modigliani developed the confidence to keep aloof from the tumult of schools and interest groups which made the Paris art world so frenzied at that time. When asked what school he was in, he replied succinctly: 'Modigliani.'

All his adult life Modigliani drank hard and took drugs copiously. If he had money he spent it quickly and was therefore usually without. He was often forced into commercial design drudgery and even peeling potatoes in a restaurant kitchen. More often he paid for his drinks with instant drawings. But he had no money for the more expensive materials and he stole masonry for his carving from the ubiquitous Paris building sites. This went on until war broke out in August 1914. Then the building boom collapsed and Modigliani's source of carving material vanished. At this point, his health undermined by continual dissipation, and finding sculpture too physically demanding, he reverted to painting.

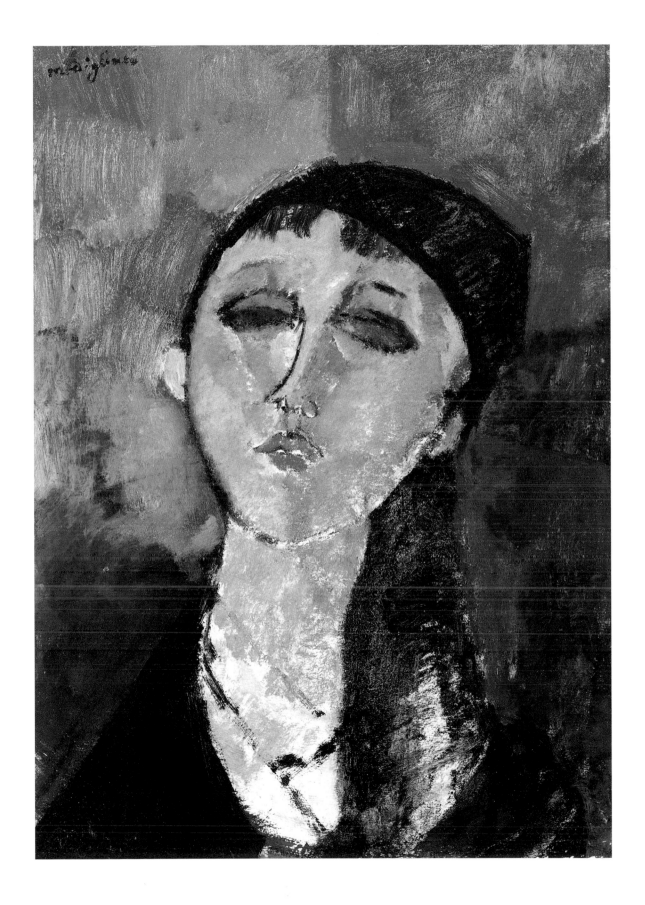

AMEDEO MODIGLIANI *1883–1920*

HEAD OF A WOMAN 1915

Pinacoteca di Brera, Milan/Courtesy of Scala

ALTHOUGH he kept himself to some extent apart, or aloof, from the other Paris artists, Modigliani breathed the same air as they and he now began to look, as they did, at the arts of other cultures, especially sculpture and masks, in the Musée d'Homme. His sculpture betrays his fascination with these subtly abstracted representations, particularly those of the Ivory Coast and Gabon in French West Africa. He saw his stone heads almost as temple sculptures, and when they were exhibited in the Salon d'Automne in 1912 as 'Heads: a decorative group', he would place lighted candles on them to emphasize the impression they give of being ritual objects.

In 1913 or 1914, Modigliani returned exclusively to painting the human figure, mostly portraits and nude studies. Early influences, apart from blue-period Picasso, were Toulouse-Lautrec and the fauvists, but his mature style was formed only after he had practised carving and seen the parallels between this activity and the technique of the late portraits of Cézanne. From now on, Modigliani's two-dimensional work was highly sculptural in its modelling.

Compositional harmony was everything to Modigliani. He owed this awareness to Cézanne, although, in his hands, harmony sometimes develops a certain facile and repetitive quality. His palette for skin tones was dominated by glowing earthen browns so that his subjects have an enviable all-over tan, as if they had just returned from the beach or a luxury cruise. However, his roughly 300 surviving paintings make a body of work which is very much of a piece and could never be confused with that of any other artist. His drawings are less well known, although it is obvious from his painting – in which careful draughtsmanship with a brush plays an important part in outlining the composition – that he would draw, and do so well. Many drawings were preserved by a young doctor, Paul Alexandre, whom he met in 1907. Alexandre became his first significant patron, purchasing paintings and drawings, or taking them in lieu of medical services, including the supply of hashish to the artist.

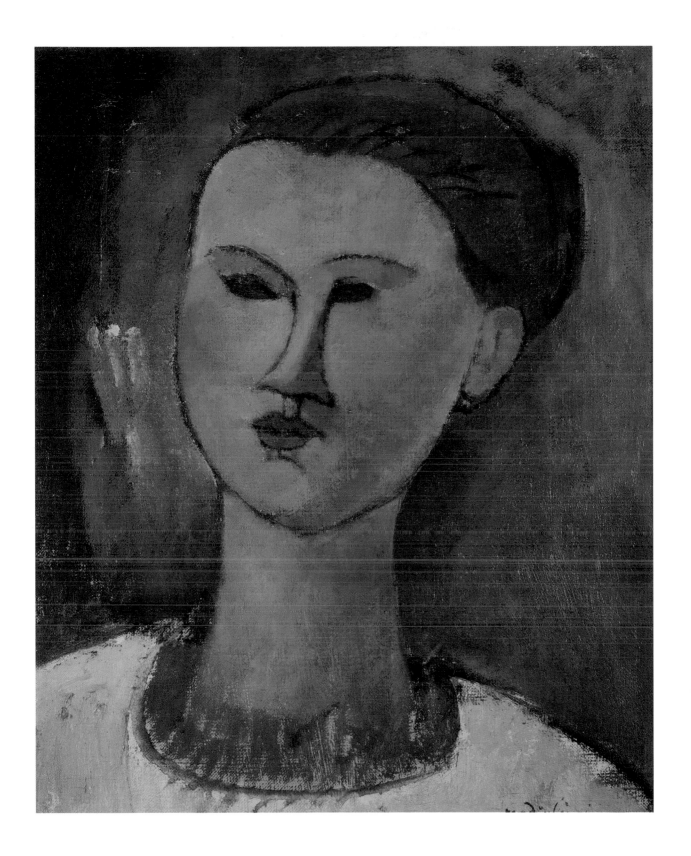

AMEDEO MODIGLIANI *1883–1920*

PORTRAIT OF BLAISE CENDRARS 1917

Private collection, Rome / Courtesy of Scala

IN 1914 Modigliani began a series of portraits of his friends and mistresses. Among the latter the most important, for a time, was Beatrice Hastings, a South African writer who had previously been a lover of the New Zealand short-story writer Katherine Mansfield. Beatrice lived with the impoverished Modigliani and gave him financial support in the early years of the First World War but it was not an easy partnership. She was no less passionate and emotionally demanding than he was and there were drunken affrays and stormy arguments. It is said that on one occasion he pushed her through a window.

Modigliani's outrageous behaviour, as when he would remove all his clothes during a drinking bout, made him notorious in the *demi-monde* of Paris. It was a society that suited him well, with its determination to subvert the bourgeois mentality. The list of friends who sat for him is a roll-call of the leading figures of the modern Paris school, including Picasso, Gris, Diego Rivera, Henri Laurens, Jean Cocteau, Max Jacob and Chaïm Soutine. Blaise Cendrars (1887–1961) was a Swiss poet from the Jura and very close to the important figure of Guillaume Apollinaire as well as the cubist painters – he himself might be described as the first cubist poet. In addition to his experimental writing, he was also an art critic, journalist and film director. In the war Cendrars lost an arm fighting with the French Foreign Legion.

Many more paintings by Modigliani would have survived had he not lost or burnt hundreds, as he was forced time and again into sudden changes in accommodation through poverty or as a result of his aggressive behaviour. He followed such a rootless, irregular path – the almost stereotypical one of the bohemian artist – that it was hard for some to take his talent seriously. The result was that, except at the very end of his life, there was no significant market for the work of a man so obviously unstable, irresponsible and bent of self-destruction.

Modigliani's portraiture was not usually one of character but rather of design, with the figures (very often, as here, a simple head and shoulders) posing against backgrounds delineated in only the most general terms as blocks of colour. Nevertheless there does seem to be an element of comment in the Cendrars portrait: the pinched severity of the sitter, his touch of the dandy schoolmaster, undermined by the crooked collar and the badly knotted tie.

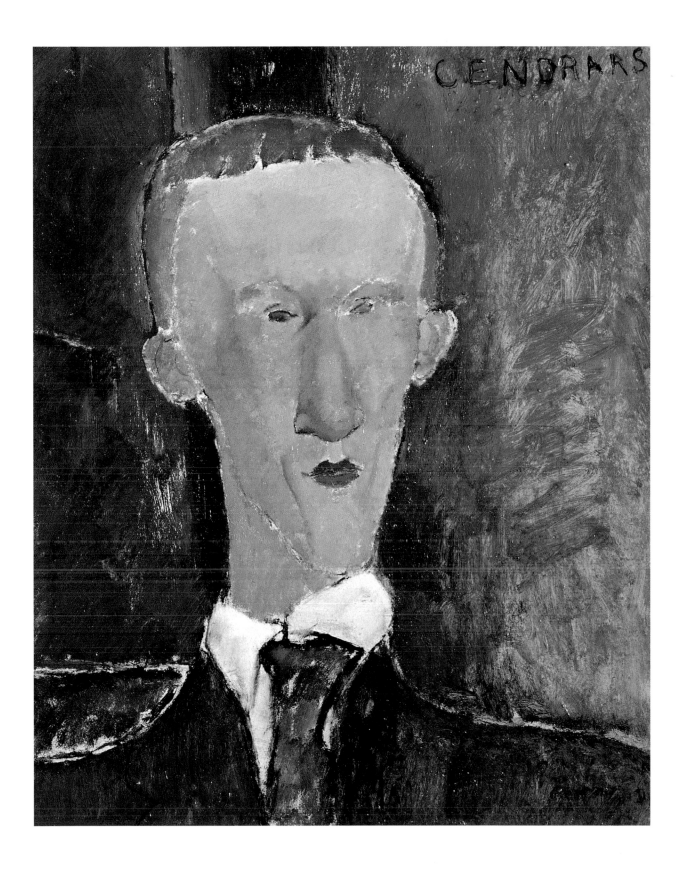

AMEDEO MODIGLIANI *1883–1920*

RECLINING NUDE ON BLUE CUSHION 1917

Mattioli Collection, Milan / Courtesy of Scala

IN 1917 Modigliani mounted an exhibition of his reclining nudes at the Galerie Berthe Weill, including his *Reclining Nude on Blue Cushion*. These images, now so celebrated for their classical simplicity and cool erotic charge, touched a bourgeois nerve. The police were called to the gallery, which was shut on grounds of obscenity. Modigliani's nudes do not in truth far overstep the mark left by his predecessors in the field, such as Titian, Velázquez, Goya or Manet. Possibly it was the public's squeamishness about pubic hair that pushed these works over the edge, if not that sense – intangible and certainly inexpressible by the works' puritanical critics – of the uninhibited, though submissive, eroticism of these sexually active women.

In the same year as the affair with Beatrice ended, Modigliani met the nineteen-year-old Jeanne Hébuterne and the couple began to live together. This affair was even wilder than the one with Beatrice, and Modigliani's behaviour, inflamed by stimulants, was often violent. His portraits reveal his ambivalent feelings towards Jeanne: some are tender images while others seem curiously distant, even cruel. In 1918, as the privations of war came to a head, the couple moved to Nice. Jeanne was pregnant but Modigliani, out of hatred for Jeanne's mother, who insisted on joining them, stormed out of their home, though he returned in time for the birth of a daughter. However, on the day set aside to register the child's birth he was too drunk to sign the birth certificate and she remained officially fatherless. Nice did not, on the whole, agree with Modigliani. Moodily, disliking the climate and missing Paris, he worked indoors as much as possible.

He returned to Paris in the summer of 1919, where his paintings were at last beginning to sell; and in a show of French art in London, one of his works fetched the highest price, a piece bought by the writer Arnold Bennett.

But Modigliani's alcohol consumption was causing concern. After riotous New Year celebrations, he was taken ill with violent headaches and back pains. A doctor, brought in too late to help, diagnosed an untreatable case of tubercular meningitis. Soon Modigliani had lapsed into a coma. He died on 20 January and the great crowd of mourners at his funeral in Père Lachaise cemetery included virtually the whole of bohemian and *demi-monde* Paris.

The next day the pregnant Jeanne threw herself from the fifth-floor window of her parents' apartment, killing both herself and the unborn child.

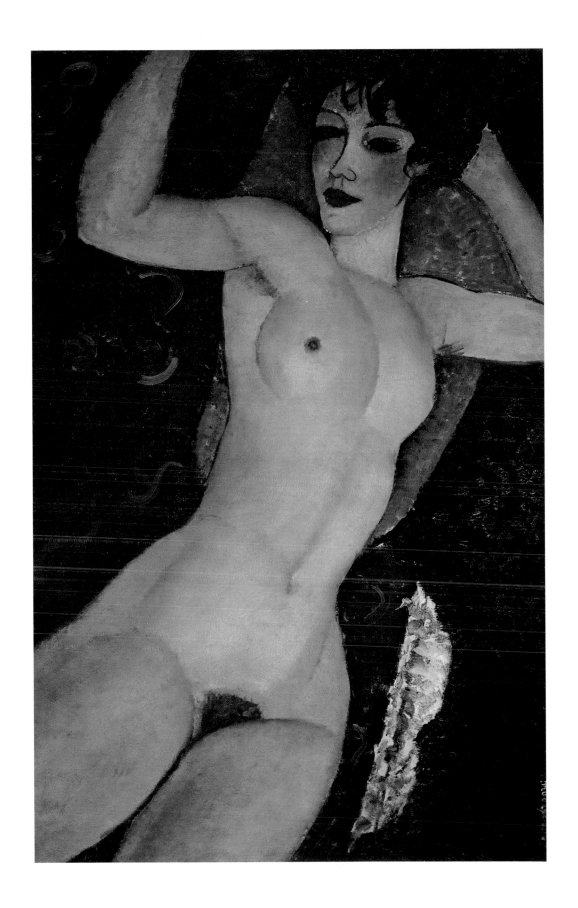

BEN NICHOLSON *1884–1982*

PAINTED RELIEF 1940

Christie's Images, London / Courtesy of the Bridgeman Art Library

NICHOLSON was the first important purely abstract painter and sculptor from Britain, though he was not exclusively an abstractionist. His father William was a successful artist with a fashionable London portrait practice and his mother Mabel Pryde was also an artist. Although briefly a student at the Slade School of Art in 1911, Ben Nicholson did not paint seriously until the 1920s, before which his style was academic and traditional. For a decade he essayed a cautious modernism in England while frequently visiting Paris, still the cutting edge of the European avant-garde, and meeting many of the major figures of the movement. But by the early 1930s Nicholson grasped the modernist nettle with both hands and became England's most 'advanced' artist. He began a series of carved and painted relief sculptures, which occupied him for much of the 1930s. Nicholson had met Mondrian in 1934, which was for him a revelation. In his own work he began to explore interacting rectangular shapes, like Mondrian, but introduced circles within them, the forms meticulously carved out of wooden boards and then whitewashed or painted in various colours.

During this period Nicholson married the sculptor Barbara Hepworth and the couple moved to the remote village of St Ives in Cornwall, which became an important centre for modernist art as other artists clustered around them, including Patrick Heron, Terry Frost, Roger Hilton and Peter Lanyon. St Ives now has a branch of the Tate Gallery in recognition of that tradition. During the Second World War Nicholson continued to work on abstractions, while also painting still lives and landscapes, as a reminder that abstract art is not a break with subject painting but a development of it.

Painted Relief is an example of the kind of abstract work Nicholson had been doing for a decade. Layers of board are cut into shapes and built up on a surface painted eggshell blue to form a panel that is part conventional easel painting, part relief. Like almost all Mondrian after 1921, Nicholson is here interested primarily in the harmony of oblongs but it might be said that if Mondrian plays a series of simple melodies, Nicholson introduces chords by making some of the shapes intrude on others. Another distinction is that Nicholson's defined shapes seem rougher and not necessarily symmetrical, with edges that are not ruler-straight. The colours here have a chalky pallor, of which Mondrian would hardly approve, giving Nicholson's work a less strident effect – a form of British understatement, perhaps, for Nicholson had none of the Messianic ambitions of the De Stijl school.

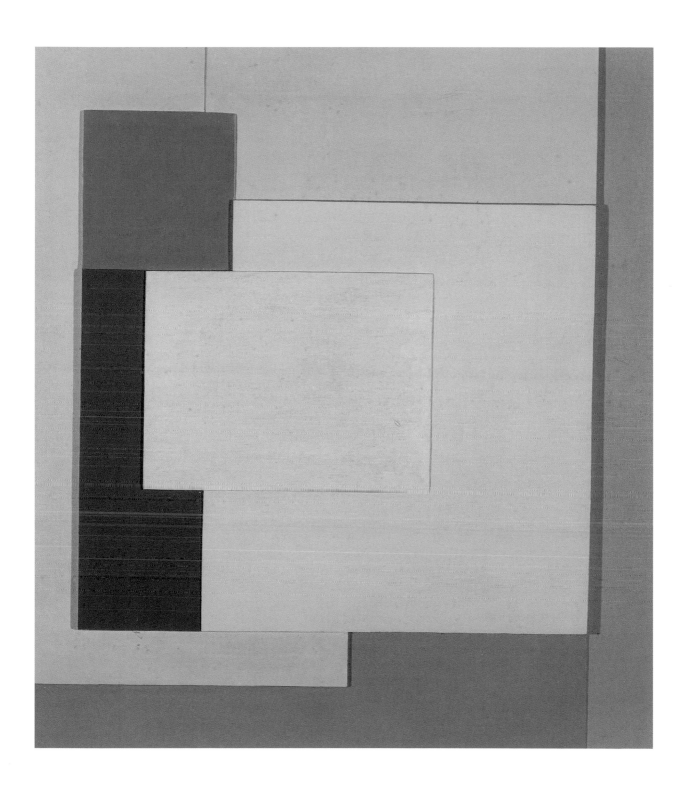

Ben Nicholson *1884–1982*

No. 66 Greystone 1966

Southampton City Art Gallery, Hampshire, UK / Courtesy of the Bridgeman Art Library

NICHOLSON fulfilled an important public commission with an enormous abstract mural for the Festival of Britain in 1951. Then, as the 1950s progressed, he began to receive international recognition, becoming the first winner of the Guggenheim International Painting Prize in 1956, with other honours following, both national and international. The Tate Gallery mounted a large retrospective exhibition in London in 1955.

The marriage to Hepworth, Nicholson's second, ended in 1951 and he remarried six years later, moving with his wife to Ticino, Switzerland. There followed a fresh series of abstract reliefs, of which the work illustrated is an example. In these, Nicholson developed an interest in asymmetry and tilted forms, without the 'squaring up' of Mondrian or Albers. He also continued to use a technique he had first employed in the 1950s, scraping and rubbing parts of the dry painted surface to give the effect of weathered stone.

In Ticino he continued to explore non-abstract themes in parallel with the abstract, including a good deal of tabletop still life. These representational paintings, betraying the long influence of cubism in their flattened perspective and split angles of view, are achieved with a lyrical, sinuous line seemingly at some distance from the geometric forms of his abstract paintings and reliefs. There were also landscapes from his travels, especially in Tuscany, which display his pleasure in the act of drawing.

In 1971 he left his third wife and returned to England, living in Cambridge and London. He continued to work quietly but industriously, and to exhibit. A second retrospective exhibition was held at the Tate Gallery in 1969.

Nicholson's work in the 1930s had once been dismissed by one critic as pallid 'bathroom art'. But his work attracted considerable popularity and success from the 1940s onwards as, despite his unassertive public persona, he (with Henry Moore) came to epitomize modern art in Britain. Since his death, popular recognition has receded to the extent that Nicholson went unrepresented at the grand opening display at London's spectacular new Tate Modern Gallery in 2000. However, the Tate has recently rescued and restored his Festival of Britain mural, which, after the festival, had gone successively to Heathrow Airport and the Students' Union of Edinburgh University, sustaining considerable damage over time, including being scarred by luggage trolleys at Heathrow and having a large hole knocked into it at Edinburgh. The prominent display of this mural in one of Europe's major modern collections may well stimulate new interest in Nicholson's oeuvre.

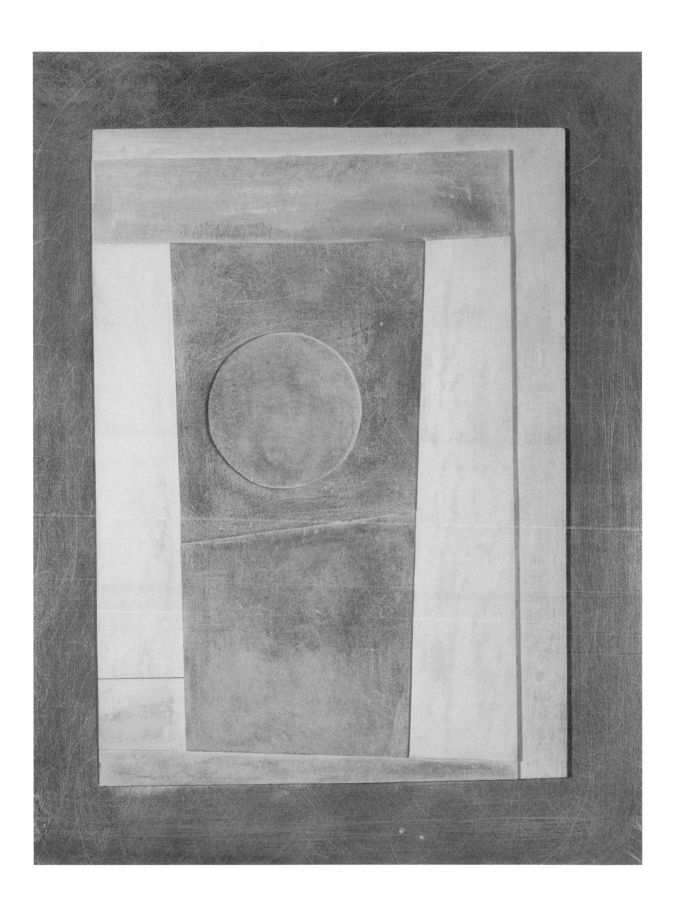

ROBERT DELAUNAY *1885–1941*

CHAMP-DE-MARS: THE RED TOWER 1910

Art Institute of Chicago / Courtesy of Scala

DELAUNAY is important both as an abstract artist in his own right and as a theorist of abstraction. He was virtually self-taught as a painter; his early work from 1900 drew on neo-impressionism, particularly Gauguin and Paul Signac, and later Fauvism. By the end of the decade he had encountered the cubists, but the dull colours of Braque did not excite Delaunay and he branched out into an exploration of bright colour effects and abstract designs, leading to his designation as an 'Orphist'. This label referred to his relative lack of interest in figuration: like the mythical musician Orpheus, his prime concern was for harmonies and abstract beauty.

His series of paintings of the church of St Severin (1909) in Paris shows his interest in the effect of light on architectural forms and in the cubist representation of surfaces, an interest he worked out with obsessive single-mindedness. His series on the Eiffel Tower, to which *Champ-de-Mars: The Red Tower* belongs, is a much more striking development along the same lines.

The Eiffel Tower had been finished for the Paris Exhibition in 1889 and stood on the Champ-de-Mars. Although an extraordinary engineering achievement – at 300 metres high it remained the tallest building in the world until 1930 – it had been initially the subject of much aesthetic controversy, with traditionalists decrying its crude, mechanistic design while the avant-garde praised it as an example of modern sculpture. Delaunay was in no doubt about the significance of the tower, which he painted 30 times from 1909 onwards. In this picture he places it in the midst of the surrounding buildings, among which it appears to be exploding into existence like a terrible new force of the human imagination.

But looked at another way, the formidable iron structure is itself under attack. Delaunay talked about this as his 'destructive' phase, because he took solid objects and showed how light undermines their solidity. The puffy, almost smoke-like area of pure light surrounding the tower appears in places like wings, in others like engine exhaust. In both cases this light represents a power that might lift Eiffel's massive building clear of the ground and make it soar upwards like a majestic rocket.

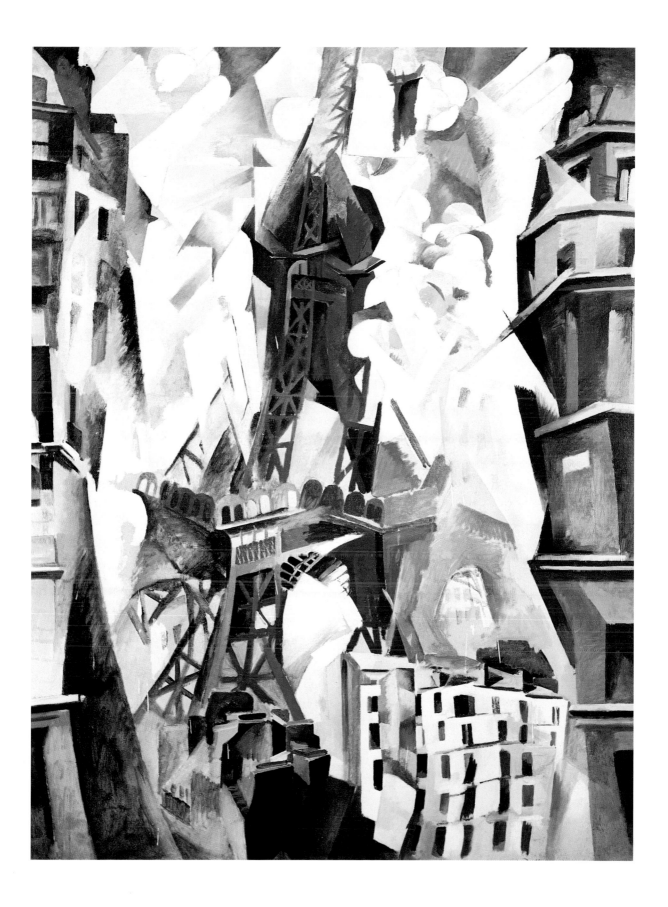

ROBERT DELAUNAY *1885–1941*

A WINDOW 1912

Musée Nationale de l'Art Moderne, Paris / Courtesy of Scala

OTHER artists associated with the Orphist group alongside Delaunay were his Russian wife Sonia, Fernand Léger, Marcel Duchamp, Frank Kupka and Francis Picabia. Delaunay did not invent the term 'Orphism' (that was a writer associated with so many artists of this period, Guillaume Apollinaire); while he did not object to the idea that he was the leading member of a distinctive trend in painting, he preferred the term 'pure painting'. Either way, the word was taken to refer to the strongly meditative flavour of its abstraction. This is best seen in Delaunay's own abstract work from what he called his 'constructive' phase, notably in the 1912 series of *Window* paintings. In these works, representation recedes almost entirely, to be replaced by patterns of coloured shapes.

A window, as Delaunay realized, has two contrasting or contradictory purposes. One is to allow a person a view of the outside, the other to admit light. For Delaunay in these works, there is no doubt which is the more important. The rectangle of the canvas easily stands for the window frame, and the sheen of colour represents the reflected pattern of light coming from the surface of the glass. But Delaunay is interested only in those reflected and refracted colours, which are in themselves a world as vivid and alive as whatever one may see through the glass. That 'real' world interests him not at all. Because of this, Delaunay's is an art of non-engagement. As he worked on his colour meditations, Europe was already sliding down the slope that would end in the First World War and the mud of Flanders – a debacle which the Delaunays would observe from a safe distance after withdrawing to live in Spain. Such an action was entirely consistent with Delaunay's sense of the artist's privileged, self-contained preoccupations.

The *Window* paintings had considerable influence, especially in Germany. Klee published Delaunay's important manifesto on light, *La Lumière*, written in 1912, and Franz Marc, Lionel Feininger and others were strongly impressed by the notion of pure painting.

Delaunay compromised on his abstract principles at various stages in his later career. In his last years he returned to abstraction but also re-explored the themes of his youth – technology and the beauty of progress – in his paintings on Blériot, the pioneer aviator.

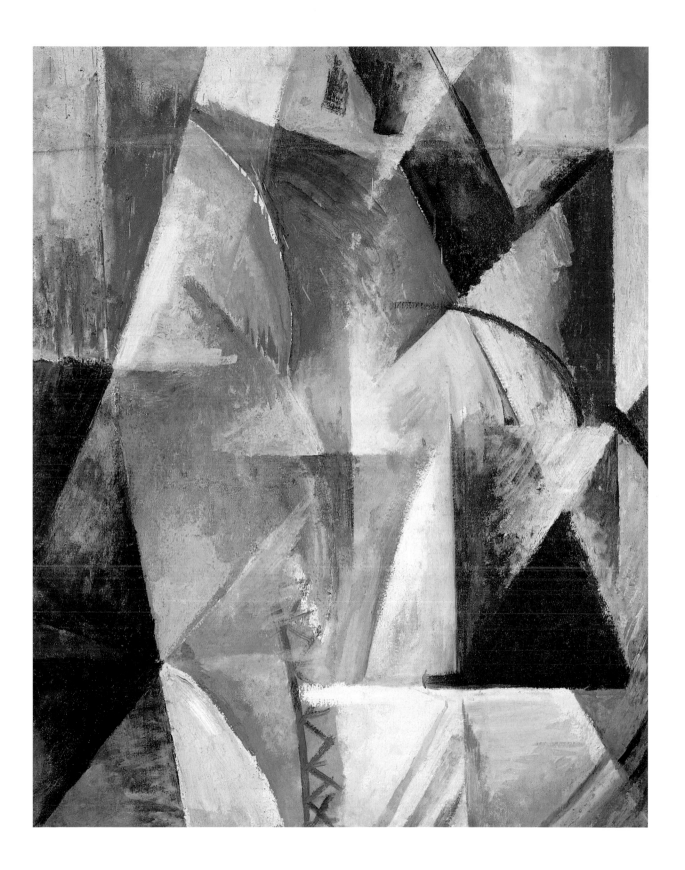

AMÉDÉE OZENFANT *1886–1966*

PURIST COMPOSITION: GLASS AND BOTTLES 1928

Pushkin Museum, Moscow/Courtesy of Scala

OZENFANT – writer and teacher as well as painter – was one of the great torchbearers of cubism after the First World War, when much of the energy of the movement had been dissipated and many of its practitioners, including Picasso, had moved on to new interests.

In 1905 Ozenfant arrived in Paris from his home town of Saint-Quentin. In addition to art classes he attended mathematical lectures by Henri Poincaré and philosophical ones by Henri Bergson, both of whom were to be important in forming the cubist mentality. Ozenfant lived in Russia for three years, during which time he and his brother produced a design for a Hispano-Suiza car, perhaps the first car body to be self-consciously designed by an artist.

Ozenfant was by now besotted by cubism but he was concerned about the direction Picasso's cubism was taking: on the one hand towards the decorative and on the other towards expressiveness. In the First World War Ozenfant ran a cubism discussion group attended by many great names from the avant-garde, and published the journal *L'Elan*. In 1918 he formed a creative partnership with Charles-Edouard Jeanneret, otherwise known as the great modernist architect Le Corbusier, and the two men founded a new journal, *L'Ésprit Nouveau*, and published a manifesto, *After Cubism*, which proclaimed 'purism', a pure form of cubism, impersonal in every way, dealing in a pared-down style with machine-made objects with a utilitarian purpose. An Ozenfant still-life painting is like a commercial design – mathematically precise and deliberately excluding any personal matter.

Ozenfant gradually parted from Le Corbusier (who nevertheless designed him a house and studio) and teamed up with Fernand Léger to found a painting academy in Montparnasse in Paris. Shortly afterwards he became interested in the prehistoric cave paintings then being uncovered at Les Eyzies in the Dordogne. His *Glasses and Bottles* belongs to the same year as his book on the impact of the cave paintings. Indeed, the sympathy between Ozenfant and cave art is easy to see in the still life: the sinuosity of the forms and the way in which they are clustered, sometimes overlapping, though not with any regard to depth of field or perspective.

Ozenfant returned to figurative painting in the 1930s, after which he became increasingly involved in art education, first in London and then in the USA, where he founded the Ozenfant School of Fine Arts. During the Second World War and after, he broadcast in French on the Voice of America radio station but was dismissed in the anti-leftist purge triggered by Senator Joe McCarthy. Ozenfant returned to France and died in Cannes.

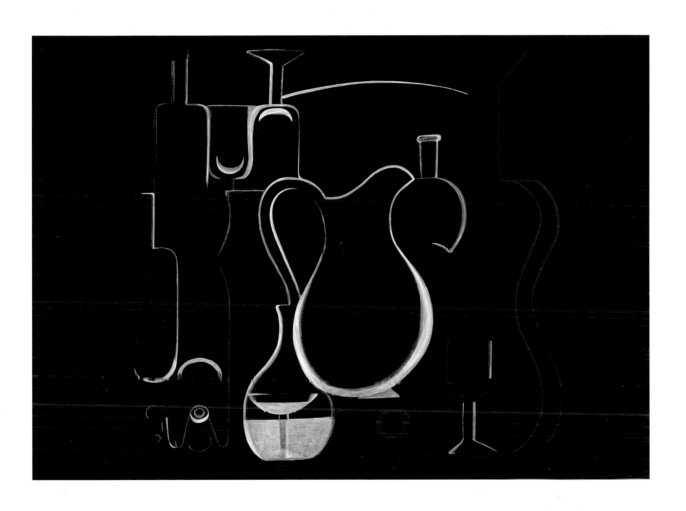

MARC CHAGALL *1887–1985*

ME AND THE VILLAGE 1911

Museum of Modern Art, New York / Courtesy of Scala

THE longest-lived painter represented in this survey, Chagall was from Viciebsk, Belarus, where he was brought up as an orthodox Hasidic Jew. He arrived in Paris in 1910, having barely finished his studies in St Petersburg – completed against a difficult anti-Semitic background – yet he was already a highly polished and original painter and gained early success in the Salon des Indépendants before quickly becoming known internationally, especially in Germany. He was confined to Russia first by the First World War and then by the Revolution, when he was assigned to work in revolutionary arts administration and teaching. But he fell foul of the ambitious painter Kasimir Malevich and moved on to theatre design before leaving Russia for ever in 1922.

Back in Paris, Chagall supported his family as an illustrator, with particular success in etching, at which he developed considerable freedom and skill. Chagall was acclaimed in the 1920s by the surrealists, who recognized in his dreamy images and obsessive return to childhood memories a fellow spirit. But Chagall was not interested in the psychological pomposity that went with surrealism and kept his distance. In the 1930s he travelled widely and became increasingly aware of the threat of anti-Semitic politics. He completed a number of political paintings, such as his *White Crucifixion*, which were overt warnings against Nazism.

He took French citizenship but was in 1941, after the German occupation of France, briefly imprisoned by the Vichy regime. He then left for the USA, where he worked again in theatre design. Back in post-war France he settled near Nice and developed a new interest in biblical narrative painting and stained glass.

Chagall's ultra-orthodox Jewish background, to which he returned for inspiration all his life, made him very well aware of the tensions in twentieth-century life between the traditional and the modern. Perhaps there is no artist who more successfully bridged the two. Like much of his work at all stages of his career, *Me and the Village* is driven by nostalgia for the small place near Viciebsk where his grandparents lived and is full of memories of peasant life and folklore. At the same time the way Chagall divides the picture plane, overlaying images and design without regard for linear pictorial logic, shows the immediate effect of the modernists he met during his first Paris period. Chagall's only rival for the intense spirituality of his vision is Klee but, unlike the Swiss artist, Chagall had no need to invent a context. His imaginary world was inherited and so all the more convincingly real.

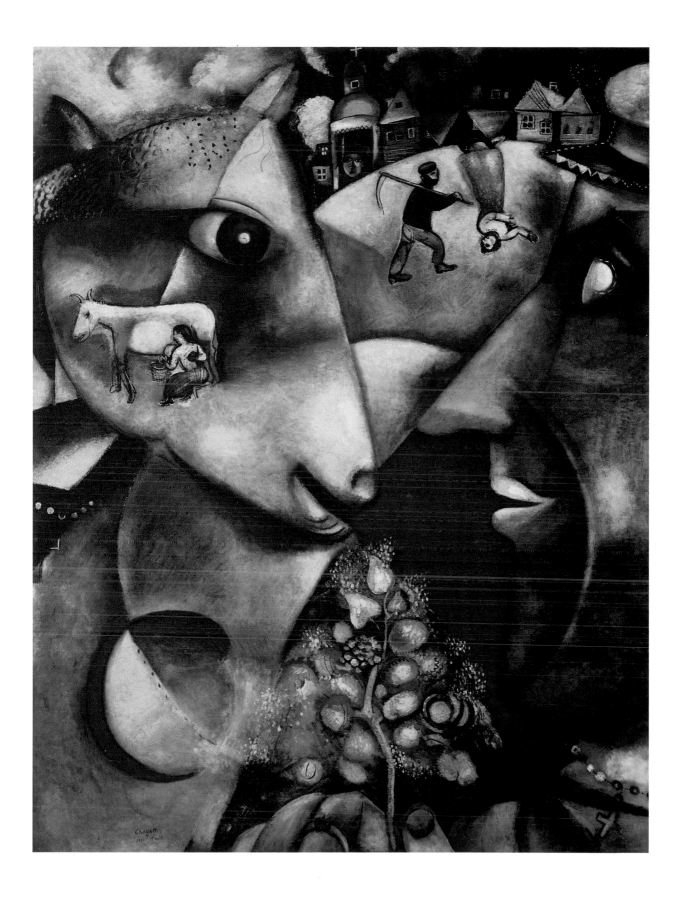

MARCEL DUCHAMP *1887–1968*

THE CHESS PLAYERS 1911

Musée Nationale d'Art Moderne, Paris / Courtesy of Scala

MARCEL Duchamp was the son of a lawyer from Bainville, Normandy, and the youngest of three brothers who all became professional artists. In the early years of the century, after arriving in Paris to join his brothers, Marcel made a living as a humorous cartoonist for two Paris newspapers. In painting he was influenced by Cézanne, the fauvists and Braque, but rapidly developed a subversive streak – appropriate to the cartoonist he once was – which eventually led him towards Dada and made him one of the great court jesters of twentieth-century art. Joker though he was, he has been a very influential one.

Chess is commonly alluded to in early twentieth-century art, for example by Ernst, Klee, Gris and Kandinsky. But Marcel Duchamp was a high-class chess master playing at the highest level and eventually becoming a delegate of the French Chess Federation. He did not hold his fellow painters in high regard as players, saying: 'I have come to the conclusion that while all chess players are artists, not all artists are chess players.'

In 1911 Duchamp and his brothers, Jacques Villon and Raymond Duchamp-Villon, formed the nucleus of the Puteaux Group, which included Jean Metzinger and Albert Gleizes among the painters as well as the writer Guillaume Apollinaire. The group was a loose association of artists both from the neo-impressionist and cubist ranks who took a less stringent view of the cubist discipline.

Duchamp's painting of 1910 looks on the whole a rather weak and juvenile effort (he was still only 23), yet the close positioning of the players, with their baboon features, is interesting. As if rising from the depths of the chessboard itself, but remaining buried in it up to the armpits, they look for a moment like arm-wrestlers engaged in a trial of physical strength rather than exponents of the world's most intellectual game. The chess pieces, scattered around and unrelated in space to the central figures, are scratchily indicated. The colouring is from the regulation cubist palette of the period.

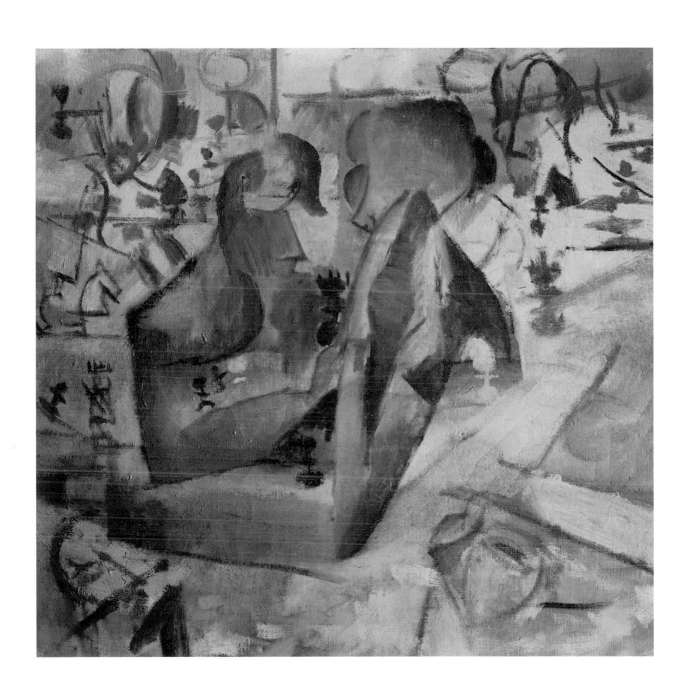

Marcel Duchamp *1887–1968*

Nude Descending a Staircase 1911

Philadelphia Museum of Art, USA/Courtesy of Art Resource/Scala

DUCHAMP tried his hand at several successive styles from Cézanne to Braque before producing this fusion of cubist and futurist ideas. Although probably not in touch with the futurists, Duchamp exploited the same mechanical ideas about the two-dimensional capture of movement that interested Balla with his *Hands of the Violinist* (1912). The model in both cases is the multiple photography of a subject in motion using a camera whose shutter opens and closes rapidly over the same piece of film.

The *Nude* was intended for exhibition at the Salon des Indépendants in 1912, to be hung alongside other work by the Puteaux Group. But Duchamp's fellow Puteaux artists disapproved of the painting and so the artist removed it in a huff and it was temporarily forgotten. Two years later it went to New York, where critics singled it out for ridicule and it became the target of American newspaper cartoonists. This made the image instantly famous and it is now seen as one of the key works of twentieth-century art.

Although it cannot be described as either subtle or rigorously cubist – the curved sweep of the brush here and there to denote the forward movement of the legs is cartoonishly descriptive, rather than analytical – there are two reasons why the painting is renowned. First, it takes Picasso's and Braque's ideas about the analysis of the visual field and of objects presented to it and places them in a new context: mechanization. Duchamp's nude is, if not actually a machine, certainly an artificial construction, which looks as if it might be made of plywood. The mechanization of sexuality was a preoccupation of Duchamp and this represents an imaginary artificial woman.

The second reason for the painting's celebrity has less to do with the content of the canvas than with its pictorial design – qualities applicable to any painting, whether by a Renaissance or a modern master. It is simply a very beautiful and commanding image. The diagonal around which it is constructed, from top left to bottom right, seems to find the very angles that will inject dynamism and flurry into the piece. Because of this, and despite Duchamp's defiant dehumanization, the painting almost accidentally acquires human content and you find yourself wondering why the woman is hurrying so precipitately down the stairs.

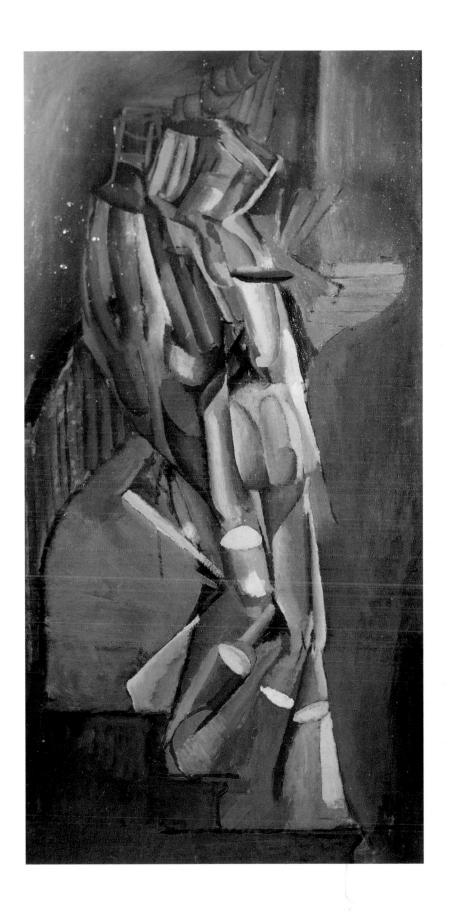

MARCEL DUCHAMP *1887–1968*

FOUNTAIN 1917

San Francisco Museum of Modern Art

FOUNTAIN is the most notorious of several teasing, iconoclastic works produced by Duchamp after the *Nude Descending a Staircase*. In 1913 he exhibited his sculpture *Bicycle Wheel*, which was a real wheel mounted on its forks and screwed into the seat of a kitchen stool. Gallery visitors were invited to do the unthinkable and spin the wheel. After this, in 1915, he went to America, where, because of the notoriety of the *Nude*, he found himself a celebrity. Duchamp produced further examples of what he called (in English) 'readymades' – a snow shovel, a kitchen draining rack – which were simply everyday objects which, by an act of creative choice, could be transformed into works of art.

Fountain is a mass-produced urinal, turned upside down and signed in almost childish capital letters 'R. Mutt/1917'. Duchamp sent it anonymously to the 1917 exhibition of New York's Society of Independent Artists, where it was rejected for public exhibition on the grounds either that it was obscene or that it was not a work of art. The original is long lost but it was photographed and in his old age Duchamp sanctioned the deliberate manufacture of several replicas, so that the original joke was folded in on itself: the despised readymade was now being made to order. He did the same with his *Bicycle Wheel*, which had also been lost.

A further step in the direction of outraging bourgeois taste was his *LHOOQ* (1919), whose title when spelt out in French translates as 'she's got a hot arse'. This was nothing less than a commercial print of Leonardo's *Mona Lisa*, with a waxed moustache and little goatee beard pencilled in. Apart from the obvious appeal of its irreverence, it was perhaps an ironic reference to Leonardo's homosexuality – a subject that went discreetly unmentioned in respectable cultural circles in those days.

Duchamp tired of these cultural games and turned instead to the game that was his first love, chess, in 1926. For a time he virtually gave up the production of art, though he kept up with his artist friends and sometimes bought and sold their work. However, he did in fact continue to make art sporadically and on the sly, becoming a cult hero of the avant-garde and ultimately a figure with the reputation of being the father of pop art and, even more so, of conceptual art, with its ever-ironic attempts to find subversive answers to the question 'What is art?'

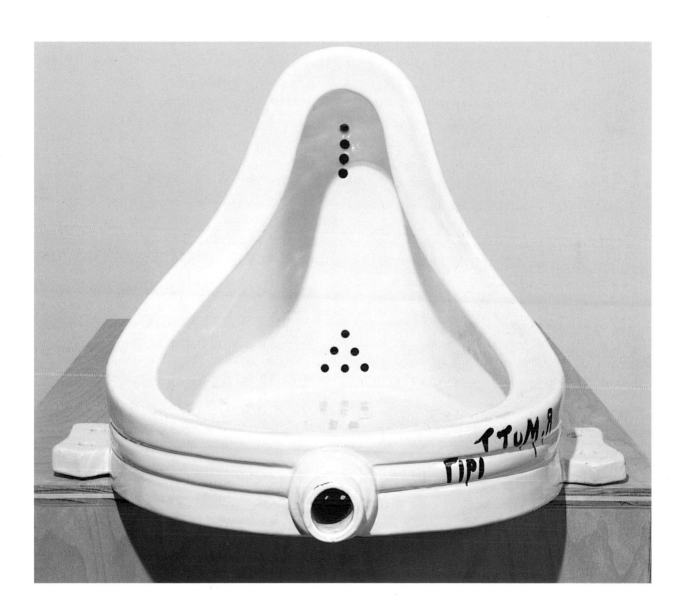

JUAN GRIS *1887–1927*

LE TOURANGEAU 1918

Musée Nationale de l'Art Moderne, Paris / Courtesy of Scala

IN his writings Gris lucidly sets out the relationship in his work between abstraction and representation, saying that if mathematical abstraction was a means – you could almost say a medium – the possibility of its generating the representation of a figure or an object was the ultimate goal. On the other hand, to use a phrase that would not gain currency for another half a century, Gris was aware that the medium was a large part of the message: 'It is not picture X which manages to correspond to my subject, but subject X which manages to correspond with my picture.'

It is very easy to see how these ideas determine the appearance of *Le Tourangeau*. The underlying 'architecture', as Gris would put it, is the arrangement of coloured planes whose positions and relationships are determined according to a set of mathematical rules invented by the artist. But out of this meticulously evolved framework emerges a subject: a man sitting with an open door at his back. He wears a hat and on the table in front of him is a closed book, a clay pipe, a copy of the newspaper *Le Journal*, a glass and a bottle of wine. Purely as a subject for a painting it is just the kind that Cézanne, one of the primary inspirations for cubism at its outset, would have revelled in.

It might be argued that by quite explicitly juggling between abstraction and representation, Gris was trying to have his cake and eat it. He would have disagreed. He once wrote that a purely abstract painting is practically impossible. He likened it to trying to weave a piece of cloth with the threads running in only one direction, whereas to allow objects to emerge from the carefully constructed shapes of abstraction is what gives the cloth its cross-weave. Figuration provides the initially abstract process with an essential extra dimension, an added power.

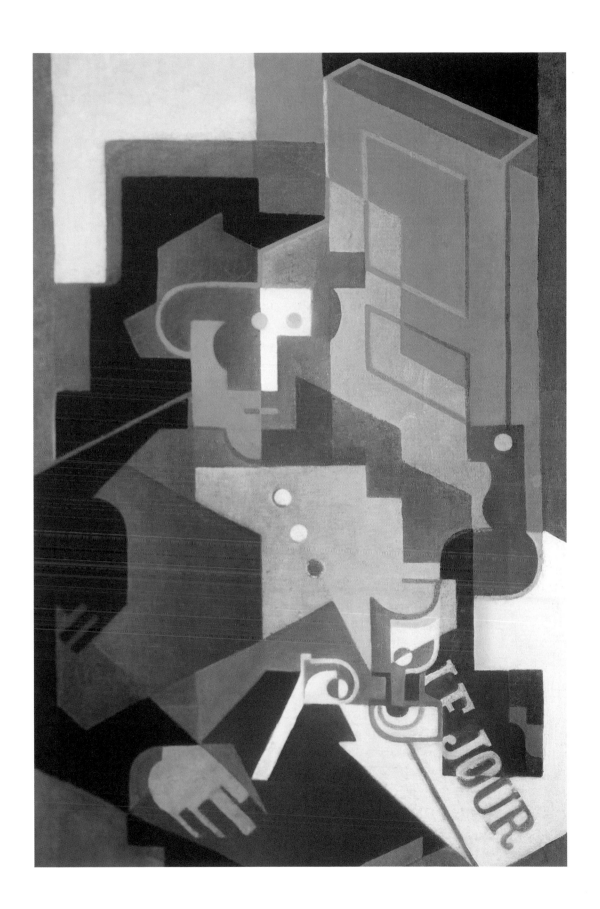

JUAN GRIS *1887–1927*

GLASSES, NEWSPAPER AND BOTTLE OF WINE C.1920

Christie's Images, London / Courtesy of the Bridgeman Art Library

GRIS, born in Madrid, was for a number of years a student of mathematics, physics and engineering before turning to art, working initially as an illustrator with an art nouveau approach. When he moved to Paris in 1906, taking a studio not far from Picasso's at Bateau-Lavoir in Montmartre, he was ideally placed to take up the challenge of Picasso's and Braque's ideas.

Ten years after the first flux of cubism, Guillaume Apollinaire tried to explain its mathematical basis as follows: 'It may be said that geometry is, to the plastic arts, what grammar is to the art of the writer. Today scholars no longer hold to the three dimensions of the Euclidean geometries. The painters have been led quite naturally, and so to speak by intuition, to . . . the fourth dimension.' Like other cubists, Gris was very interested in the theories – then much discussed in intellectual circles – of the mathematician Jules Henri Poincaré (1854–1912), and in ideas about the fourth dimension and the 'hypercube'. Unlike many, however, he had the background knowledge to understand these abstruse concepts and became an important theoretician and explainer of cubism, teaching its principles to a number of younger members of the brotherhood. He expounded these ideas in a series of articles and essays, for example in Amédée Ozenfant's magazine *L'Esprit nouveau* (the New Spirit) which was an avowedly purist publication, denouncing all deviations from the true path of cubism.

The cubist elements in this painting are paradoxically easy to read because they are relatively restrained. The familiar still-life objects, connected in this case either to pleasure (bottle, glass) or information (newspaper), are carefully arranged in relation to each other. This is one of a number of still lifes based around a core set of objects that Gris created in the early part of the twentieth century.

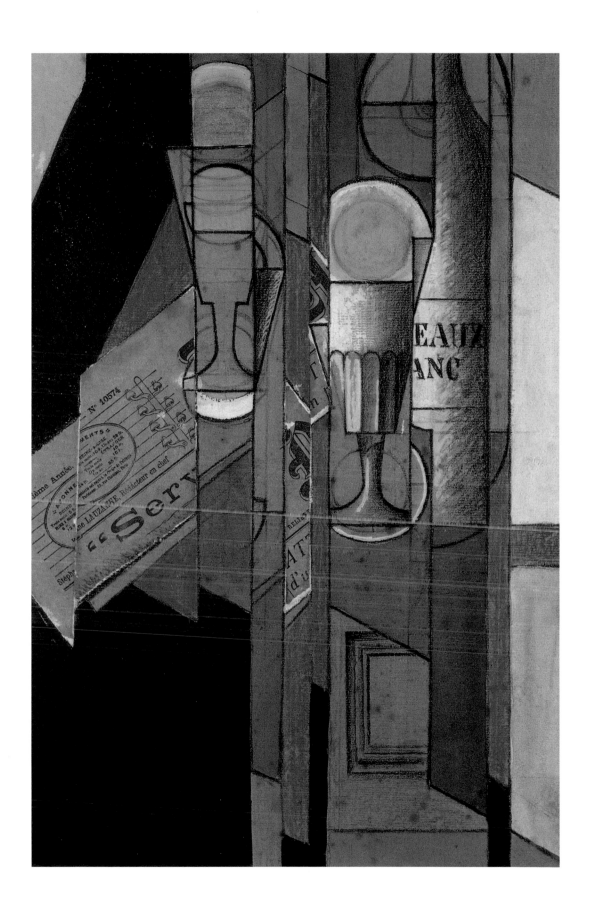

JUAN GRIS *1887–1927*

THE VILLAGE

Galérie Louise Leiris, Paris / Courtesy of Scala

GRIS suffered several bouts of serious ill health but he possessed, in any case, a markedly depressive side to his personality. This comes through in his paintings, many of which have a most sombre character. What is disturbing in particular about the essays in cubism is not the kind of shock of violence or distortion which Picasso could convey so well, from *Les Demoiselles d'Avignon* onwards. Gris's paintings are disturbing because they have desolation at their heart. The mood is so lovingly formalized as to be, at times, touching, but it is hardly life-affirming. His deserted *Village* is certainly not a joyful settlement. Even the touch of green at the centre of the picture, suggesting a tree or a plant climbing the wall of the house, is allotted a pale, lifeless khaki.

The canvas has a certain dreamlike quality, however, which helps to explain why Gris's work interested surrealists such as André Masson, Antonin Artaud and Michel Leiris, who knew Gris well in the early 1920s. Gris was recuperating from a serious bout of illness, possibly undiagnosed tuberculosis, and had moved to a house provided by the dealer in modernist art Daniel-Henry Kahnweiler at Boulogne-sur-Seine. Masson in particular may have found encouragement for his experiments with automatic drawing – done in parallel with other surrealists' attempts at automatic writing – in Gris's theories about the way subjects could emerge from abstract designs. On the other hand Gris, with his insistence on logical draughtsmanship (he used geometrical drawing instruments in his preparatory sketches) cannot have approved of the irrationality at the heart of surrealism.

Gris died after his health had again collapsed in 1927. By this time he was relatively well known, after holding several exhibitions and (like Picasso before him) working on stage designs for Diaghilev. He had also rediscovered his old interest in illustration, prints from which were published by Kahnweiler. Gris's colours in latter years had become brighter, as if trying to be more attractive, but he was nevertheless an unrepentant cubist to the end.

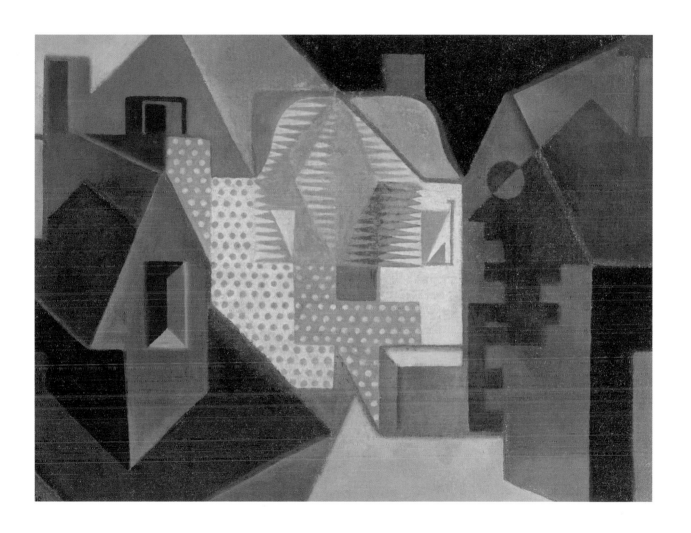

GEORGIA O'KEEFFE *1887–1986*

PURPLE PETUNIAS 1925

The Newark Museum/Courtesy of Art Resource/Scala

IN the course of an immensely long life, O'Keeffe became the best-known and most committed woman artist in America. She was born at Sun Prairie, Wisconsin, trained in Chicago and New York and worked first as a commercial artist drawing needlework advertisements and later as an art teacher. She became an enthusiast of the anti-academic system of art teaching, developed by Ernest Fenellosa and Arthur Wesley Dow, and for six years taught its principles, a heady mixture of art-for-art's sake ideas from the 1890s. Later, however, she was impressed by European modernism, especially Kandinsky's writings: 'Every work of art is a child of its time. Often it is the mother of our emotions.'

O'Keeffe announced herself as an original artist in 1915–16 with a series of abstract paintings whose genesis she described. 'I hung on the wall the work I had been doing for several months. Then I sat down and looked at it. I could see how each drawing or painting had been done according to one teacher or another, and I said to myself "I have things in my head that are not like anyone has taught me – shapes and ideas so near to me – so natural to my way of being and thinking that it hasn't occurred to me to put them down". I decided to start anew, to strip away what I had been taught – to accept as true my own thinking.'

O'Keeffe now produced a series of abstracts called *Blue Lines* that launched her on her career as the most advanced and original American-born painter of her generation. Although there are clear signs in her work of the art nouveau forms she had learnt as a student and employed as a commercial artist and teacher, O'Keeffe now became an exponent of glowing still life, most often of flowers seen in extreme close-up, a point of view she borrowed (among other effects) from photography.

These *Purple Petunias*, amplified until they fill the canvas, demand an awed response, though the flowers are in reality quite small. O'Keeffe remembered that she had resolved to 'paint what I see – what the flower is to me – but I'll paint it big and they will be surprised into taking time to look at it. I'll make even busy New Yorkers take time to see what I see of flowers.'

The artist applied her oil paints very thinly so that they may sometimes be mistaken in reproduction for watercolours. The delicacy of her touch is seen everywhere in *Purple Petunias*.

GEORGIA O'KEEFFE *1887–1986*

RED GLADIOLA IN A WHITE VASE 1928

Private collection / Courtesy of the Bridgeman Art Library

O'KEEFFE was impatient with the critical reception she received in the 1920s and 1930s. This centred firmly on her gender and analysed the work in Freudian terms. It is certainly easy to see the psychoanalytical appeal of a picture such as *Red Gladioli in a White Vase*, where the petals are blood-red and fleshy, folding over the secret germinal centre of the flower. But O'Keeffe rejected the suggestion that her images could be explained as instinctual expressions of female sexuality. For her they were simply transmissions of a way of seeing that was particular to her. She told the critics: 'You write about my flower as if I think and see what you think and see of the flower – and I don't!'

The flowers in this painting seem to inhabit an unearthly space of their own, in which the light does not fall but delicately settles itself on and around the petals. This effect is emphasized by the aura of pale green which the flower seems to hold around itself. Despite her dismissal of any equation with sexuality, it cannot be denied that O'Keeffe had a way of looking at and into a flower that is not just sensitive but highly sensual. For her the flower becomes as powerful as the magnificent American landscape that had been ecstatically painted by artists for over a century. O'Keeffe had more of the late-romantic artist in her than any modernist of her generation (she was born in the same year as Chagall, Gris and Duchamp), at least in the sense that her art was always concerned with the beauty and tranquillity of nature.

This held true even when she lived and painted in New York from 1926 to 1929. She again used a variety of photographic effects, such as lens flare and image convergence, to produce views of skyscrapers at night, the East River and Long Island City, which make as striking a vision of the twentieth century man-made environment – cleaned up but not overtly prettified – as any. They also provided her Freudian admirers with further fuel for their theories: the tall, spare, engineered forms making fine phallic counterparts to the enlarged flowers.

After 1929 O'Keeffe devoted her summers to working in New Mexico and twenty years later moved there permanently. She painted extraordinary landscapes, in which the hills and mountains appear fibrous like muscle tissue, and very often made studies of bones in the desert, some of which have a startling surrealist quality.

Josef Albers *1888–1976*

Homage to the Square

Haags Gemeentemuseum, Netherlands / Courtesy of the Bridgeman Art Library

ALBERS was born in Bottrop, in Germany's Ruhr, and after preliminary studies in Essen and Munich he attended the Bauhaus, where he was subsequently taken on as a member of staff. Albers was a natural for the Bauhaus movement, a fanatic for technical skills and formal invention; he specialized for a while in constructions made out of broken bottle glass recovered from the city dump. When the Nazis closed down the Bauhaus in 1933, Albers accepted an invitation to teach at the newly founded Black Mountain College in North Carolina, USA, which became one of the leading centres of the American avant-garde in the visual arts and literature. In 1950 he moved on to Yale.

Albers's abstract paintings in America often repeated a single design concept with different colours and minor variations in arrangement. *Homage to the Square* is one of a vast series of over 1000 paintings of concentric or nesting squares, which occupied the last 25 years of Albers's life. The number of squares varied from three to four, the range of colours differed and to some extent the relative positions of the squares, although they are always 'squarely' placed with the edges and corners aligned. With no outline the squares consist of pure colour. Yet they seem to have a floating independent life of their own and perform, after a few minutes of attention, illusions of three-dimensionality, elision, oscillation and other optical tricks.

Albers was regarded as a world specialist in colour theory and his book *The Interaction of Colour* became a standard work for art students throughout the world, exploring the characteristics of different colour combinations – their complex interactions, illusions and modulations.

All the *Homage*s were made along strictly standardized lines, like controlled laboratory experiments. Colour was applied straight from the tube with a palette knife on the rough side of wood fibreboard panels, primed with many coats of white. The artificial lighting was varied along a known and controlled scale from warm to cool. Albers often started with the central square and worked outwards.

Despite the calculated methods of its production, the *Homage to the Square* series built up an inexhaustibly various array of effects, based entirely on colour interaction and with no emotional input from the artist. These ideas had important influence on 1960s op artists like Bridget Riley.

MAN RAY (EMANUEL RABINOVITCH) *1890–1976*

THE GIFT 1921

Courtesy of the Man Ray Trust / ADAGP / Télimage

A PHOTOGRAPHER, painter, sculptor and Dadaist, Man Ray was an American, the son of a small-time artist and photographer. He was widely known by other artists around the end of the First World War and, in the 1920s, made portrait photographs of most of them. His most important artistic relationship, however, was with Marcel Duchamp. Meeting in 1915 in America, they formed the New York school of Dada, and produced their 'readymades' – commercially manufactured objects which, by exercising their own artistic choice, they designated as art works for serious consideration by the public.

Man Ray took up photography in a big way in Paris in 1921. He had exceptional talent as a portraitist, and became in effect a successful society photographer. But he also used the camera as a way of making art, the first avant-garde figure to do so. Ray introduced new photographic techniques for aesthetic purposes, such as the 'Rayograph'. This is a photogram made by arranging objects on a sheet of light-sensitive paper in the darkroom and flashing a light on them, often with very beautiful results. There is no intervening negative in the process, which makes every original Rayograph unique. Another process creatively used, though not discovered, by Ray was solarization, by which a print could be made in which part of the image is seen as positive and part as negative. He also enhanced or interfered with photographs, as in his *The Violin of Ingres*, in which the rear view of a particularly voluptuous female nude, modelled on a painting by Ingres, has had the twin f-shaped piercings of a violin added on either side of her spine.

With Duchamp, Ray also made films and continued to produce readymades. He was a skilful and interesting painter, an aspect of his work that has been generally overlooked.

The Gift is one of Man Ray's most famous Dada sculptures. It is not strictly speaking a readymade since Ray has added the row of glued nails to the flat-iron. In 1945 he said that his work 'cannot be considered experimental. The pursuit of pleasure, my guiding motive, is not a science. Or, as I have previously stated, the desire not the necessity is the stimulant.' The image of an iron capable only of tearing what it seeks to flatten can, of course, be read as an image of frustrated desire but that, Ray would insist, is in the mind of the spectator, not the artist. 'The experiment is with the spectator in his willingness to accept what his eye conveys to him.'

DAVID BOMBERG *1890–1957*

THE MUD BATH 1914

Tate Gallery, London / Courtesy of the Brigeman Art Library

BOMBERG was born in Birmingham, England, the fifth child of a Polish immigrant leatherworker. He was precociously talented as an artist, but struggled to support himself as a young art student until finally finding the patronage to attend the Slade School of Fine Art in 1911.

'I look upon nature but I live in a steel city,' Bomberg said, expressing his sense that it was time for art in England to shake off its academic chains and embrace the twentieth century. He was particularly stimulated by two post-impressionist exhibitions mounted in London by the Bloomsbury critic and painter Roger Fry in 1912. At around the same time he saw work by Italian futurists such as Boccioni and Balla. Meanwhile, Wyndham Lewis, Edward Wadsworth, William Roberts and others were developing the ideas of vorticism, an artistic style dedicated to a dynamic kind of abstract painting. This reached its ultimate expression in Lewis's polemical magazine *BLAST*, which appeared for two issues in 1914. Bomberg was never closer than the fringes of vorticism, but some of its ideas, with those of cubism and futurism, went into the mix of his highly individual vision.

This apparently abstract painting is a splendidly vibrant exercise in white, black, brown, with the three (almost) primary colours. But after only a few moments of looking it is apparent that the blue and white shapes might in fact be representative of figures. A pair of feet and legs are seen standing at the edge of the red rectangle, bending at the knees. A shadow is cast by another figure in the right foreground while, in front of the brown post, yet another figure seems to fall sideways, twisting and disappearing into the scarlet area behind.

The suspicion that these are figures is, of course, correct. Moreover they are very specific figures – clients at Schevzik's Vapour Baths in the Whitechapel district of London's East End. This was a predominantly Jewish quarter and Bomberg, himself a Jew, knew it well. The scene at the bath house is an entanglement of individual energies with the figures hurling themselves excitedly around the plunge bath, at the edge of which stands a brown pillar. Perhaps the surprising aspect of this painting is the absolute refusal by Bomberg to sentimentalize the scene. He disdains even to accord it the ethnic identity that was always so essential to Chagall, who was only three years older than Bomberg himself.

DAVID BOMBERG *1890–1957*

PORTRAIT OF EUNICE LEVI **1933**

Phillips, The International Fine Art Auctioneers, UK/Courtesy of the Bridgeman Art Library

THE First World War, in which Bomberg served with the Royal Engineers, was a defining experience for him, not only because of the atrocious experience of warfare itself but also because of the reception he was given when he tried to record it in paint. In 1917 he received a Canadian government commission to commemorate an operation in which Canadian sappers had successfully undermined the German salient at Saint-Eloi near Arras and detonated a huge landmine under it. It was a commission for which Bomberg, as a Royal Engineer himself, must have been thought particularly suitable.

Despite being told to steer clear of 'cubism' he produced a canvas, *Sappers at Work*, which in its non-imitative colours and near-abstract treatment of the figures was similar to Bomberg's earlier *The Mud Bath*. To his intense disappointment, the painting was rejected. Under protest Bomberg completed a second, figurative version of the subject, in which he included a self-portrait, carrying a heavy beam to indicate the onerous task he had been set.

The experience of war, made worse by the reception of his *Sappers at Work*, had a drastic long-term effect on Bomberg. Like many of those who saw action in 1914–18, he suffered for many years from recurrent attacks of depression. Meanwhile he struggled technically, unsure of his direction. He finally abandoned the audacious near-abstract machine-age imagery he had developed for himself at the Slade and began a laborious search for a new style. He travelled widely, to the Middle East and elsewhere, painting in various modes and sometimes with remarkable results. But also at times he came up with highly literal, almost photographic work, which puzzled his remaining supporters.

The *Portrait of Eunice Levi* shows that, by the 1930s, Bomberg had started to work in a more Bonnard-like post-impressionist idiom. His brushwork is thick, with heavy impasto, but the result is not ponderous because the portrait seems, in a psychological sense, highly alert. The artist is seen to respond directly to the sitter's mood, although this is perhaps not a very positive or encouraging one. She is nervous and her palpable tension conveys the impression of wishing she were somewhere else rather than sitting for Bomberg. In this way Bomberg's own insecurities, bound up with the expectation of rejection which his work all too often received, seems to come through.

DAVID BOMBERG *1890–1957*

CYPRUS 1948

Southampton City Art Gallery, Hampshire, UK/Courtesy of the Bridgeman Art Library

BOMBERG'S paintings from nature in Scotland and Spain in the 1930s increasingly sought to express feeling through vigorous brushwork. The results seem now compellingly dramatic, rapid, direct and full of powerful light effects. But these fine landscapes brought him little success at the time; and when the Second World War began and he eagerly applied for work as a war artist, the scene was set for more disappointment. Bomberg received a commission to record aspects of the home front and he opened with an impassioned series of paintings on the theme of a bomb store. The canvases he handed in were met with stony lack of comprehension and there were no further commissions.

After the war, Bomberg was edged further away from the limelight in the art market. He derived some compensation as a member of the teaching staff at the Borough Polytechnic, London, where he was at least beginning to achieve some recognition as an outstanding teacher. It was here that he met Frank Auerbach and Leon Kossoff, two of his best pupils.

Bomberg made many powerful paintings during a series of visits to Cyprus, including the one illustrated here, which records a Homerically dark Mediterranean seascape against a coastline around which Bomberg's brush winds and bounces before churning into the bright surf with a remarkable effect of white and yellow pigment. Strong, direct and dramatic, these landscapes were aiming, so the artist said, to find the 'spirit in the mass'. In many people's eyes, this painting, along with others done in the English West Country and around Cuenca and Ronda in Asturia, southern Spain, is work that now seems to make an important contribution to English landscape painting, in a direct line from its founders Constable and Turner.

Unfortunately for Bomberg, this was not the prevailing opinion at the time, and he found little enthusiasm for one-man shows, scant critical attention and very few buyers. His very last work is dark, perhaps tragic. It speaks bleakly of Bomberg's despondency at the way in which he had been marginalized and forgotten, after a career that began in the first decade of the century with such a blaze of hope and originality.

MAX ERNST *1891–1976*

DADA 1923

Thyssen-Bornemisza Museum, Madrid/Courtesy of Scala

ERNST was born into a Catholic family near Cologne, Germany, and went to university at Bonn to study psychoanalysis and art history. He was an untrained artist, but his father, a teacher of deaf mutes and something of a domestic tyrant, was a keen amateur painter. He recalled his father painting a view of the garden but leaving out a particular branch because it ruined the balance of the composition. When he had finished the painting he went out and cut off the offending branch.

Ernst had himself begun to paint when he was called up to fight as an artilleryman for Germany in the First World War. He was profoundly affected by the conflict's barbarity. 'I was born with very strong feelings of the need for freedom, liberty,' he wrote, 'and that also means very strong feelings for revolt. And then one is born into a period when so many events conspire to produce disgust: then it is absolutely natural that the work one produces is revolutionary work.' He was drawn to satirical paintings and the bizarre logic of the painter Giorgio de Chirico. Ernst had also known the leaders of the dadaist movement Tristan Tzara and Jean Arp and was a founder of the Cologne school of Dada. But tiring of the movement's childish anarchism, he embraced the more programmatic ideas of surrealism. After 1924 he became, in effect, the first surrealist painter.

In style, subject matter and technique Ernst was a restless experimenter and there is no such thing as a typical Ernst production. As well as brush painting, he was particularly adept at collage, frottage (a process akin to brass rubbing), grattage (scraping pigment across canvas laid on a heavily indented surface) and even (in the USA) a form of drip painting which seems to have inspired Jackson Pollock.

With their nonsense titles such as *The Hundred-headless Woman Opens her August Sleeve* and *Two Children Menaced by a Nightingale*, his paintings cannot be, and are not intended to be, explained. They project dreams and hallucinations, through which the artist's neuroses and disturbed eroticism can be glimpsed, though never quite grasped. Although his instincts were rebellious, he was not actively political, seeing art as a deeper form of political engagement.

JOAN MIRÓ *1893–1983*

THE BOTTLE OF WINE 1924

Joan Miró Foundation, Barcelona / Courtesy of Scala

MIRÓ was a Catalan, the son of a goldsmith. His father intended him for a career in business but illness intervened and Miró changed direction, going to Barcelona to study art under, among others, the inspirational teacher Francesco Galí. It was Galí, in the drawing class, who put a blindfold on the young man and ordered him to feel objects with his hands before he looked at and began to draw them.

Barcelona was a sophisticated artistic centre during the First World War and Miró attracted attention with his figure paintings and landscapes, vividly painted works in Fauve-like colours. In the early 1920s he began to move towards greater control over detail, developing the precision that is characteristic of his mature work. Revisiting his childhood in southern Catalonia, he made a series of paintings of farm life at this time, in which the objects are shown with the same kind of scrupulous hyper-realism that he would later lavish on invented forms.

But Miró was soon ready to discard this naturalism. Already half a surrealist, he began to introduce fantastic animals, schematic insects and diagrammatic micro-organisms into his paintings, mixing them with naturalistic elements in a dizzying confusion of scales. He was, in fact, moving towards a style that would inspire the movement's guru André Breton to refer to him as 'the most surrealist of us all'. Yet Miró never officially signed up as a surrealist, being unhappy with the movement's political stance and its tendency towards smug exclusiveness. But he was content to exhibit at their first Paris exhibition of 1925, along with Jean Arp, Giorgio de Chirico, Max Ernst, Paul Klee, Man Ray, Pablo Picasso and his own particular friend André Masson.

The Bottle of Wine belongs to this first phase of Miró's alliance with surrealism. It is both a still life and a landscape, reminiscent of the hot and arid lands of southern Catalonia. But no form is unambiguous here. The dimple at the base of the bottle becomes a volcano, the mountains resemble ploughshares and a red-eyed, whiskered invertebrate swims or drags itself towards an insect which it may be hoping to eat. The sinuous contours of this nameless creature are recognizably the work of Miró, who was always concerned with setting wavy lines off against straight, as he was with contrasting the simulated organism with the man-made object, here represented by the bottle.

JOAN MIRÓ *1893–1983*

THREE WOMEN 1925

Calder-Saché Collection, Paris / Courtesy of Scala

COMPARED with the fantastic illusions painted by Magritte and Dalí, Miró's work was abstract surrealism and he approached his subject first of all from the point of view of design and colour. In the mid-1920s he produced a series of works based on a colour field of an intense deep blue. If you took away the few humanoid aspects of this image – the little legs, the eyes and noses – it would appear a perfectly good piece of abstract art. But the fact is that these minimal gestures of representation are there, and to serve a purpose: Miró's irrepressible sense of fun.

He knew that the human imagination can locate and accept form and meaning in the most perverse shapes, and can conjure a story from quite disparate elements, as long as a few hints are provided. Here he gives the viewer just enough information to give a suggestion of floating, with the three women of the title pressing upward towards the top of the space as if impelled by water pressure. Two of them have struggled out of their black dresses, perhaps to save themselves from drowning, while the third, lower down, is still entangled (fatally?) in her white garment. In this way Miró's painting offers us a narrative game we can play, alongside the more austere pleasure of aesthetic appreciation.

In the 1930s he temporarily abandoned this posture and went through a period of intense misanthropy, engendered by his anxiety about the Spanish Civil War and the spread of Fascism. At this time Miró produced a number of paintings, drawings, murals and prints remarkable for violence and disgust, with their echoes of Hieronymus Bosch and Francisco Goya. Ultimately his faith in humanity – playfulness, social harmony, the positive use of the imagination – returned.

The tragic mood returned to Miró at times in the last 25 years of his immensely long life, with darker tones and more strained themes. He had been experimenting with decorative work, printmaking, pottery and sculpture but now he revisited and reappraised abstraction, simplifying his vision. He illustrated books and continued to do sculpture, still with a surrealist edge and often in his old spirit of humour. He died in Mallorca on Christmas Day, at the age of 90, an artist who had always sought to balance play with thought.

HENRY MOORE *1898–1986*

RECLINING WOMAN 1930

Mostra temp. 'H. Moore', Florence / Courtesy of Scala

MOORE came from a large family, being the seventh child of a progressive, self-educated coal miner in Castleford, Yorkshire. Moore fought with the British army in the First World War, but was gassed at the Battle of Cambrai and invalided out. As a student at Leeds School of Art (1919-21) and then at the Royal College of Art in London (1921-4), he was recognized as an outstanding prospect and the Royal College appointed him to the teaching staff in sculpture in 1924.

Moore travelled widely. In Paris he was deeply struck by the painting of Cézanne, and Italy provided lessons from the early fresco painters Giotto and Masaccio. He was also intrigued by the carvings he saw from Michelangelo's old age, such as the unfinished series of *Slaves*, in which the figures are seen as if struggling out of the half-worked marble blocks. These reinforced Moore's already strong belief in direct carving, which he shared with many of his great sculptor-contemporaries such as Brancusi, Epstein and Gaudier-Brzeska, and his insistence that a sculptor must never force his material but must allow it to guide his chisel into the appropriate forms.

His first one-man exhibition was held in 1928 and in the same year Moore was commissioned by London Underground to provide a relief carving for their new headquarters building near St James's Park. In response Moore produced his *West Wind*.

The model for Moore's long series of life drawings (1929–35) of a seated or reclining female figure was his wife Irina, whom he married in 1929. These drawings evolved into his many sculptures of the same subject.

Moore maintained that *Chacmool*, a Toltec-Maya representation of a reclining warrior-priest carved in basalt (in the National Museum, Mexico City), was a major influence over his early sculpture, almost all of which was in either wood or stone. He admired the piece's 'stillness and alertness, a sense of readiness, and the whole presence of it, and the legs coming down like columns'. In his own reclining figures of the period, Moore announces himself as the public artist, producer of work on a monumental scale. In Moore's mind were parallels between the contours of the figure, his ostensible subject, and the landscape around him. *Reclining Woman* deliberately sets out to establish this confluence of ideas about the female principle and the landscape. He takes us back, in other words, to the idea of Mother Earth.

HENRY MOORE *1898–1986*

BRONZE FIGURE WITH STRINGS 1939

Mostra temp. 'H. Moore', Florence / Courtesy of Scala

IN the 1930s Moore, feeling the far-reaching influence of Picasso, began to make figurative pieces in which the form was pierced, distorted or dismembered. Moore was also very interested in the surrealist movement, which was then reaching its height. The use of strings in a bronze piece is reminiscent of the cubists' mixed-media experiments, as well as their interest in music and harmony. But it also has an undoubted surrealist flavour to it.

Moore's work at this time floated free of verisimilitude, though he would say that all his forms were connected thematically or symbolically to organic forms, specifically his preoccupation the female figure and the mother and child.

From 1933 onwards Moore was a member of a group of artists known as Unit One, living and working in Hampstead, London; other members were Barbara Hepworth and Ben Nicholson. These three in particular shared ideas, though there was no overt collaboration.

Moore's work in the 1930s was met with blank incomprehension by the critics. One wrote: 'The cult of ugliness triumphs at the hands of Mr Henry Moore. He shows an utter contempt for the beauty of women and children.' Another, in the *Daily Mirror*, wrote: 'A monstrosity of an exhibition by Mr Henry Moore which surpassed in repulsiveness even that of Epstein.' But this attitude was to change in the dramatic circumstances of renewed war in 1939.

Moore's Hampstead studio was bombed and he moved to the Hertfordshire countryside. At the same time he was appointed official war artist and began a series of drawings and prints of Londoners sheltering in tube stations during the nightly bombing raids. These deeply felt representations of huddled and sleeping figures, shrouded in blankets and gloom, their faces without distinguishing characteristics, were felt to have extraordinary power when exhibited in wartime London, and they made Moore famous. The intense humanism of the images was both moving and paradoxically uplifting so that he was generally praised for carrying out his war-artist function with such effectiveness.

The secret of Moore's success was that the subject so readily appealed to his sculptural interests: the tube shelter was a living gallery of sitting and reclining figures. At the same time the atmosphere of the tunnels reminded him of his mining forebears, deep underground in ever-present danger. When the London Blitz finished in 1941, he followed up this connection by going back to the coalfields, where he produced drawings of miners hewing coal which emphasize the primitive, almost primal nature of the work.

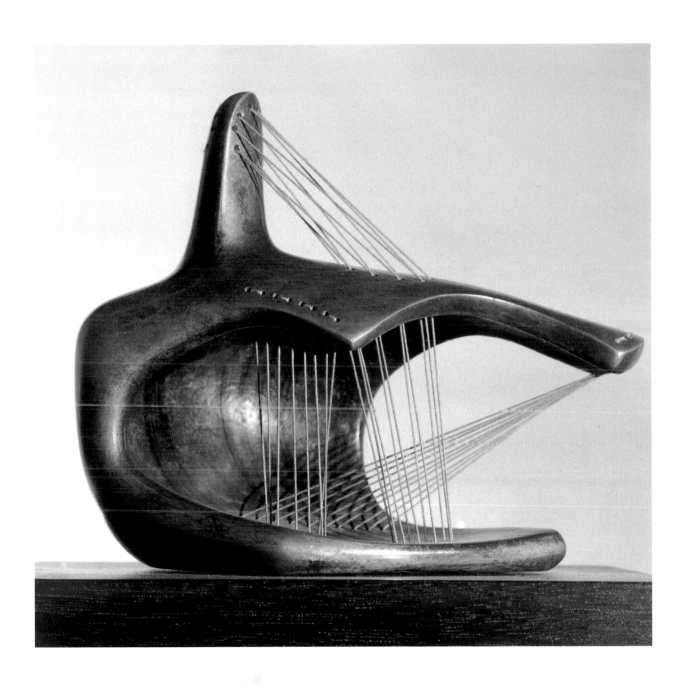

Henry Moore *1898–1986*

King and Queen 1952–3

Collection Moore Mary Much Hadham, Florence / Courtesy of Scala

MOORE'S king and queen are in a completely different register from his ovoid, undulating and hyphenated forms of the pre-war years. They continue the process, begun during the Blitz, whereby he retreated from those more personal and extreme distortions of human form to develop a simpler and universally understood language.

Moore had always been interested in the theme of the *Mother and Child* – he had made a serene piece on the subject for St Matthew's Church, Northampton, which stands opposite a deeply contrasting commission, Graham Sutherland's anguished *Crucifixion*. Then, in 1946, Irina gave birth to Moore's daughter Mary, and many drawings and sculptures of nursing mothers and domestic life followed, including his first life-sized version at the Barclay School of Art, Stevenage, near his home in Hertfordshire. In this case, as he had done since the late 1930s when planning a large bronze, Moore first made small-scale terracotta or plaster models – maquettes – which were also sometimes themselves cast in metal. Moore, now working almost exclusively in bronze, had come to prefer these maquettes to preparatory drawings, which he thought discouraged the all-roundedness he increasingly aimed at.

His king and queen are a quite obviously married couple, but this is a very different work from the earlier family groups. The piece was made in Queen Elizabeth II's coronation year, when royalty was a subject of great public interest. But as in his later *Large Arch*, Moore takes a sculpturally traditional theme – in this case the representation of rulers sitting in state – and universalizes it. The rulers are simplified so that their essential similarity to the broad mass of humanity comes to the fore. They sit in state, in judgement, but only in the sense that they are installed for the purpose by those they rule. This almost democratic view of monarchy was necessary to Moore, whose socialist coal-miner father had imbued him with political ideas not easy to square with the elaboration and privilege of the traditional British monarchy.

Honours, including royal ones, were showered on Moore throughout the last four decades of his life. He was invited to exhibit around the world. His sculptures were installed at the UNESCO headquarters in Paris and at Lincoln Center, New York, and year by year he won prestigious commissions, international prizes and high trusteeships. In this way he became the best-known British artist alive.

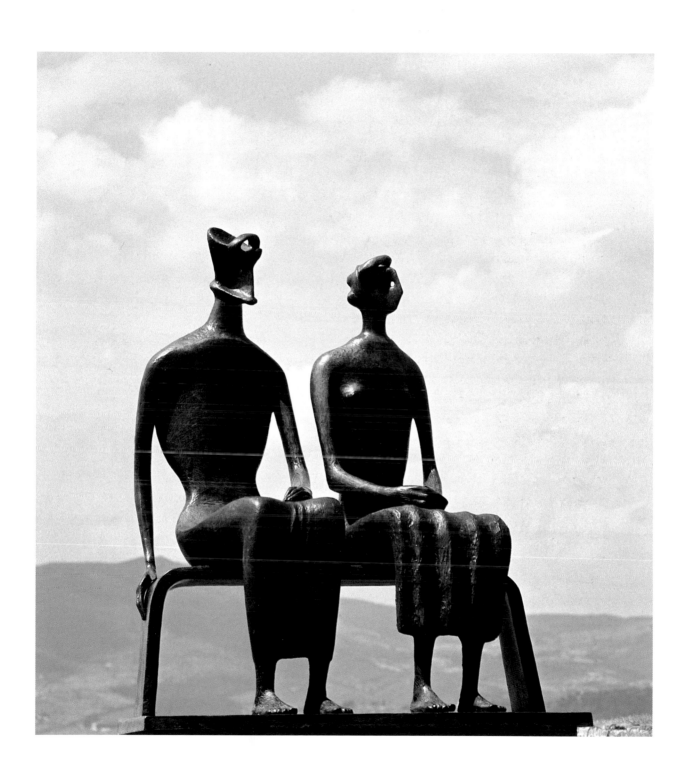

HENRY MOORE *1898–1986*

LARGE ARCH 1963–9

Henry Moore Foundation, Much Hadham, Florence / Courtesy of Scala

ARCHES are not only support structures or gateways but also ceremonial and symbolic, as in certain children's games or the arch of swords formed at a soldier's wedding. Artists have long designed arches for ceremonial occasions – Peter-Paul Rubens made them in the southern Netherlands, as did Inigo Jones in England. But these were painted and temporary structures for coronations and triumphal entries. In emulation of the Arch of Constantine in Rome, more permanent grand arches have been built as focal points for national pride, as in Paris's Arc de Triomphe or the gigantic self-glorifying Celebration Arch of crossed scimitars erected by Saddam Hussein in Baghdad.

Moore's six-metre-high arch, which weighs many tons, is as solid and permanent as one of these. Its meaning is nothing like them, though the sculptor certainly intended to project a sense of power. He said of *Large Arch*: 'I would like to think my sculpture has a force, a strength, a life, a vitality from inside it so that you have the sense that the form is pressing from inside trying to burst or trying to give strength from inside itself. This is perhaps what interests me most in bones as much as in flesh because the bone is the inner structure of all living form.'

The *Large Arch* looks organic, like a structure of bones. But it is also reminiscent of the circular monument at Stonehenge, Wiltshire, stones that were erected up to 5000 years ago for a purpose that is still a matter of guesswork. Moore himself said: 'As a young sculptor I saw Stonehenge and ever since I've wanted to do work that could be walked through and around.' The *Large Arch* takes on much of the unknowable, timeless quality of the ancient stones on which it is based.

By the 1970s Moore's fame had made him wealthy and he decided to endow the Henry Moore Foundation at his home in Much Hadham, Hertfordshire. This is where the *Large Arch* now is. But there are other versions: smaller castings of the maquettes, including one in the Museum of Modern Art, New York, and a second full-size variant which stands in front of the Bartholomew County Library, Columbus, Indiana, a building designed by the architect I. M. Pei. This *Large Arch* was a singular technical feat, being sand-cast in bronze in 50 sections by a West Berlin foundry. It was unveiled in 1971.

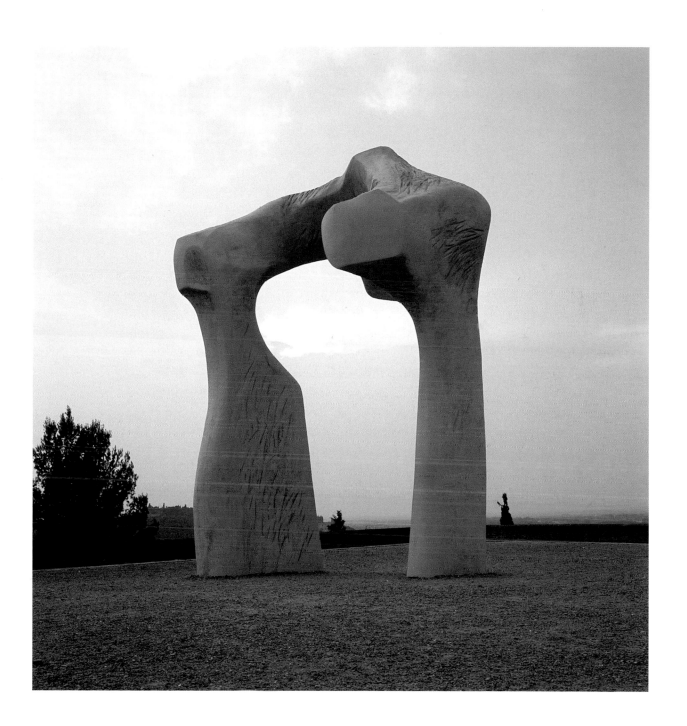

RENÉ MAGRITTE *1898–1967*

THE BALCONY 1950

Musée des Beaux Arts, Ghent / Courtesy of Scala

RENÉ Magritte was born at Lessines in Belgium and studied art in Brussels. He became an art student in 1916 and for a decade graduated through various painting styles before coming to the type of work which he would continue to produce for another 40 years. This is the disturbing, meticulously rendered image of some perceptual disturbance or disruption: a man looking into a mirror at the back of his own head; a rain of businessmen; an inverted mermaid with the legs of a woman and the head of a fish; a burning tuba.

Magritte once told how as a child he played with a little girl in an old disused cemetery, pulling open the heavy iron trapdoors of the vaults and climbing down to wander daringly among the crumbling coffins. Returning to the daylight, he would generally notice an artist or two painting scenes of the old cemetery. In the children's heightened state of fear and relief, these calm figures seemed charmed individuals and painting itself became for Magritte one of the magical arts, exercising powers not of mere illusion but of real transformation.

Magritte had in greater measure than most twentieth-century painters a radically transformative imagination. This was not like Picasso's, with its formal distortions and interest in the subversion of observed space. Magritte subverted reality in more conceptual ways. He inverted ideas, put images at odds with their titles and exploited dramatic alterations of scale, as when a green apple entirely fills an otherwise empty room. His experience of working in advertising gave him experience of the power of everyday images, especially when transferred to an unlikely context. Finally his painting technique was laboriously precise, representing objects with such accuracy that questions about how they were done are irrelevant.

The Balcony is a piece of dark humour with the conceptual simplicity of a cartoon. The skin is our outer covering, by which we are recognized but which, after death, is replaced by a coffin. Magritte's canvas is a replica of Manet's *The Balcony,* except that the members of the bourgeois family posing on their balcony – taking the sun or watching some passing event below – are already dead and in their coffins.

As in all the best Magritte paintings, there are multiple possible interpretations. Apart from the obvious forebodings about death, it is possible that Magritte was making a statement about the inertness of the academic painting that still informed the taste of the bourgeoisie, which was Magritte's own class.

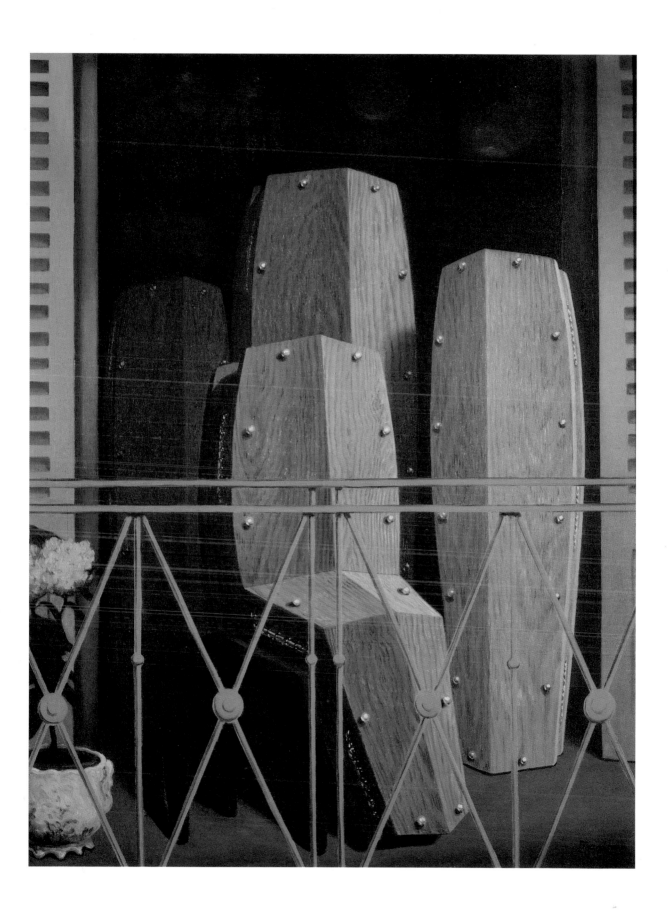

RENÉ MAGRITTE *1898–1967*

VIEW FROM ABOVE C.1950

Jeanneut Collection, Geneva / Courtesy of Scala

MAGRITTE was a surrealist but not entirely in harmony with the Paris surrealists, led by André Breton and Joan Miró, who were at the forefront of the movement in the 1920s and 1930s. A reserved and private man, Magritte never quite approved of their endless publicity stunts but nor, at a deeper level, could he abandon reason as they prescribed, in favour of total submersion in the unconscious. Magritte valued reason not as an absolute thing but as one of the most important quantities to be heaped into the scale when measuring out human experience. There is always a palpable tension in his work between the weight of reason and the insistent downward tug of madness.

View from Above, though perhaps more akin to conventional surrealism than most of Magritte's work, is nevertheless very characteristic. Reason says that the snow-covered mountains are far away, and yet the observer can affect and change them by conjuring faces and shapes from their icy and distant contours.

Magritte was obsessed with windows and balconies and would certainly have agreed with Breton that 'a picture is a window that looks out on something. The question is: on what?' And in an essay of his own, he gives a sort of answer to Breton's question: 'This is how we see the world, outside ourselves, and yet we have a representation of it inside us. In the same way we sometimes situate in the past a thing which is happening in the present.'

Magritte worked at various stages of his life in advertising and designed numerous posters and signs. He was also much influenced by films. The bowler-hatted men scattered throughout his work appear to be derived from a series of detective movies he liked, in which the plain-clothes police all dress identically in bowler hats and dark overcoats.

Magritte was extremely prolific but he did not mind repeating himself, so that there are many painted variations on the idea which prompted *View from Above*. Magritte's deliberate posture in his work is that of the naïve painter trying faithfully to reproduce reality. The distance by which he misses this supposed objective, measured by the insanity of the images actually produced, is of course a humorous one and Magritte surely means us to laugh, before we choke.

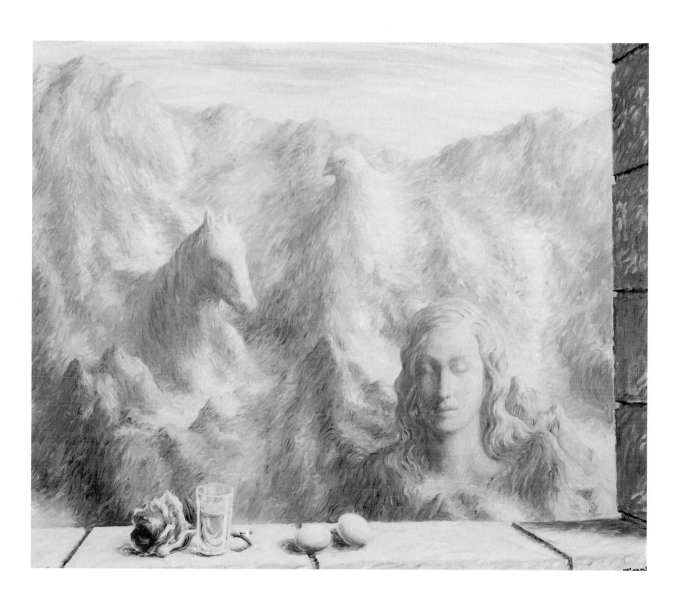

ALBERTO GIACOMETTI *1901–66*

DOG 1951

Collection Thyssen, Lugano / Courtesy of Scala

ALBERTO Giacometti was the child of the Swiss post-impressionist painter Giovanni Giacometti. The son was precocious at painting and drawing and attended art school in Geneva. Early on he emulated his father's style but by the age of twenty he was ready to supersede it. With his brother Diego he went to Paris, where Alberto intended to do only sculpture, studying cubism and African art and producing totemic works that are not at all like the characteristic modelled bronzes, of the human or animal figure, for which he is celebrated. At the same time they were important to him for their frontal and frank celebration of gender.

In the early 1930s, after a phase of producing plaques on which figures appeared as flattened abstractions, Giacometti made contact with the surrealists and began to treat the themes of unconscious sexuality, violence and fantasy. His forms were increasingly geometric and he also produced work such as *Surrealist Table* which approach installation art.

But by the mid-1930s Giacometti faced a dilemma. 'I saw afresh the bodies that attracted me in life and the abstract forms which I felt were true to sculpture, but I wanted the one without losing the other.' He resolved the problem by rejecting surrealism and returning exclusively to direct life-modelling of the figure. He struggled to recreate his vision, to keep to the optical scale on his retina. At times he felt tormented, even threatened by madness in front of his models. 'The exact limits, the dimensions of this being, become indefinable . . . The distance between one wing of the nose and the other is like the Sahara, without end, nothing to fix one's gaze upon, everything escapes.'

It was now that he began to model the stringy bronze figures for which he is known, building the clay up on a wire embrasure. Yet despite their brilliance and originality, it was not until the writer and existential philosopher Jean-Paul Sartre wrote an introduction to the catalogue of Giacometti's 1948 New York exhibition that he began to be truly well known. Sartre linked Giacometti's ascetic figures explicitly to existential anxiety, the desire for, and fear of, absolute spiritual freedom.

Giacometti saw his slinking, depressive bronze *Dog* as a self portrait. 'It's me. One day I saw myself in the street just like that. I was the dog.' It is one of his best-known pieces and recently at auction was sold for more than $15 million.

MARK ROTHKO *1903–70*

THE BLACK AND THE WHITE 1956

Fogg Art Museum, Harvard University Art Museums, USA/Courtesy of the Bridgeman Art Library

ROTHKO was a Latvian Jew, the son of a pharmacist, who migrated to America with his family at the age of ten, settling in Portland, Oregon. Young Marcus Rothkowitz was a very clever child and in 1921 was admitted to Yale University to pursue a remarkably wide course of study in humanities, mathematics and both human and physical sciences. But discovering that he wanted to paint, he left Yale prematurely in 1923 and went straight to New York. His awareness of world literature, science and psychology would, however, remain with him.

By the 1940s, Rothko's anxiety about world affairs, in particular the rise of Hitler and Stalin and the uncertain position of the Jews, led him to move away from representation into new symbolic areas. Later, after Auschwitz, only abstraction was of use any more. 'It was with the utmost reluctance that I found the figure could not serve my purposes . . . But the time came when none of us could use the figure without mutilating it.'

A letter to the *New York Times*, dated 1943 and signed by Rothko with Barnett Newman and Adolph Gottlieb, shows with what impassioned seriousness the abstract expressionists took their work: 'It is a widely accepted notion among painters that it does not matter what one paints, as long as it is well painted. This is the essence of academicism. There is no such thing as a good painting about nothing. We assert that the subject is crucial and only that subject matter is valid which is tragic and timeless. That is why we profess a spiritual kinship with primitive and archaic art.

'We favour the simple expression of the complex thought. We are for the large shape because it has the impact of the unequivocal. We wish to reassert the picture plane. We are for flat forms because they destroy illusion and reveal truth.'

By 1947 all trace of mythic imagery and of surrealism, with which he had played in a variety of ways, disappeared from Rothko's work. At the same time he ceased to affix conventional subject titles to it. He thought these were too prescriptive, locking the work into preconceived meanings or dictating responses. Once, when asked why he would never discuss the meaning of his work, he murmured: 'Silence is so accurate.'

This succinct phrase will serve for guidance as well as anything when looking at Rothko's most luminous works.

MARK ROTHKO *1903–70*

UNTITLED 1966–7

Private collection/Courtesy of the Bridgeman Art Library

THE greatest phase of Rothko's professional life was the 1950s, when the best of his 'signature' work was produced, the all-over abstracts on the subject of pure colour. The effect of these paintings is very hard to describe and, in a crowded public art gallery, not always easy to experience (knowing this, Rothko did not like his paintings displayed among the work of others). But it is always enhanced by a very long look, rather than the cursory glance most gallery visitors will give. Rothko sets his colours playing with and against each other in blurry rectangular veils, which sometimes recede from and sometimes float above the chosen ground. He was attempting to use paint as a trap to capture light and, in it, delight. He worked painstakingly upwards from the canvas, starting with a delicate underpaint and placing layer upon layer of pigment to give the painting surface its depth.

Like Clyfford Still, Rothko liked to work on canvases of great size, but he did so for a different reason. Still's aggressive posture towards the metropolitan world made him want to dominate and intimidate. Rothko's reason for making very large pictures was sweeter. 'I paint large pictures because I want to create a state of intimacy. A large picture is an immediate transaction: it takes you into it.'

These colour meditations of Rothko were for some years calm, assured canvases. But in truth his art was a defence against neurotic storms, and when this *Untitled*, from the mid-1960s, is compared with the superficially similar *The Black and the White*, a considerable increase in turbulence is observed. The higher they climbed in the pricing chart for works by living artists, the more the paintings darkened in colour and mood.

What had happened was that celebrity hit Rothko. He had all his life fought off depression but now he found his increasing fame and wealth an intolerable burden. He was not, in any case, good at living in material society. He could at times be warm and amusing, but just as often was savagely suspicious. Money bothered him terribly because possession of it fuelled his paranoia: somebody was always cheating him. He preferred not to think about money at all. In a money-driven culture, painting was one of the few things Rothko was not hopelessly inept at.

But after a decade of struggling with celebrity, Rothko one night in 1970 let his defences down. He took a bottle of barbiturates, slashed open an artery with his razor and died in a lake of his own blood.

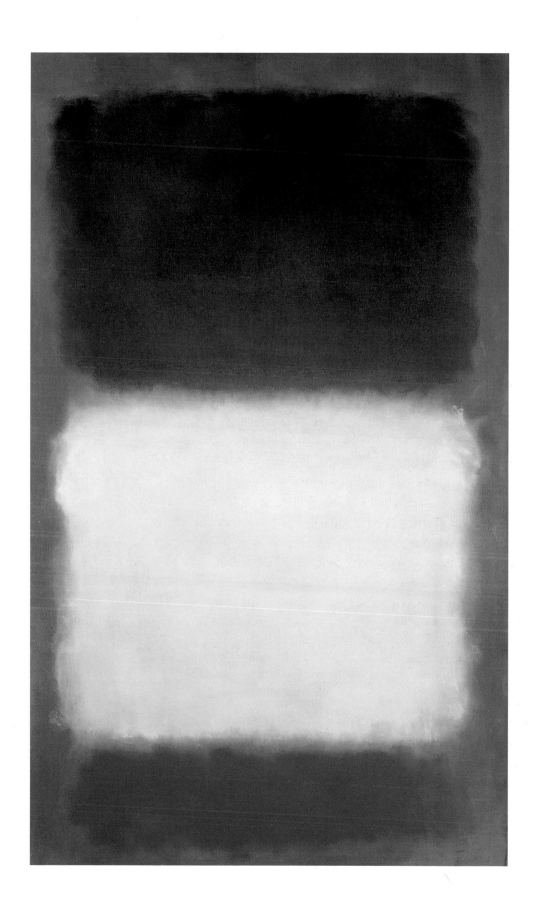

BARBARA HEPWORTH *1903–75*

MOTHER AND CHILD 1934

Wakefield Museums and Galleries, Yorkshire, UK / Courtesy of the Bridgeman Art Library

LIKE Henry Moore, Hepworth was from Yorkshire. After schooling in her home town of Wakefield and at art school in Leeds (with Moore), she had similar early success as a student at the Royal College of Art. Although she was five years younger, her career continued to unfold in parallel with Moore's, to the extent that this comparatively early *Mother and Child* might even be mistaken for one of his. Yet, although there was influence between the two artists, this was mutual. Both occasionally used taut strings, like birdcage wire or guitar strings, but it was Hepworth, not Moore, who in the early 1930s first pierced or drove holes through her solid carvings. Nor did the pair have mutual interests in all directions: to take two instances, Hepworth, unlike Moore, was left cold by surrealism, and she beat a steadier and more determined path into abstraction than he did.

Hepworth was successively married to the sculptor John Skeaping and the abstract painter Ben Nicholson, with whom she eventually settled in St Ives, Cornwall, keeping her home and studio there to the end of her life, despite divorce from Nicholson in 1951. After the 1940s she was increasingly drawn to crystalline and away from organic forms. She continued to carve in stone or wood almost exclusively until, in the mid-1950s, she began to work for the first time on a large scale in metal, now making harder-edged forms.

Hepworth's public work made her famous and she was invited to exhibit and undertake commissions the world over, including the Dag Hammarskjöld Monument *Single Form* which was installed at the United Nations in New York in 1964.

Mother and Child was made long before this and is a particularly personal and sensuous carving in Ancaster stone. During Hepworth's training in sculpture, students did not learn direct carving but rather learnt modelling. Hepworth, however, was determined to carve, receiving initial help from her first husband. This piece attests to her skill and sensitivity with a chisel when she was not yet 30, in a work which, despite its lack of surface features, expresses the real tug of mutual fascination between a mother and her baby.

Hepworth died in a fire at her St Ives home, which is now the Barbara Hepworth Museum, an offshoot of the Tate Gallery.

SALVADOR DALÍ *1904-89*

PORTRAIT OF JOSÉ TORRES 1920

Museum of Modern Art, Barcelona / Courtesy of Scala

THE *Portrait of José Torres*, a juvenile work influenced by Matisse, is far from typical of Dalí, the arch-surrealist and outrager who has been known to the world for three-quarters of a century. Dalí lived to become one of the most famous artists in the world, perhaps the most famous after Picasso. Yet the question of whether he was a genius, a madman or a fraud has never been answered.

It was a debate he himself was happy to foster. His sense of identity was disturbed from childhood and youth, much of which was spent at Port Lligat in north-eastern Spain. He was born in Figueres, Catalonia, the son of an atheist republican father and a devoutly Catholic mother, and was named Salvador in memory of a deceased brother he never knew. In 1921 he went to the Royal Academy of Fine Arts in Madrid but was ultimately expelled for insubordination – always a strong character trait of his. It was not until he encountered surrealism at the end of the 1920s that he found a cause which his chronic exhibitionism could happily serve.

In 1929 Dalí made the experimental film *Un Chien Andalou* with his friend Luis Buñuel, which abounded in weird images overtly derived from dreams. This was seen and liked by André Breton, the leading Paris surrealist, and Dalí was admitted into the fold. He quickly made his mark with his eerie renderings of the Spanish coast near his home, which he furnished with 'paranoiac elements' – rigid objects such as pocket watches incongruously melting under the sun and meaningless quasi-organic forms. Dalí was not afraid to hang out his sexual problems for all to see – impotence, masturbation guilt – merely translating them into dream imagery which he executed on the canvas with fanatical accuracy.

Dalí's subsequent career and his long marriage to his muse Gala have been exhaustively documented, not least by himself and not always accurately. He was one of the first celebrated artists deliberately to seek commercialization of his work, authorizing the copying and industrial manufacture of his sculptures, and producing signed prints for sale through mass-media channels. By the end, with Gala dead, it was suspected that he collaborated in the faking of his own drawings by signing hundreds of sheets of blank paper, on which others could draw or make prints.

185

ARSHILE GORKY *1904–48*

UNTITLED 1946

Private collection, Manza / Courtesy of the Bridgeman Art Library

ARSHILE Gorky was not his real name and nor was he (as he claimed) a cousin of the Russian author Maxim Gorky, whose surname he borrowed. Gorky was in fact Vosdanig Manoog Adoyan, from Turkish Armenia. At the age of fifteen he became a victim of the Turkish assault on his people, and during a 120-mile forced march his mother died in his arms. He and his sister made their way to America, where eventually, after adopting his new identity as a Russian émigré, he studied art to fulfil a personal project to preserve his mother's image in a portrait. This impulse was to lead Gorky into virtually re-enacting, in his own lifetime, the history of painting from the icon painters to the beginning of abstract impressionism.

Gorky attended art school in Rhode Island but set his own goals and was effectively self-taught. At first he studied and blended the look of his native culture's holy icons with elements of Titian and Picasso's blue period. He came to impressionism and Cézanne and then, in the early 1930s, cubism, of which he was such an enthusiast that he was known as 'the Picasso of Washington Square'. Within a few years he had passed through the influence of the surrealists, especially Miró, adopting 'biomorphic abstraction', in which meaningless shapes resembled life-forms. After this he developed an interest in Kandinsky. Throughout this time Gorky combined his brilliant gifts of mimicry with a deeply personal vision that transcended pastiche.

A fundamentally instinctive artist, Gorky rejected the mathematical precision of Kandinsky and Mondrian and found his own style very late in his short life. This happened in 1943 with a series of flowing, glowing works of rhythmical abstraction, always with highly charged figurative implications and underpinned by meticulous preparatory drawings. A dramatic personality who adopted and discarded roles in life as quickly as he had role models in his art, Gorky was now the acknowledged leader of the New York School, around which hovered many major painters in flight from the turmoil of Europe.

But in 1946 a series of disasters pushed Gorky, always a highly emotional personality, over the edge into despair. Despite his eminence he was not making money and some of his pretences had been exposed. A studio fire destroyed many canvases and drawings, he broke his neck in a motor accident and his marriage ended. Finally he endured an operation for throat cancer. With thoughts of the family destroyed by the Armenian holocaust ever haunting him, he hanged himself.

WILLEM DE KOONING *1904–97*

WAVE 1942–4

Smithsonian American Art Museum, Washington, DC/Courtesy of Art Resource/Scala

ALTHOUGH born in Rotterdam, de Kooning is a thoroughly American artist and one of the prophets of abstract expressionism. He was classically trained in the Netherlands and first worked as a commercial artist. In 1926 he stowed away on a ship to America and continued as a graphic designer and sign painter while making contacts on the New York art scene. In the mid-1930s, like Jackson Pollock, he was admitted to the Federal Art Project for struggling artists and worked on a series of mural projects, none of which was completed.

De Kooning remained simultaneously an abstract artist and a figure painter for most of his life and naturally the two overlapped. His series of pictures on the theme of 'woman', while clearly figurative, are concerned with the removal of modelling from the forms and the treatment of the parts of the body as plane surfaces – an extension of the process begun by Picasso in *Les Demoiselles d'Avignon*. By the same token *Wave*, still to be regarded as an early work, although de Kooning was 40 when he painted it, is one in which abstract forms and relationships seem to grope blindly towards identity. There are elements in the painting that might be marine life. An orange rectangle suggests a possible building and hence the seashore. A red circle may be the sun. 'Even abstract shapes must have a likeness,' de Kooning once stipulated. But likeness is not identity and he was always a teasing, ambiguous artist when it came to the correspondence between abstract and figure painting.

The energy in the piece – the energy which prompted the critic Harold Rosenberg to invent the term 'action painting' – comes from de Kooning's underlying drawing, with its easy, swooping formations which generalize the smaller, more specific forms de Kooning had admired in the work of Miró.

'Art never seems to make me peaceful or pure,' complained de Kooning. 'I always seem wrapped in the melodrama of vulgarity.' This is his own way of describing the quality in his work which is called by critics 'gestural': it packs crude emotion into the brushwork and the drawing. There is also a hint here that he felt at times too versatile and responsive to outside influences to be his own man. But de Kooning had a huge personal impact on the art scene, bringing into being not only hordes of followers and imitator but also a significant reaction in the cool, impassive work of Johns, Rauschenberg and the 1960s.

CLYFFORD STILL *1904–80*

JAMAIS (NEVER) 1944

Peggy Guggenheim Foundation, Venice / Courtesy of the Bridgeman Art Library

STILL was from farming stock and grew up close to the prairies of southern Alberta, in Canada. He was influenced by the vast, bare, windswept horizon of the plains, against which he saw life arising vertically and with aggressive self-assertion. For most of his career, Clyfford Still's paintings reflect this stern pattern, continually insisting on the vertical in vivid, doom-laden colours, which impose on the canvas like a moral weight.

While working as a teacher at Washington State College, Still the painter had already made his mark in the West. He turned his back on what he thought of as the decadent modernism of Europe, producing dramatic symbolic canvases, visions of prairie landscapes that are riven always by dark, rearing verticals. He would introduce mysterious presences into these, such as the small owl perched at the top of the monolithic, blasted tree in *Jamais*. As Still increasingly turned to abstraction during the 1940s, he carried these same habits along with him.

In the mid-1940s Still reached New York, becoming a leading force, with his friends Rothko, Newman and Pollock, in what became the New York school of abstract expressionists. The four shared the view that paint carries not meaning but feeling, not only in the choice and placement of colours, but 'gesturally' too, in the way they are applied by the artist's hand. Yet there was a dogmatic and almost messianic quality to Still which set him apart from the others. 'I had made it clear,' he said of the time when he first came to New York, 'that a single stroke of paint, backed by work and a mind that understood its potency and implications, could restore to man the freedom lost in twenty centuries of apology and devices for subjugation.'

Still did not think much of political or religious systems. He was an individualist who hated the cowed, mechanized conformity of the masses and professed instead spontaneity and honesty. Like the other abstract expressionists, he created works on a very large scale, which, along with the uncompromising jaggedness and singularity of so many of the forms, tends to maximize their emotional punch.

As he grew older, Still repudiated the idea that his abstracts were disguised landscapes. He wanted his paintings seen as experiences in their own right, without the benefit of any external associations. 'I have no brief for signs or symbols or literary allusions,' he said. 'They are crutches for illustrators and politicians, desperate for an audience.'

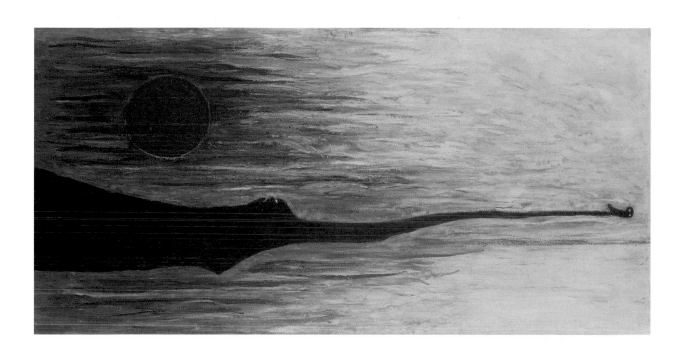

FRANCIS BACON *1909–92*

STUDY FOR VELÁZQUEZ POPE 1953

Collection of Modern Religious Art, Vatican City / Courtesy of Scala

BACON was born in Dublin of English parents. He suffered from asthma as a child and had only sporadic schooling. As an artist he taught himself while, in a small way, making furniture in London. It was not until the Second World War that he took up full-time painting.

Bacon's vision is a bleak one. His figures are distorted in a way that suggests hideous disfigurement or genetic malformation. They twist and writhe as if in physical pain, or they scream from mental torment. A menacing, isolating darkness surrounds them.

All this violence is done with a fluent, confident brush. In Bacon's own words, painting should always strive 'to make idea and technique inseparable. Painting in this sense tends towards a complete interlocking of image and paint so that the image is the paint and vice versa. Here the brushstroke creates the form and does not merely fill it in. Consequently every movement of the brush on the canvas alters the shape and implication of the image.'

Bacon's work used photographs as the basis for most paintings: a still from Eisenstein's film *The Battleship Potemkin*, a sequence showing humans and animals in motion by Edward Muybridge, a medical textbook on radiography. He also began to rework old masters from photographs.

This study is an early stage of the artist's extraordinary adventures with Diego Velázquez's *Portrait of Pope Innocent X*. Velázquez's work is one of the supreme portraits of the seventeenth century, a penetrating study of a bruiser in the robes of a pope. Bulky, louring and sweating, he perches suspiciously on his throne as if debating with himself how best to strike at his enemies. In Bacon's hands Innocent shrinks to one trapped in a twentieth-century existential nightmare. His throne becomes as inescapable as a wheelchair, or the bondage-throne of a penitentiary gas chamber. His mouth is often screaming. This is a more conventional preparatory study, with which Bacon goes through the process of getting to know his subject. But even here the hunched figure, placed uncomfortably off-centre against a background of hellish darkness, rehearses the artist's lifelong preoccupation with loneliness. The pattern of self-disgust and horror is less evident.

Bacon achieved considerable fame in his lifetime and was almost a household name, the screaming pope becoming a particular point of public identification. He remained independent of any group, movement or artistic message, saying simply: 'I have nothing to express.' On this point, most of those who look at his savage, grotesque paintings are forced to disagree.

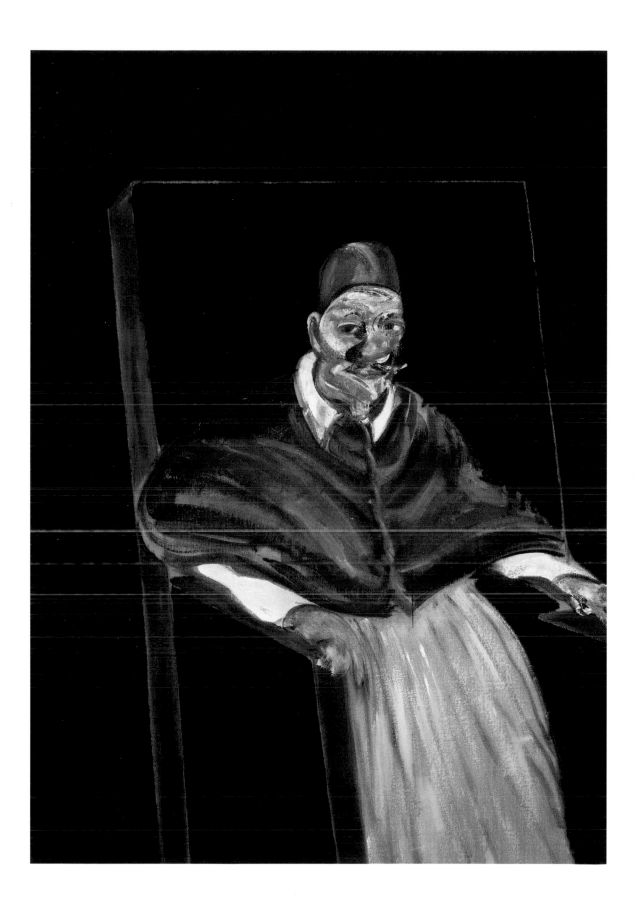

JACKSON POLLOCK *1912–56*

ENCHANTED WOOD 1947

Guggenheim Museum, Venice / Courtesy of Scala

AFTER 1947, and over the next five years, Pollock made his name with his 'drip painting' or, as one critic, not entirely with Pollock's endorsement, called it, 'action painting'. One of his objectives certainly was a more 'active' painted surface enabling him to claim that although he remained a subject painter, his subject had become the process of painting itself. At the same time he used fewer Jungian archetypes in the titles of his works, drawing his ostensible subjects from the natural world or, in some cases, merely giving them numbers.

Pollock began one of these paintings by unrolling an unstretched canvas across the studio floor or pinning it on the wall. He liked to have a hard surface underneath. He was dissatisfied by the discontinuous nature of brush painting, whereby the brush is successively reloaded. This forces a break in the painted line, whereas Pollock wanted a free and continuous line. To this end he began to pour paint from a can, usually with a straight stick protruding from it so that the paint flowed continuously down the stick and on to the canvas. He also sometimes used a heavily loaded brush and even a turkey-baster filled with paint to create the flowing, meandering, looping black line whose tracery is the structural element in so many of these works. The final effect of the line was controlled by various factors. The relative thinness or viscosity of the paint medium and the angle of the stick determined the speed and volume of the flow. At the same time the artist's arm and body movements gave it shape and direction. Film of Pollock in action show the artist's rhythmical, almost dancing movements, very often drawing the lines, like handwriting, from left to right.

Around and between this line, Pollock would place additional colours by splashing, flicking, spattering and even dabbing with a brush. In many cases he also embedded ordinary objects (sometimes by emptying his jeans pockets on to the canvas): coins, matches, buttons, cigarette butts. This process is derived from cubist collage, with its notion of varying the depth of the picture medium and giving an element of relief to the surface, which was also relief from mere paint. Yet in Pollock the objects themselves are often almost invisible, sunk and lost in the welter of pigments.

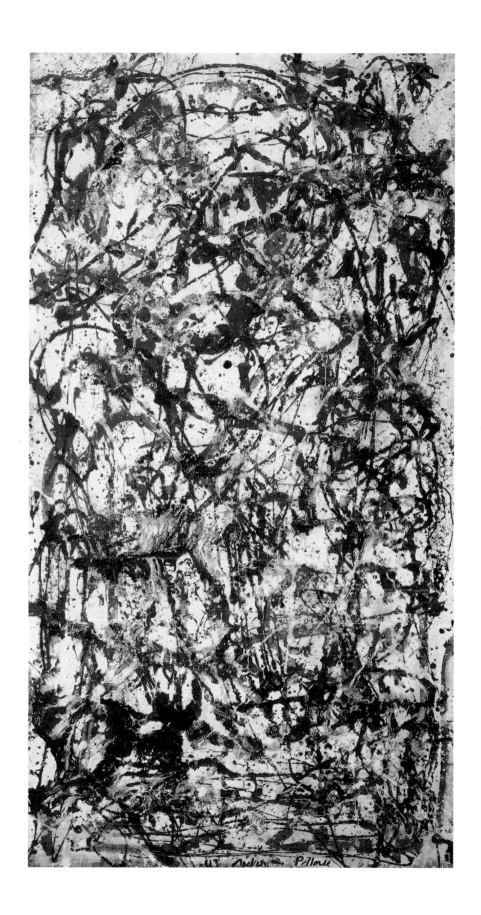

JACKSON POLLOCK *1912–56*

LAVENDER MIST 1950

National Gallery of Art, Washington, DC

POLLOCK'S painting became larger as his reputation increased. But so did the burden of his position as the leading figure among a new generation of American-born artists. Pollock did not really enjoy his celebrity. He was an intense, unhappy individual, tortured by questions of identity, ill at ease with himself and unsure of his relationship with his art. When he poured paint over a canvas on the floor, he was pouring out some of this anxiety. 'On the floor I am more at ease. I feel nearer, more a part of the painting, since this way I can walk around it, work from the four sides and literally be in the painting. This is akin to the method of the Indian sand painters of the West.'

After his earlier flirtation with surrealism, Pollock in these paintings always ran the risk of being seen as an exponent of randomness or pure automatism in art. He denied this. 'When I am painting I have a general notion as to what I am about. I can control the flow of paint. There is no accident.'

Lavender Mist is a large piece (207.5 x 285.5cm), created in oil, enamel and aluminium paint on canvas. It is a perfect example of his 'all-over' style, which he had practised long before he began to drip paint. As if afraid of voids, he works in careful rhythms across the entire length and breadth of the canvas, covering it entirely. This has the effect of destroying unitary composition in any traditional sense and giving the impression that the canvas is simply a visible part of an infinite painting. 'There was a reviewer a while back,' said Pollock once, 'who wrote that my pictures didn't have a beginning or an end. He didn't mean it as a compliment but it was. It was a fine compliment.'

One particularly enjoyable aspect of Pollock's painting is that it gives the opportunity to see things in it, entirely unintended by the painter, as the viewer's fancy directs. This can sometimes result in interesting finds, such as when shapes and resemblances loom out from between the meandering lines, or when the crazed detail resolves itself into geoscapes of cities seen through the camera of some orbiting satellite.

Pollock's life ended tragically and prematurely. After 1953 he felt he had exhausted the potential of drip painting and had started to repeat himself. Unsure of his new direction, labouring under the weight of his role as a leading artist, he resumed heavy drinking and was killed in a motor accident in the summer of 1956.

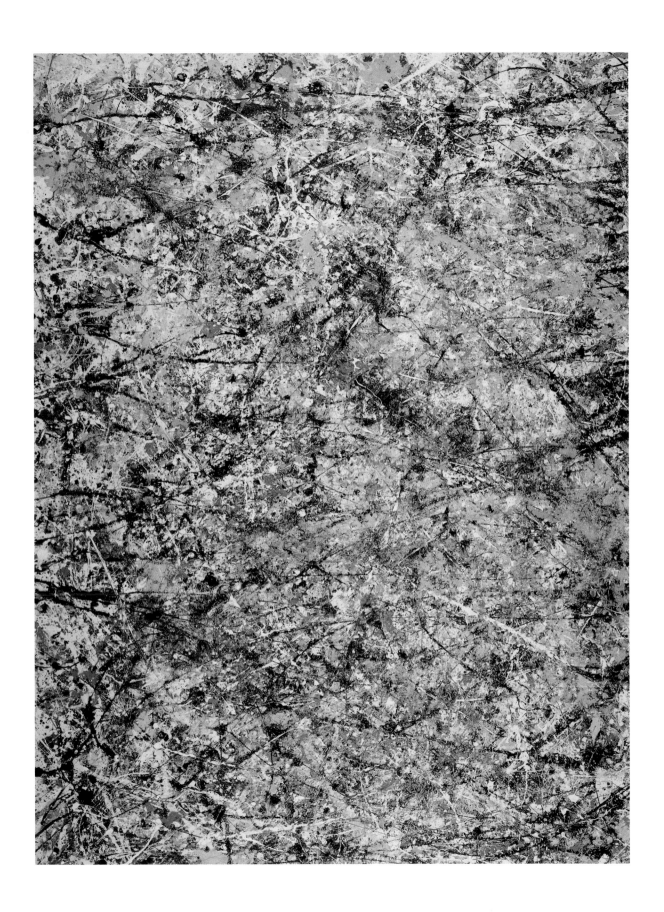

JACKSON POLLOCK *1912–56*

BROWN AND SILVER 1951

Thyssen-Bornemisza Museum, Madrid / Courtesy of Scala

ONE of the earliest American-born artists to be of real significance in modern art, Pollock was born in Cody, Wyoming. His childhood was exceptionally restless, with nine changes of address as the family shifted between California and Arizona. Stimulated by his elder brother into an interest in painting and sculpture, he studied art in Los Angeles and in 1930 migrated to join his brother in New York's Greenwich Village, to continue his studies and to paint. For five years Pollock was the epitome of the penniless artist. Then, in 1935, he benefited from a New Deal programme, the Federal Art Project run by the Works Progress Administration, which provided artists with work as mural and easel painters, but also with enough free hours to develop their own creative ideas.

Pollock's early painting was influenced by the revolutionary Mexican artists, such as the muralist José Clemente Orozco, and was figurative, yet introduced themes which he would return to many times as an abstract expressionist, such as four-footed animals and moonlight. The treatment of paint was tempestuous, sometimes bordering on violence.

Treatment for alcoholism resulted in Pollock's undergoing Jungian analysis after 1938. With its orientation towards archetypal symbols in the unconscious, this discipline provided an important strand in Pollock's understanding of his art. Other intellectual interests in the background of his work were theosophy, to which he had been introduced by his first art teacher in Los Angeles, and surrealism with its interest in automatism.

Through his girlfriend and, later, wife, the painter Lee Krasner, Pollock met the New York art teacher Hans Hofmann in 1942. Hofmann was a well of knowledge about the European modernist tradition – it was said he could tell you more about Matisse than Matisse – and Pollock drank deep. He became obsessed with Picasso, and in particular with *Guernica*, Picasso's large anti-Franco canvas painted in 1937. He still used recognizable Jungian/surrealist imagery – Tower, She-Wolf, Moon-Woman – but was experimenting in the application of pigment. He first poured paint to create part of his 1942 painting *Male and Female*.

The idea gradually emerged of a form of monumental abstract painting which was also subject painting. This would go beyond cubism in being entirely non-figurative, yet deal with large themes through the freeing of the spontaneous, unconscious mind, as the surrealists had been doing. The difference was that now the unconscious would be expressed through technique, through pouring, dripping and splattering as much as through brushwork.

✣ JACKSON POLLOCK

AD REINHARDT *1913–67*

UNTITLED 1940

Smithsonian American Art Museum, Washington, DC / Courtesy of Art Resource / Scala

REINHARDT was born in Buffalo, New York, and received a broad education in the humanities before he decided to become an artist, going on to study at the American Artists' School in Manhattan. He was an abstractionist from the first, as well as subscribing to the leftish political views of the American avant-garde in the 1930s. Reinhardt in this phase mixed Cubist-inspired interlocking pieces of colour with more curvy, organic forms, often using collage.

He worked in commercial design during the 1940s and became a cartoonist for the radical *PM* newspaper but by the mid-decade he was well enough known to be exhibiting and attracting collectors.

Reinhardt's personality was caustic and his relationship with painting was complex and problematic. He hated emotion and tradition, pursuing an aesthetic 'without illusion, allusion, delusion'. 'All art,' he said, 'is art-as-art and everything else is everything else', making a much more fundamental break with representational painting than cubism had ever done, because it makes a final separation between art and life.

There was a part of Reinhardt that wanted, like his contemporaries Barnett Newman and Mark Rothko, to make abstract art that could serve in the same way as Mondrian's – as objects of contemplation. However, it was not theosophy but the ancient oriental religions that pointed the way. Newman and Rothko developed into abstract expressionists, a school that Reinhardt thoroughly disapproved of for its personality cults and sentimentality, which he lampooned in his cartoons. His own direction was reminiscent not only of Mondrian and his grid structures, but also of the suprematist Kasimir Malevich. Like Malevich, Reinhardt produced proto-minimalist canvases in near monochrome. He received encouragement from Josef Albers, of whom Reinhardt was for a short time a teaching colleague at Yale, and who was pursuing an almost parallel path.

Reinhardt's series of paintings in the 1950s such as *Red Painting* and *Blue Painting* – overlapping rectilinear areas of colour, very close to each other in tone but with clearly defined edges – owed much to Albers but they culminated in something that went much further in the direction of minimalism. These are his series of all-over *Black Paintings*, whose purpose may have been to some extent satirical gestures towards the absurdity of art. They are square canvases on which equal-sized internal squares are painted in shades so close to black as to be almost invisible.

LUCIAN FREUD (1922–

GIRL WITH BERET 1951

Manchester City Art Galleries, UK/Courtesy of the Bridgeman Art Library

FREUD, who was born in Berlin, is the son of the architect Ernst Freud and the grandson of Sigmund Freud. With a Nazi takeover of Germany imminent, Ernst took his family to England and Lucian Freud became naturalized in 1939.

After war service, Freud settled in Paddington, an area of London's inner city which has remained his home. He passed through a period of surrealism, a movement that owed so much to his grandfather's ideas, then settled into the urban realism which became his signature idiom: the undeniably glum depiction of Paddington interiors, still lives and carefully realist portraits.

In *Girl with Beret* there is strong emphasis on the drawing and the palette is typically low key, with greys and browns predominating. Here Freud's debt to the great German portrait painter Hans Holbein the Younger (1497–1543) becomes apparent. Holbein did his best work at the court of Henry VIII and Edward VI in England, and was well represented (as Freud himself now is) in the collection of London's National Portrait Gallery. There is further evidence of the debt to Holbein in Freud's palpable sincerity and the care with which he tries to reach Holbein's standard of unblinking truth. The critic Herbert Read called Freud the Ingres of existentialism, but it might be said with equal accuracy that he was the Holbein of post-war austerity.

A key canvas of the era is *Interior in Paddington* (in the Walker Art Gallery, Liverpool), which has the dishevelled, bespectacled photographer Harry Diamond posing in a bare room. He looks every inch the 'kitchen-sink' anti-hero of the time, complete with grey gabardine raincoat and untipped cigarette. Beside him stands a tall and exotic houseplant – a stagy juxtaposition and one of the surrealist traces that persisted in Freud's 1950s painting. Another characteristic work, *Girl with a White Dog* in the Tate Gallery, is also a carefully staged and detailed image, this time of Freud's wife Kathleen sitting on a bed, with her legs curled under her and a bull terrier resting its head on her thigh. Tensely, apparently with no expectation of approval, she exposes one breast while covering the other, although it is already concealed under the dressing gown, with her hand.

Even more than in *Girl with Beret* the face expresses vulnerability, which reflects the awkward nature of the pose. It is painted with Freud's own form of reserved tenderness, particularly evident in its highly meticulous detailing, especially around the eyes.

LUCIAN FREUD *1922–*

DOUBLE PORTRAIT 1988–90

Private collection / Courtesy of the Bridgeman Art Library

FROM the 1960s onwards, Freud's brushwork became more obvious and expressive as he lost interest in surface realism and abandoned the delicate sable-tipped brushes with which he had previously painted in favour of more robust bristles and a palette knife. He still confined himself indoors so that even his cityscape canvases are window views. But Freud has been largely content to remain within his own studio world, an apparently dull and tatty place but one that at times becomes so intense that it seems to shut out other realities.

This intensity is all Freud's. He invites his models in and studies them, most often with their clothes off, though sometimes clothed in simple garments, as here, playing their flesh against the browns and greys, the dust, smoke and harsh light which is all that he provides by way of an environment. The subjects lie on studio beds, asleep or gazing into space, their nudity illuminated, apparently, by unsoftened electric light bulbs. They seem exhausted, used-up figures, good for nothing except to be the artist's models, yet indifferent to the process of being painted.

It may be indicative that Freud prefers to know, or get to know, his subjects intimately. In the early 1970s he began a series of over 1000 portraits of his mother in twelve years, among which are some of his finest portraits. He has also painted his children and artist contemporaries such as Francis Bacon and Frank Auerbach. In the 1980s Freud's ideas have expanded into larger works, as well as into the smaller-scale work of etching, which he learnt in the 1940s but did not return to for 30 years.

'I want paint to work as flesh,' he said in an interview. 'I would wish my portraits to be of people, not like them . . . As far as I am concerned the paint is the person. I want it to work for me as flesh does.'

On the changing role of the face in his portraits, he has said: 'Normally I underplay facial expression when painting the figure, because I want expression to emerge through the body. I used to do only heads but came to feel that I relied too much on the face. I want the head, as it were, to be more like another limb.'

ELLSWORTH KELLY *1923–*

BLUE, RED 1964

Detroit Institute of Arts / Courtesy of the Bridgeman Art Library

KELLY came from Newburgh, New York, and studied technical art until called up for war service in 1943. In the army he was assigned to the camouflage unit. He served in France and after demobilization returned there, using Paris as his European base for six years. It is known that he visited Colmar in Germany to see Mathias Grünewald's *Crucifixion*, whose multi-panel format he was to apply to his own abstracts at various stages, though the content of his and Grünewald's work could hardly be more at odds.

Painting in Paris in the late 1940s and early 1950s, Kelly began to concentrate on abstraction. He was convinced that all the elements of the abstract canvas should be derived from observed reality and found his own inspiration in the contemporary architectural forms of the city under post-war reconstruction. He would take photographs of colour effects and forms and used them as specific reference points for making painted wooden reliefs.

This painting was one of the works that represented Kelly – long after he had returned to the USA – at an exhibition with Frank Stella, Al Held and other abstract artists mounted in 1964 at the Los Angeles County Museum of Art. These painters were generally older than the pop artists, many being then around the age of 40. But they had reacted with equal decisiveness against the gestural painting style of Pollock, Still and de Kooning, developing instead a hard-edged, impersonal look which was dubbed by one of their most vocal supporters, the powerful critic Clement Greenberg, 'post-painterly abstraction'. This was, however, not a school, a wave or a movement, but a convenient and transient descriptive label. Greenberg undoubtedly spotted a new development, but post-painterly abstraction seems now a kind of first staging post, or even just a finger-post, on the journey away from abstract expressionism. Many forking paths were trodden by artists throughout the 1960s and 1970s, and in its clarity of purpose, logical concerns and impersonality, the work of Kelly and his fellow 1964 exhibitors points the way to several of the more important ones, from pop and op to minimalism and conceptual art.

ELLSWORTH KELLY *1923–*

FOUR PANELS: GREEN, RED, YELLOW, BLUE 1966

Christie's Images, London / Courtesy of the Bridgeman Art Library

KELLY'S concern again and again in these 1960s paintings is the centred and symmetrical play of flat shapes with crisp edges and of very clear fields of saturated colour. And once again with *Four Panels* Kelly's title reveals that it is colour he is most interested in. Yet this is a more complicated object than a painting, a reminder that Kelly was also a sculptor and installation artist.

The quartet of identically sized rectangular panels are each allotted a different monochrome colour – the three primaries and the most important secondary – framed in metal and attached in a regular row to an aluminium groove in a wall covered in grey-brown textile. The work has elements of relief in it, as well as of installation art – which can be defined as the related deployment of disparate objects and materials in three-dimensional space.

This question of whether it is a painting, a sculpture or an installation lends the piece particular interest, and this is fortunate because it is hardly a seductive work. Between the individual colours Kelly has chosen – each of a rather plain intensity – it is not easy to see relationships. To stand in front of the painting feels like a dull routine, a little like inspecting ceremonial soldiers. The primary colours are solid and self-explanatory, standing proud of each other and united only by the fact of all being colours together. Green stands beside red to which, since there is no red in it, it is complementary. But there is no inflection among these guardsmen of the spectrum, and no real individuality. There is just the rather inert statement of the colours as given quantities, neither a vital force, as Pollock saw them, nor a form of spiritual nourishment, as in Mondrian.

In his later career Kelly developed his two-dimensional sculpture – flat cut-out forms silhouetted against white walls – and irregularly shaped paintings, still consistently abstract. In the 1970s he also made paintings in which curves play a more important part, no doubt in response to the fact that he was now living in the countryside of upstate New York. Kelly's sculptures at this time also changed, stressing form and material (steel, aluminium, stainless steel and bronze) rather than colour. He was also busy in the 1980s with public commissions for Lincoln Park, Chicago (1981), Dallas (1985) and Barcelona (1986).

ROY LICHTENSTEIN *1923–97*

IN THE CAR 1963

Private collection / Courtesy of the Bridgeman Art Library

LICHTENSTEIN was born in New York City and studied at Ohio State University, where H. L. Sherman was teaching an influential course on visual psychology and optical illusion. His early work was in the American realist tradition, gradually giving way to a more modernist approach under the influence of cubism and abstract expressionism. He also experimented with found objects.

In the 1950s he worked as a freelance commercial and graphic artist before himself becoming a teacher, first at New York State College of Education and then at Rutgers University. In 1964, when Lichtenstein's career as a full-time artist began, he had already made a stir with his large hand-painted canvases reproducing commercial comic-strip frames.

Lichtenstein described in detail his method. He drew a small picture of a size to fit into his small projector so that the drawing could be thrown on to a large canvas. 'I don't draw a [pre-existing] picture in order to reproduce,' he said, 'I do it in order to recompose . . . [But] I try to make the minimum amount of change.' He pencilled an outline of the projection on the canvas, making adjustments as he went. The areas of Ben Day dots – in imitation of the method of cheap newsprint or commercial colour printing – were stencilled on first, using a toothbrush and a metal mesh screen. Any white areas were masked off using tape in advance. He preferred to use Magna colour, a type of acrylic, because it is removable by turpentine, leaving no record of any changes. The colour was thinly applied and the weave of the canvas was clearly visible when seen close to.

It is notable that Lichtenstein was selective in his use of dots. All the areas in this painting, except the skin tones and the pale light reflected from or through the car window, are painted in solid colour or black.

Lichtenstein always insisted that his work obeyed pictorial rules imposed by himself, and that these were independent of the pictorial source. He wanted, he said, to show that pictures do not reflect an external reality, but instead create their own reality – an 'ideal' reality, not in the sense that it is a version of the artist's distilled desire, but because it need have no reference to the material world outside the artist's (or viewer's) mind. This lesson had long been absorbed by artists in respect of abstract art: Lichtenstein's contribution, however, was highly significant in that it applied the same principle to figurative imagery.

ROY LICHTENSTEIN *1923–97*

ANXIOUS GIRL 1964

Private collection / Courtesy of the Bridgeman Art Library

MUCH comic-strip art is confectionery for the eyes, and Lichtenstein very much liked to reproduce this saccharine aspect, as he does with such panache here. But his stereotypical 'anxious girl' looks from the picture without a context, leaving the viewer to guess her dilemma.

At other times Lichtenstein would portray the kind of mechanized violence that was a mainstay of comics in the 1950s and 1960s, as in his widely known *Whaam!* (1963), a two-canvas work in which a US airforce jet fighter downs an oncoming plane with a well-aimed burst of rocket fire. Here the image does not come from any printed source but is invented by the artist, although it is a completely convincing pastiche, complete with the bubble containing the pilot's thoughts and the letters of the title bursting upwards with the flames of the burning enemy aircraft.

Lichtenstein aimed to make his paintings appear programmed ('I want to hide the record of my hand,' he said) but it is important to note that his underlying drawing was carried out with notable fluency. This usually shows up in several areas of the finished canvas, for instance in any hair or shading.

Apart from the legendary comic strips, Lichtenstein based his works on a variety of advertisements, flyers and commercial packaging, especially where these imitated work by famous artists or reflected clichés that he thought merited re-examination.

The question of originality (or lack of it) tends to crop up in discussions of this artist. Was he just copying? Is his an art of 'found objects'? He said no. As has been mentioned, he sometimes used no specific source at all, and when he did, he always transformed it in some way. On the other hand, one of the points of pop art was to overturn the idea of unique expressiveness, of 'genius', which the romantics accorded to artists, musicians and writers and which gave a privileged place (and a very high price) to 'original' works 'by the artist's hand'. Lichtenstein's work creates a powerful paradox in this context. He turned out hand-made works that are almost indistinguishable from reproductions and have, in the form of posters and prints, actually become best-sellers in the mass market. The final irony of this is that his original works are found among the highest-priced canvases sold in the last 40 years.

ROBERT RAUSCHENBERG *1925–*

RESERVOIR 1961

Smithsonian American Art Museum, Washington / Courtesy of Art Resource / Scala

ROBERT Rauschenberg, one of the most adventurous and playful of American artists, was born at Port Arthur, Texas. During the war he was a nurse in a US navy psychiatric hospital and afterwards went to Black Mountain College in North Carolina, where he was taught by Josef Albers. Rauschenberg often paid tribute to Albers, who, he would say, was his only important teacher, endowing him not with a style but with an attitude. This was to keep his personality out of his work, which should not be an expression of reality but a discovery of it. Rauschenberg, like many pop artists who followed him, did not make art so much as choose it.

For this reason he developed in the 1950s the idea of 'combine painting', in which common objects found in the environment were fused into the painting. This went much further than Pollock's buttons and dimes and owed a debt to Marcel Duchamp, who was still living and working in America. In 1955 Rauschenberg produced his *Bed*, on which pillow, linen and blankets, made up as a bed on the canvas, are daubed and defiled by thick, dribbling splashes of different-coloured paints. The list of media and supports used in *Odalisk* (1955–8) is an even odder one: oil, watercolour, pencil, fabric, paper, photographs, metal, glass, electric light fixtures, dried grass, steel wool, necktie on woodstructure with four wheels, plus pillow and stuffed rooster.

Rauschenberg now became a leading player in the game of outraging middle-class taste and sensibility. In 1953 he asked the revered abstract expressionist Willem de Kooning for a drawing specifically so that he could rub it out and exhibit it as a work of his own, *Erased de Kooning Drawing* (1953). In his later *Monogram* (1955–9) he takes a stuffed goat, found in a Manhattan shop window, and jams it half-way through an old motor tyre – a defiant image of homosexuality, at a time when that was a subject not openly discussed.

Reservoir, one of his last combine paintings, incorporates the harvest of a plausibly productive morning of beach-combing: a couple of clock faces, a pram wheel, driftwood and other discarded rubbish. It does not intend to say anything, it is just there, lodged, as Rauschenberg might have put it, in the gap between art and life.

ROBERT RAUSCHENBERG *1925–*

SLIPPER 1984

Private collection/Courtesy of the Bridgeman Art Library

IN the late 1940s Rauschenberg had produced, with his wife, the artist Susan Weil, a series of *Blueprints*, including one for which they asked a nude model to lie on a sheet of light-sensitive paper in a dark room, before shining a bright light on her. This is the first of Rauschenberg's works to combine more than one medium – painting, photography, printmaking – within the same frame.

In the 1950s he began to use a method of transferring newsprint to canvas by what he called transfer-drawing, a process whereby the newspaper or magazine cutting was first treated with solvent and then rubbed on to the canvas. He also began at this time to use the photo-mechanical method of silk-screen printing, soon to be a favourite technique of pop art. After a period in the 1960s, during which he developed an interest in performance art with the Merce Cunningham Dance Company, and then of dreaming up three-dimensional installations, Rauschenberg returned to making framed pieces mixing found elements with brushwork in a mixture of printing, photography, graphics and painting.

Slipper is a long rectangular canvas divided at half-way by a horizontal line. On the top half Rauschenberg has transferred a shot of a yacht's mast and sail, a close-up of the business end of a long-handled brush and (in red) a group of people standing, fishing or playing on a quay. Below are other photographic images of various sorts, all overlapping each other. The whole is decorated here and there with a brush dipped in acrylic colours. There is no reason to suppose that the images were carefully selected in any thematic way. They simply 'presented themselves' to the artist, who used them as he found them.

Rauschenberg is too much the individualist to be easy to categorize. He was one of those, like Jasper Johns, who came to despise abstract expressionism with its tortured seriousness which all too easily crossed the borderline into absurd pretension. He linked back to European ideas which, despite the fame and notoriety of Duchamp and Dalí, had hardly taken root in America: those of Dada and surrealism. The importance to him of surrealism must not be overstated, however. Rauschenberg appears never to have been much interested in the unconscious. His field of action is the ingenuity of the conscious mind in all its multifarious connections and combinations. If his body of work seems disparate, even restless, it points the way to many important developments in art after 1960.

YVES KLEIN *1928–62*

BLACK AND ORANGE WALL C.1960

Collection Thyssen, Amsterdam / Courtesy of Scala

KLEIN was not only a painter but a sculptor, a legendary performance artist and a judo black belt. He was born in France; and both his parents were painters, his mother Marie Raymond being an abstract artist of note in the 1950s.

Klein first came to public attention through his all-blue *Monochrome Proportions*. These were large canvases painted in a single shade of colour: red, purple, orange, yellow and, above all, blue. Later he did the same in gold leaf and pink. He had a particular hatred for drawing lines. These were either 'prison bars' or the track of 'a tourist walking across the space'. Monochrome, on the other hand, was 'an open window to freedom' in which one was 'immersed in the immeasurable existence of colour'.

In search of the perfect blue, his idea of the colour of infinity, Klein worked with an industrial chemist to produce his patent International Klein Blue, or IKB, which he subsequently used to paint, and to name, a series of numbered canvases.

Klein was a true harbinger of the 1960s counter-culture. He was a minimalist who sought the void and the infinite, while at the same time operating as a tirelessly provocative self-publicist and stuntman. One of his performances was to throw himself off a high building in order to demonstrate human flight. In Milan he showed eleven apparently identical monochrome blue canvases, each with a different price tag. In another show in 1958, La Vide, no paintings at all were exhibited and visitors were invited to enjoy four white walls while sipping a bright blue cocktail of gin, Cointreau and methylene blue. For the next few hours their urine turned blue.

Klein's performances became well known in France. He created 'paintings' with a flame-thrower and in his *Anthropométries* – inspired, he said, by the 'shadow' cast by dematerialized victims of a nuclear explosion, and by the sweat stain left by fighters thrown on a judo mat – he smeared nude models with IKB and asked them to imprint themselves on large sheets of paper, while an orchestra played Klein's literally monotonous 'Symphony'. This performance was restaged for a well-known Italian film of the early 1960s, *Mondo Cane*, and it was just after attending a screening of this that Klein died of a heart attack at the age of 34.

Compared to most of his neo-Dada antics, Klein's mural *Orange and Red Wall* is a conventional essay in abstract expressionism.

ANDY WARHOL *1928–87*

MARILYN 1962

The Andy Warhol Foundation, USA / Courtesy of Art Resource / Scala

WARHOL was from Pittsburgh, Pennsylvania, the son of devout immigrants from Ruthenia in eastern Europe. He showed early skill as a draughtsman, studied at the local art school and then went to New York, where he achieved success and a good income in the 1950s as a commercial artist, winning the Art Directors' Club Medal for shoe advertisements in 1957. But he was determined to break into the serious art world and, as the 1960s began, he did so with a series of paintings of consumer items and frames from comic strips.

At this stage Warhol used a parody of the expressionist painting style, but he rapidly dropped this in favour of deadpan, impersonal canvases, looking like industrially produced objects. This was quite deliberate: Warhol called his studio 'the Factory' and said: 'I want to be a machine.' He dropped his interest in comic strips – a seam already being richly mined by Roy Lichtenstein – to concentrate on the subjects that would interest him for the rest of his life: death, consumerism and fame.

Most people know Warhol's prediction that one day every individual would have fifteen minutes of fame. He was obsessed with fame because his outlook was shaped by the mass media and he could not, or would not, see past them. Marilyn Monroe, who had recently died, apparently by suicide, is a perfect example of a media icon, her face and body so universally known that it became impossible to imagine what it felt like to be her. Warhol took a studio publicity shot (from the 1952 film *Niagara*) and used the silk-screen method to transfer it photographically to canvas in his own synthetic polymer colours. Like most Warhol designs, it comes in numerous versions, differently sized, with different colours and various multiplications of the image. Warhol had been an advertising man: when he found a formula that worked, he liked to work it to exhaustion.

Multiplication became one of his most familiar gestures, demonstrating the effect of media repetition – in space, through millions of identical editions, and over time, as television and newspapers chew again and again over a particular event or image. Here Warhol found his message: that such repetition dulls the senses and generalizes the response. In the hands of the media, Marilyn's beauty ceases to be a personal thing and becomes a commercial property publicly for sale. The process is faithfully reproduced in Warhol's art. Here there is no transformation or salvation for Marilyn. Instead, through millions of posters and prints marketed by Andy Warhol Enterprises, Inc., she remains a commodity on sale.

ANDY WARHOL *1928–87*

TUNA FISH DISASTER 1963

The Andy Warhol Foundation, USA/Courtesy of Art Resource/Scala

THE American consumer boom of the 1950s – and later the European equivalent – was fuelled by easy credit and commercial television, but it would not have happened without the post-war 'baby boom' generation, born between 1945 and 1955. This large and vocal section of the population developed its own culture, which was characterized by sex, sentimentality, easy gratification and a throw-away mentality. For business this represented a huge market, gaping to be filled. For culture, as Warhol saw, it meant that a mass-produced and ephemeral object might suddenly acquire iconic status.

His most memorable essay in taking a banal consumer object and particularizing it as a work of art is his *Soup Can*, an accurate, impersonal representation of a tin of Campbell's soup exactly as it would appear in an advertisement. The idea cleverly packs a double punch, one aimed at the art world, fetishizing what its feeds on, and the other at consumerism, so easily satisfied by things that are stupefyingly impersonal and banal.

Tuna Fish Disaster takes another everyday supermarket product, here lifted straight from a news story. This related how two women, 'ordinary housewives', died after eating contaminated tuna fish. Warhol, a churchgoer despite his underground image, was horrified by mortality and in his work often dwelt on burning cars and other catastrophes. As usual, this large (three metres long) painting is in silk-screen ink over synthetic polymer paint on canvas. Once again Warhol is emphasizing the effect of repetition. As he said, 'When you see a gruesome picture over and over again, it doesn't really have any effect.'

But legitimate questions arise. Is Warhol's stance one of outrage at the way tragedy loses its force through endless media recital? Or is he deliberately soothing his own fear of mortality and evil by removing its sting? However impersonal Warhol tried to become, these questions recur because of the obsessiveness of his work, which reaches on occasion beyond the point of boredom and into the realm of psychosis. Again in Warhol's own words, 'The more you look at the exact same thing . . . the better and emptier you feel.'

Warhol's life's work was haunted by death in its many forms: death by celebrity, by accident, by greed, by boredom. Equally incapable of joy and of tragedy, Warhol, for all his cleverness, is a dispiritingly morbid artist, with a basilisk eye that quick-freezes whatever it looks at.

Seized shipment: Did a leak kill . . .

. . . Mrs. McCarthy and Mrs. Brown?

ANDY WARHOL *1928–87*

DOLLAR SIGNS 1982

Connaught Brown, London / Courtesy of the Bridgeman Art Library

ONCE again, this is one of a series of dollar sign pictures. Warhol had been deeply impressed many years earlier by Jasper Johns's *Flag* paintings [see page 230] and here he attempts a subject almost as emotive and emblematic to the American psyche.

It is a late work. After 1968, when he survived an assassination attempt, Warhol's inventiveness declined and he settled down to make money, screen-printing Polaroid portraits of wealthy clients to order, organizing the franchised merchandising of his more famous work and publishing a society-gossip magazine. But in the last few years of his life, before he died from complications following a minor operation, he did begin to hand-paint again. Like other successful artists (Picasso, Dalí), Warhol entered a phase when he wished to measure himself against the old masters, producing, for example, a huge reworking of Leonardo's *Last Supper*, in which the original vision is infected by the inclusion of brand-name logos. Again, the question of whether the artist is celebrating or regretting remains open. Given the celebrated blankness with which Warhol liked to project his personality, it must be on the cards that he is merely neutral: but, if so, why did he make the piece?

Warhol grew to fame at a time when the *Zeitgeist* was one not only of irreverence and rebellion – postures he relished – but of revolution and of a view that culture can (indeed should) be a revolutionary activity. In fact, neither Warhol's elitist personality nor his cynical art looked sympathetically towards the left-wing revolutionaries of the era. It is true that, in the 1970s, he fund-raised on the liberal Teddy Kennedy wing of the Democratic Party. But this was largely a pose. Warhol was a true believer in commodity capitalism and it is significant that his modish Mao Zedong paintings belong to the year in which Nixon made America's peace with Marxist China. Yet, as a testament to the muddled thinking of the 1960s and 1970s, the best artist produced by consumer capitalism was also a counter-cultural hero.

So the come-back of capitalism in the early 1980s, led by a perfect embodiment of the Warholian iconography in the person of Ronald Reagan, was an appropriate background for Warhol's *Dollar Sign* series. With their lushness and calligraphic pleasure, these design variations impart, for Warhol, an unusual aura of celebration. Capitalism, they seem to proclaim, has survived; the dollar is still almighty.

CLAES OLDENBURG *1929–*

FLOORBURGER 1962

Private collection / Courtesy of the Bridgeman Art Library

OLDENBURG was born in Sweden but migrated with his family as an infant, settling in 1936 in Chicago, where he grew up and was based for the next twenty years. He decided to become an artist while studying at Yale University and moved permanently to New York in 1956.

As a young artist, Oldenburg delighted in affronting the abstract expressionist establishment with popular figurative images and found objects, often reflecting the detritus of a culture which discards almost as much as it consumes. Oldenburg was now quickly evolving into a pop artist and he saw that for the first time the world's most dominant culture, America, had become a legitimate subject – or target – for art.

Also at this time he played around with performance art or, as these events were beginning to be called, happenings. They were plotless theatrical performances like dream sketches or animated tableaux, in which everyday objects were sometimes magnified to nightmare proportions. His next departure was to produce objects of this kind as sculptures, such as this huge soft hamburger made of painted canvas sewn and stuffed with foam.

Like Lichtenstein's comic strips, Oldenburg's hamburgers are seen not as by-products of the American way of life, but as essential elements or definitions of it: you are what you consume. In one way, Oldenburg's hamburger is a sculpture of a type of industrialized food product. But the burger is also an emblem of the standardization of appetite, which in itself represents a move to crush individual impulse and persuade the masses into conformity. That critique of American society, which is built into so much of Oldenburg's work, is what made him one of the most pertinent artists of his time. 'I am for an art that is political-erotical-mystical,' he said, 'that does something other than sit on its ass in a museum.'

But his topicality works against him in the long run, and it must be admitted that 40 years on *Floorburger* is an item with less impact than it had when the notion of pliable, sittable-on sculpture was revolutionary. (And it is sitting around in a museum.)

Many of Oldenburg's instincts in the 1960s and 1970s were those of the hippy counter-culture. He was both an individualist and an egalitarian, an idealist and a merciless satirist. 'I do things that are contradictory,' he said. 'I try to make the art look like it's part of the world around it. At the same time I take great pains to show that it doesn't function as part of the world around it.'

Claes Oldenburg *1929–*

Cheesecake from Javatime 1963

Private collection / Courtesy of the Bridgeman Art Library

WHEREAS Lichtenstein turned out images from comics and Warhol loved packaging and pin-ups, Oldenburg dealt for much of the 1960s with food, because it seemed to him to go to the heart of the unfulfillable desire that drove American capitalism into all its worst excesses.

Oldenburg's *The Store* (1961–2) was an actual shop on New York's East Side, where he sold hard plaster replicas of soft foodstuffs. In the two months of its existence, the Store was also the venue for a variety of happenings. It was furnished with stuffed and sewn objects (the origin of the soft sculptures such as *Floorburger*) but many of the saleable stock consisted of 'food' items made of enamel-painted plaster, not unlike this slice of 'cheesecake' from a couple of years later. Oldenburg went on to develop his mocked-up interiors, such as an entire motel room, subtly distorted and deeply kitsch, which is now 'sitting on its ass' in the National Gallery of Art, Ottawa.

Oldenburg was a highly articulate and intelligent spokesman for the subversive aspect of the pop-art movement. He was always looking for ways to surprise Americans, so complacent and incurious about themselves, into looking again at their core assumptions, the meaning of their rituals and their fetish objects. But at the same time, aware that American culture was spreading globally, he also looked abroad, dreaming up fantastic schemes for monumental sculptures in showcase settings. One of these was for a giant lipstick to replace Eros in London's Piccadilly Circus. Another was his *Proposed Chapel in the Form of a Swedish Extension Plug*. These proposals were carefully drawn up with architectural precision.

Later some of them were even commissioned and installed, including his half-buried *Giant Three-Way Plug* (1970) made in steel and bronze, which stands in front of the Art Museum in Oberlin, Ohio, and the twelve-metre-high *Giant Trowel* (1976) in Germany.

Much of Oldenburg's writing is in the great tradition of artistic manifestos, like the ones produced by the futurists and others before the First World War. Yet there is also a strain of real poetry that raises it above the ordinary ranting of the man on the barricades of art: 'I am for the art of things lost or thrown away,' he wrote. 'I am for the art of teddy bears and guns and decapitated rabbits, exploding umbrellas, raped beds . . . I am for the art of boxes, tied like pharaohs.'

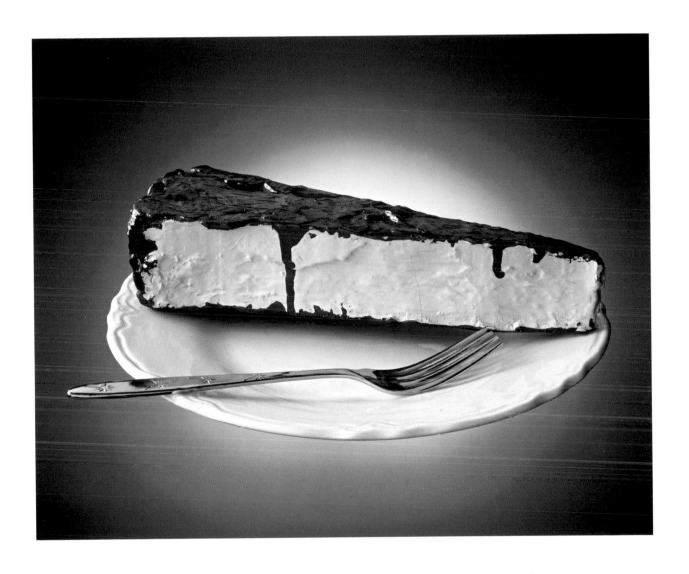

JASPER JOHNS *1930–*

THREE FLAGS 1958

Private collection/Courtesy of the Bridgeman Art Library

JOHNS is a Southerner from Augusta, Georgia. After art school he came to New York in 1952, where he met and became close friends with fellow artist Robert Rauschenberg. Pop and op art both owed a debt to the example of Jasper Johns, although he should properly be seen as an abstract artist reacting against the cult of emotion that surrounded abstract expressionism. The celebrated *Flag* paintings represent that reaction.

The story is that in 1954, when Johns was still an unknown artist, he made a make-or-break decision to destroy all his previous work and purge himself of all influences. He would then start again. The idea of a painting of the American flag came to him in a dream and he went on to produce a series that would become the images with which he is still most closely associated. He later painted a *White Flag*, a flag against an orange background, pencil-drawn flags and many other reiterations. His first example, however, was a straightforward flat representation of the US flag which covers the canvas edge to edge – a painting that is both startlingly coloured and at the same time weathered, as if to emphasize the 'old' in the nickname Old Glory.

The flag seemed a perfect vehicle for Johns's reinvention of himself in the wake of abstract expressionism. It is at one level a cool and geometrical painting like Mondrian's, a design made up of elements that are abstract, unless the stars are admitted as representational (which is a nice question). Yet it is not an abstract painting because the flag is a thing, out there, raised and struck every day beside schools and military establishments across the country. The flag is about as familiar as any object can be, yet it is not simple but freighted with complex meanings about American nationhood. These give the painting a furious resonance, which belies Johns's matter-of-fact treatment of it. This appeared early in its existence, when the Museum of Modern Art wanted to buy the work but were nervous that the public would reject it as some kind of desecration.

Three Flags measures 108 x 154cm, more or less the same size as the 1955 single flag. Like the original, it is painted in encaustic, pigment mixed with liquid wax, making the kind of quick-drying medium Johns preferred. Floating the two scaled-down flags in sequence above the larger one, the artist shows himself prepared to indulge in an illusionist effect by providing shading beneath them.

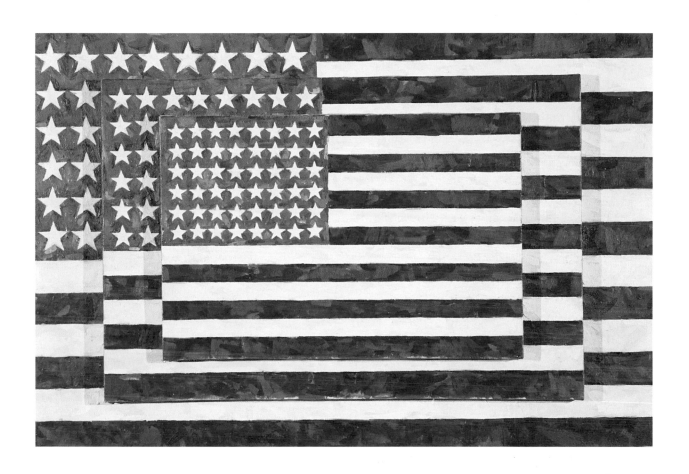

Jasper Johns *1930–*

Diver 1962

Private collection / Courtesy of the Bridgeman Art Library

'In the earlier paintings,' said Jasper Johns, 'I looked for subject matter that was recognizable, letters and numbers for example. These were things people knew, and did not know, in the sense that everybody had a relation to letters and numbers, but never had they seen them in the context of a painting. I wanted to make them see something new. I am interested in the idea of sight, in the use of the eye. I am interested in how we see and why we see the way we do.'

Around 1960, Johns's work took a more untidy and more subjective turn, while on the other hand becoming more abrasively mocking of the abstract expressionists. *Diver* – which was sold in 1988 at a record mark for a living artist of $4.8 million – is a work divided into five sections. With its raucous display of colour, stencilling and embedded objects, the painting seems to flirt with abstract expressionism, only to reject it and to converge instead with Rauschenberg's combine paintings. There is an element of representation too, a sense that you are seeing into something and not just viewing the fiery decoration of a surface. The graded cream and green rectangles in the second section from the left might be a stair leading up into darkness; the circular figure on the extreme left could be one of Johns's targets, almost as legendary as his flags; and the three right-hand sections resemble the panels of a decorative screen.

Magrittean wit is often present in Johns's work, as when he exhibited a toothbrush, with teeth set in place of the bristles, calling it *The Critic Smiles*. In *Diver* the stencilled words 'Blue', 'Red' and (incomplete) 'Yellow' link Johns to the semantic games played by Magritte when he painted a clay pipe and wrote underneath '*Ceci n'est pas une pipe* [This is not a pipe]'. In Johns's picture the words do not correspond either to their own colours or to those on which they are laid, so that the viewer can only speculate about their meaning in the work as a whole. This interest in language games also reflects Johns's reading of the philosopher Ludwig Wittgenstein during the previous year. Wittgenstein was deeply concerned with the correspondence between words and things, and Johns's interest in the relation of these terms with paintings was to him the same kind of inquiry.

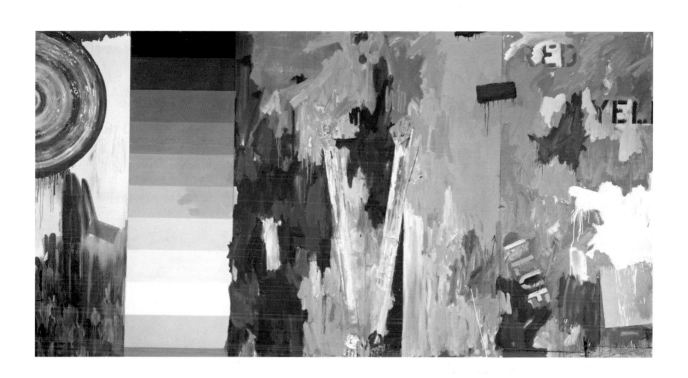

ROBERT MORRIS *1931–*

UNTITLED (FIVE TIMBERS) 1969

Solomon R Guggenheim Foundation, New York, Panza Collection / Lee B. Ewing

MORRIS is from Kansas City and trained in the Midwest and San Francisco. This was interrupted by service in the Army Corps of Engineers, during which he did a tour of duty in Korea. By the early 1960s he was at Hunter College in New York.

Morris used banal everyday objects in his sculpture and was one of the pioneer sculptors in minimalism, but moved beyond pure form and (in a movement akin to the cubists' dimensional concerns) towards an attempt to introduce time and process into sculpture as a fourth dimension. A characteristic piece is *Metered Bulb*, in which a working electric light bulb is wired through an electric company meter whose dials turn, recording its energy use.

Morris was a dancer as well as a sculptor and participated in performances and happenings. He was also a vocal and provocative theorist who wrote a number of influential articles. In one of these, 'Antiform' (published 1968), he argued that sculpture can be done without any concern for longevity and can even be made deliberately mutable. Chance and transience, change and decay, can be admitted by 'random piling, loose stacking, hanging'. This interest in evanescence was related to Claes Oldenburg's soft sculpture but it also introduced the effect of time and occasion on an artist's work. The fact that Morris was prepared to relinquish control and open the way to the unpredictable alteration of his work means that he was assaulting one of the last ramparts in the citadel of romanticism. To relinquish control had been considered the essence of 'selling out'. But now artists like Morris were advocating just that: an art that gave way to circumstance and was becoming known as process art.

Morris often worked in hard, heavy objects, as in *Five Timbers*, which has much in common with the work of another minimalist, Carl André. But he was also drawn to work with other combinations of weight and texture, from mirrors and plywood to the thick folds of industrial felt hanging off the wall, and even the damp ephemerality of steam.

The guiding principle for Morris and other like-minded artists in the 1960s – minimalists, conceptualists and process artists – could be expressed in his 1970 statement that 'the notion that work is an irreversible process ending in a static icon-object no longer has much relevance'. He was interested only in 'the detachment of art's energy from the craft of tedious art production'.

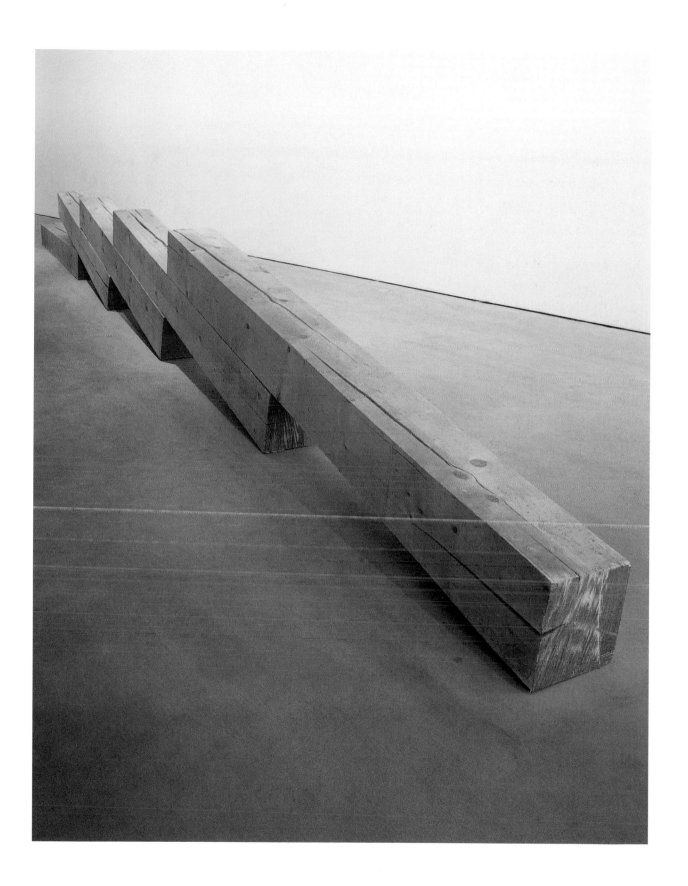

BRIDGET RILEY *1931–*

MOVEMENT IN SQUARES 1962

Arts Council Collection, Hayward Gallery, London/Courtesy of the Bridgeman Art Library

RILEY was one of the first notable successes produced by London's Goldsmith's College, where she studied from 1949 to 1952 before entering the Royal College of Art. In the late 1950s she worked in advertising while privately exploring unusual colour effects through Seurat-like dot paintings, in which Italian landscape colours are apparently made to vibrate under the still summer Mediterranean heat.

By the 1960s Riley was an abstract painter and becoming increasingly absorbed in the optical effects that could be achieved by an arrangement of shapes and colours. *Movement in Squares* belongs to her four-year black and white phase in the early 1960s and shows a chequered field which produces its effect by a simple process. Riley progressively shortens the width of the quadrilaterals as they move towards a vertical line drawn down the canvas, which makes a valley appear in the field as if it had been chopped or creased. Visually all the painting's energy is in that crease, which shimmers and ripples in the eye like a flowing stream.

These monochromatic, experimental abstracts by Riley were an instant success. In terms of school or tradition she is identified with Victor Vasarély (1908–97), the Franco-Hungarian painter who had been interested in retinal-kinetic matters since the 1930s and is considered the father of the art that concerns itself with optical illusions through the creation of abstract patterns: op art. This began as interest in visual ambiguity, a simple one being a composition in which the ground and the pattern are interchangeable so that it can be read in alternate ways. But Vasarély went much further, finding all sorts of ways of tricking and traducing the eye into reading instability and movement into a fixed and two-dimensional pattern.

Riley's work in this field is outstanding for its precision and polish, the result of careful calculation, experiment and a fanatical approach to technique. It made Riley one of the new stars of the art world in 1960s London. As commercial youth fashion became big business, she was a style-setter, her designs, and those of many imitators, being seen on fabrics and posters everywhere. Yet Riley has herself said that her black and white paintings came out of a time of personal anxiety, which seems to have given this work an excited, even violent quality.

BRIDGET RILEY *1931–*

NATARAJA 1993

Courtesy of the Tate Gallery, London

FOLLOWING the black-and-white period, Riley began to reintroduce colour into her work, cautiously at first, creating geometrically spaced wave patterns or pyjama stripes, calculating the juxtaposition of colours so that visual instability of some kind is always achieved. But as Riley's personal life calmed down, her illusions and effects became increasingly benign: in place of the grosser, more ferocious pattern disruptions of the early and mid-1960s, she was now dealing in new, optimistic and colour-filled fields of light.

The colours are so ravishing that it is tempting to think that a chromatic Riley canvas such as *Nataraja* would be beautiful even without optical effects. Yet these provide its multiplicity, its character, and cannot be disregarded. Beside the overall sensation of coloured light descending diagonally in shafts, it is possible, for instance, to attend to the coloured bands, looking like horizontal bars and making a cage for the diagonals. On a second look, it is possible to discern a three-dimensional space, as if the view was of the slats of a venetian blind tilted to admit beams of bright sunlight or, again, a fantastically coloured cross-weave of light interlaced to form a grid of nets hanging in indeterminate space. There is a little of the Alice in Wonderland in Riley: full of patterns which seem secure before they lurch into another dimension. There is something also of the discoveries of Josef Albers (see page 148) in her process, but she has galvanized them into action so that the difference between her and Albers is like that between a moth on a tree trunk and a hive of bees.

Riley does not paint every centimetre of canvas herself and assistants may be employed to apply the acrylic paints she insists on. This would have been unthinkable in an abstract expressionist like Pollock, but it of little concern to Riley. She maintains complete control over the image through her personal preparations: drawing and sketches. But there is no question that the artist's hand is needed here. The painting may evoke or compel emotion, but the effect is achieved by intellectual effort, and not at all in an effusion of feeling.

But she does not subscribe to the idea that her art is wholly non-referential and complete in itself. For Riley the vibrancy in mathematical and coloured pattern beats a rhythm which is also the rhythm of life in nature.

PETER BLAKE *1932–*

TITANIA 1961

Private collection / Courtesy of the Bridgeman Art Library

IN the 1960s Peter Blake was known as England's leading pop artist, at a time when British popular culture achieved world-wide recognition. He was born in Dartford, Kent, and studied with great success at the Royal College of Art before travelling around Europe on a Leverhulme scholarship to look at folk art and popular imagery. As a professional artist he has often worked in commercial graphic design as well as producing independent works.

Blake's early paintings are nostalgic for lost, fading or degraded entertainments, decorations and traditions in, for example, the circus, fairground, canal boat, Gypsy caravan and tattooist's parlour. But he was drawn also to the idea of pop art, articulated by his fellow Briton Richard Hamilton in 1957: 'Pop Art is Popular (designed for a mass audience), Transient (short-term solution), Expendable (easily forgotten), Low cost, Mass produced, Young (aimed at youth), Witty, Sexy, Gimmicky, Glamorous and Big Business.'

At this time, Britain lagged half a generation behind America as a consumer society (it caught up dramatically in the 1960s) but Hamilton, Blake and other British pop artists had glimpsed the future in television, films and in their visits to America. They weighed the new images of mass production, advertising and packaging against the dying decorative and design traditions which had particularly interested the young Blake. The pop artwork that resulted, unlike that of their American counterparts, often retained an openly hilarious or satirical edge because it tended to identify consumer art forms as outside (i.e. American) encroachments, for better or for worse. In the USA they were native developments, to be treated with a corresponding degree of seriousness.

Titania is a mixed-media image which combines a few of Blake's disparate interests in a simple but (for its time) unconventional way. The row of portraits is a collage of pop-star glamour photos, with one of their records affixed at the left. Below is an area coloured like a fairground prop in enamel paint and divided by batons. The effect is to fix an ephemeral, and almost certainly accidental, clash between different kinds of design and different categories of feeling: traditional and transient, local and international, real and imaginary. It is the sort of juxtaposition we speed past in our cars every day, without a thought. But it is as much part of everyday perception as Monet's water lilies.

PETER BLAKE *1932–*

KENDO NAGASAKI, WRESTLER 1965–9

Private collection / Courtesy of the Bridgeman Art Library

IN 1960s Britain, wrestling provided staple fare for television audiences on Sunday afternoons, its protagonists dressing in melodramatic costumes and adopting exotic personae. The wrestler portrayed by Blake, with his synthetic Japanese name and prominent nose, is unlikely to have really been Japanese. Yet we do not have enough information to make a definite decision on this. The mask imposes a bizarre and distorting simplification to the features. It squeezes the mouth, hoods the eyes and frames the nose within a circle. No underlying face can be constructed from this paucity of information, which is what makes it a good disguise.

It also, quite intentionally, disturbs. The mask is alienating, its colour is harsh and bloody. It caricatures the human features with a crude pattern of holes for eyes, nose and mouth, only to negate them by imposing the grid of white bars that seem to imprison the face. This suggests that inside the mask lurks a caged monster, which obtrudes threateningly as if trying to escape through the holes. Knowing that this is in fact an ordinary human face and that its presentation is quite obviously playful and artificial (the mask made from nothing more sinister than soft cotton) does not remove the effect. As in a dream, that which is only partially seen is seen most fearfully.

As an example of how Blake measures traditional popular culture against its counterparts in the television age, the painting contrasts sharply with *Got a Girl*. Blake's wrestler is just the type who used to fight in Edwardian fairground booths, putting on spectacular but simulated bouts for paying customers. However old-fashioned his trade may seem, he has continued to ply it on television, with all the melodramatic posturing, choreographed action and tacky costumes of old. Because of this continuity, 'Kendo Nagasaki' is not a clash between the old and the new. He is a survivor of the past still as vigorous as ever in the present.

In 1967 the Beatles' turning-point album *Sgt Pepper's Lonely Hearts Club Band* appeared. Its cover by Peter Blake rehearsed similar themes: the Beatles, dressed as a circus band from the Edwardian era, stand surrounded by a collage of the heroes of popular culture. But the old and the new are not always good bedfellows and by uniting them Blake sometimes showed himself to be an insecure pop artist. Soon afterwards, he was to turn away from the style towards a more transcendent approach to memory and perception.

PETER BLAKE *1932–*

GOT A GIRL 1960–61

Whitworth Art Gallery, Manchester/Courtesy of the Bridgeman Art Library

IN *Got a Girl* the painting's central figure stares outwards with hypnotic intensity, yet she seems quite deliberately passive, an object of scrutiny rather than an active agent, like the strippers that Blake has occasionally taken as his subjects.

In the 1970s Blake lived at Wellow in Dorset. He had become profoundly disillusioned with the art establishment in Britain, in the way it had turned its back on figure and landscape painting, indeed on all painting, towards minimalist concepts, performances, texts and other activities which negated the painterly skills. In Dorset he was instrumental in forming a new group, the Ruralist Brotherhood, whose heroes were William Blake, Samuel Palmer and the Pre-Raphaelites.

Joining him in the Brotherhood were five other painters: David Inshaw and the married couples Graham and Annie Ovenden and Graham and Ann Arnold. Based in the countryside, they adopted a self-consciously traditionalist, anti-metropolitan position, which looked back to the English world of Lewis Carroll and Edward Elgar. There was an element of New Age mysticism here, and a yearning for an idyll, which gives their work at times a sentimental and at others a surreal flavour. To the London art world, however, the most shocking thing about the Ruralists was their adherence to the very traditions that modernism had assaulted and tried to destroy.

Peter Blake refused to accept that this was an about-turn or a denial of his earlier pop art. On this subject he said: 'What I am working on now is in direct line with what I was working on 25 years ago: the same fantasies. I've always wanted to explore the limits of humanity. I've always been more interested in disability than perfection.' He does not mean 'disability' in its usual sense. In Blake's eyes, pop stars, strippers and wrestlers are fascinating because they are extraordinary. In the same way fairground freaks used to entertain the public, just by being freaks. Blake sees a connection between this interest and the story-book fairy world. He once collected books with illustrations by Arthur Rackham and was obsessed with the deranged Victorian artist Richard Dadd, who also painted fairies. The girl, in this image, is seen as the star of the fairy world, standing frozen and exposed in a spotlight and surrounded by her retainers. Seen in this way, the painting becomes a meditation on the ambivalence of fame.

R. B. KITAJ *1932–*

IF NOT, NOT 1975–6

Scottish National Gallery of Modern Art, Edinburgh/Courtesy of the Bridgeman Art Library

KITAJ was born in Cleveland, Ohio, to a family with a largely European and socialist sensibility. As a young man, like Gauguin, he was a merchant seaman in Latin America; like Monet he was drafted into the army and served abroad. In both cases these were formative experiences, broadening Kitaj's outlook and range of sympathies. In 1958 he began training as an artist at the Ruskin School of Art in Oxford, where he was devoted to surrealism, then a deeply unfashionable preoccupation, and modernist literature, especially that of T. S. Eliot and Ezra Pound. He also became extremely knowledgeable in the obscurer recesses of art history and iconology.

At the Royal College of Art in London from 1959 to 1961 Kitaj, several years older than most of his fellow students – including David Hockney – and with a good deal of disparate experience behind him, found himself in a leadership role. His work was ambitious, referential and wide-ranging, using a collage-like method of construction and rich colouring to create pictures that are almost narrative paintings, executed with a great flair for drawing.

Although he was there at the birth of British pop art, Kitaj was really a 1960s artist of a different, more serious stamp. Ironic or playful variations on consumerism did not interest him. He took a longer and more tragic view of affairs, which is why *If Not, Not* takes as one of its subjects T. S. Eliot's modernist poem *The Waste Land*, published in 1922. It also refers to the Jewish holocaust in the shape of the building at top left: the guardhouse gate at Auschwitz.

Kitaj's work is always intensely aware of Europe's tradition of fine art. His landscapes have the look and feel of versions of a Babel tower by Brueghel, a Purgatory by Bosch or the landscape background in an early Italian fresco. At the same time he is recognizably an artist of his time. The scraps of alternately lush and bleak imagery, the sense of fractured, even circular narrative, the crowdedness and incident in Kitaj's big works, is nothing at all like the minimalist concerns of many contemporaries working in the plastic arts. And it takes its place in pop art not because it is like Warhol (it could hardly be more different) but because it represents another strand in 1960s culture, the prolixity of the novels of William Burroughs and the rock songs Bob Dylan was writing from the mid-1960s.

FRANK STELLA *1936–*

FLIN FLON 1967

Private collection / Courtesy of the Bridgeman Art Library

IT was seeing Jasper Johns's paintings of the American flag in 1958 that convinced Stella to become an abstract artist. He admired the cool matter-of-factness that he saw. There was no projection of personality, no possibility of emotion creeping in. His early masterpieces are the *Black Painting* series. These consist of severely geometric bands of black paint arranged in stripes with the narrow spaces between them delineated by bare canvas – 'pinstripe painting', as it was dubbed by the press. Stella, who had been working as a housepainter, used commercial enamel house-paints and two-inch brushes.

Stella's avowed aim, as he moved beyond the *Black Paintings* in a highly premeditated development programme, was to banish the artist's creative ego from his work. This meant minimalism – the systematic elimination of any possible illusion of depth beyond the picture plane, and the complete avoidance of visible brushstrokes. This insistence on the canvas as a made object did not, however, prevent the introduction of colour and Stella's next departure was to make coloured geometrical designs of rectilinear mazes and concentric nesting squares in which bright, unmixed colours are used.

During 1967–9 Stella made a surprise move by abandoning minimalism with his *Protractor* series. On very large canvases, and using synthetic polymer and fluorescent paints, he introduced curved lines and geometrically defined patches of contrasting colours. *Flin Flon* gets its effect from the vibration of its colours laid out in a way that is surprisingly reminiscent not only of Islamic decorative patterns but also of certain art deco pottery designs of the 1930s. Despite Stella's earlier resolute anti-illusionism, the painting seems to vibrate with such energy that viewers routinely think of snake heads, butterfly wings or a child's kite. But, as Stella says when asked about the meaning of his work, 'what you see is what you see'.

Stella's later art shaded from painting into something akin to construction – collages in bas-relief and then high relief made in aluminium shapes (sourced in at least one case from metal rejected by a canned soft-drinks factory) and decorated by doodles in coloured paint. These reliefs, Stella insists, are not sculptures, since they are designed for the wall.

In 1983 Stella was appointed professor of poetry at Harvard University, which called for six theoretical lectures to be delivered. Published in book form as *Working Space*, the lectures are now seen as a classic explication of a painter's way of thinking in the late twentieth century.

DAVID HOCKNEY *1937–*

CALIFORNIA BANK 1964

Mayor Gallery, London / Courtesy of the Bridgeman Art Library

THE youngest of a remarkable trio of twentieth-century Yorkshire artists, Hockney is a generation after Moore and Hepworth. He was born in Bradford, where he studied at the School of Art before moving to the Royal College in London in 1959. He drew and painted with great facility and tried out a number of styles, while paying tribute in particular to Picasso and the French artist Jean Dubuffet (1901–85).

In the early 1960s pop became the new art wave sweeping through Britain, but Hockney, although he moved in the same world as the pop artists, did not particularly identify with them. Instead he made raw, Dubuffet-inspired figure paintings, often scrawled with messages and quotations in the style of wall graffiti. These canvases are about urban life. Charged with homosexual eroticism, they also wear a look of innocent, youthful carelessness, although there is an underlying awareness in all Hockney's work of good technique, especially of good drawing, that set him apart. He knew he was capable of absorbing and using a great range of influences and even held an exhibition in 1962 entitled Demonstrations of Versatility. The paintings were full of sly and humorous allusions to other painters.

In 1963 Hockney left England and settled in the bright, sybaritic, semi-artificial world of Los Angeles, California. Immediately his paintings changed, the light becoming garish and the painted space newly organized into hard-edged forms and spaces. His 'breakthrough' work in this manner was *A Bigger Splash*, a look down from a swimming-pool diving board moments after the diver has entered the water. The glittering splash of pool water which dominates the image took Hockney two weeks to complete.

In America he switched from oil paints to acrylic, a medium in which he found the superficial evenness he now wanted. In a series of outdoor views of Los Angeles life – all shimmering pool water, sprinkled lawns and blank buildings – he found a clinically innocent, photography-based style which answered to the environment he was looking at.

Hockney's fame as a painter has enabled him to develop many related activities, as an illustrator, a stage designer and printmaker. Finally it would be a mistake to overlook his drawings from life, for Hockney's sketch portraits and other drawings are almost as fluent and sparely true as those of Picasso.

Bruce Nauman *1941–*

Run from Fear/Fun from Rear 1972

Sammlung Ileana and Michael Sonnabend/Courtesy of AKG Photo

NAUMAN is a sculptor, photographer and performance artist. He originally worked as a mathematician at the University of Wisconsin. He then turned to sculpture and studied at the University of California at Davis, graduating in 1966. He was at this time making enigmatic forms in fibreglass, and has always shown a fondness for the latest trends and media – neon tubes, text art and more recently the fashionable video installation – as well as a penchant for word games and puns in the titles of his pieces.

Run from Fear/Fun from Rear, a two-part neon installation, is not unique, being an 'edition' sculpture, with six identical examples made and authenticated by the artist. When one of these was sold at Sotheby's in 2000, a protester interrupted the bidding with shouts of 'Obscenity! A disgrace to the art world!' This no doubt helped the piece to fetch over $300,000.

Nauman claims as his guru the linguistic philosopher Ludwig Wittgenstein, whose interest in language games links, in art, to a few pieces by Magritte and Man Ray and who also much interested Jasper Johns. A curatorial label on one of Nauman's works at New York's Museum of Modern Art argues that the neon words incorporated into Nauman's pieces 'go directly to the heart of the existential problem Wittgenstein's inquiries pose . . . Whether videos, neons, drawing, prints or spatial constructions, each of his works asks the same question: how does being resonate with language?'

It is difficult to see just how the text/neon piece *Run from Fear/Fun from Rear*, employing its rather childish spoonerism or letter substitution, is related in any non-superficial way to the subtle and profound thought of the Austrian philosopher. But Nauman has been one of the hottest names in the American art world during the 1990s – so hot that in 1995 the Museum of Modern Art accorded him the third largest retrospective exhibition they had ever mounted, after Picasso and Matisse – so it is not surprising to hear or read inflationary words about his subtlety and importance. In fact he seems to be just one of the more prominent artists of his and later generations who have tried to disturb gallery-goers with disjunctive pieces in emulation of the 'scandalous' work of Duchamp and the dadaists.

GLOSSARY

Abstract expressionism New York school of painting of the 1940s to 1960s. It emphasized personal expression and freedom from tradition, as in the drip paintings of Jackson Pollock and the colour fields of Barnett Newman.

Automatism Painting or drawing without thinking, to allow the expression of unconscious impulses.

Bauhaus An influential school of architecture, art and design founded in Germany in 1919 by the architect Walter Gropius. Kandinsky and Klee were among the artists who taught there. The school moved in the 1930s to the USA.

Biomorphic abstraction Art in which meaningless shapes resemble life-forms.

Der Blaue Reiter (the Blue Rider) A group of painters active in the early years of the twentieth century, based in Munich. The group was led by Franz Marc and named after a painting by Kandinsky.

Collage Pieces of paper pasted on canvas or panel, giving contrast of surface and colour and varying the depth of the picture medium. The technique was invented by Picasso and Braque.

Colour modulation The juxtaposition of different colours, irrespective of lightness or darkness, to give the sensation of three-dimensionality in a painting.

Conceptual art Art where the idea, the concept, is presented as a substitute for the work.

Concrete art Art free of pictorial representation and sentiment of any kind. The term was coined in 1930 by Theo van Doesburg.

Cubism A style of art showing things from several points of view simultaneously, developed by Picasso and Braque in 1910-14. They used muted colours to focus on forms and their relationship to music.

Dada Anarchistic and playful movement in the arts, originated in Zurich during the First World War and led by the poet Tristan Tzara and the sculptor Jean Arp.

Divisionism Seurat's name for pointillism.

Expressionism Art that primarily communicates the feelings or inner visions of the artist. Expressionism flourished in Germany in the early twentieth century.

Fauvism Figurative painting characterized by glowing, non-naturalistic colours and headlong brushwork. Matisse was the leader of the Fauve, or 'wild beast', group of painters, which flourished in Paris during the first decade of the twentieth century.

Frottage A process akin to brass rubbing.

Futurism Movement in the arts celebrating machinery and modern life, and attempting to capture speed and noise. Futurism was launched in Italy in 1910.

Grattage Scraping pigment across canvas laid on a heavily indented surface.

Happening An art event or performance with elements of randomness and audience participation.

Impasto Paint laid on thickly to create texture.

Impressionism A style of painting developed in France in the 1870s and 1880s, concerned with the perception of light and colour. The impressionists painted from nature, using free brushwork.

Installation art The related deployment of disparate objects and materials in three-dimensional space.

Maquette A small-scale terracotta or plaster model for a sculpture.

Minimalism The elimination of any illusion of depth beyond the picture plane, and the avoidance of visible brushstrokes.

Modernism The styles of art that developed from the break with academic tradition in the late nineteenth century.

Nabis, Les A French group of painters of the 1890s, influenced by Gauguin and symbolism.

Neo-impressionism A more analytical approach to impressionism, as in pointillism.

New York school The painters working in New York in the 1940s and 1950s, particularly the abstract expressionists.

Op art Abstract art exploring optical effects.

Orphism A poetic and meditative abstract art developed from cubism by Robert Delaunay, characterized by vibrant colours.

Papier collé Paper pasted on canvas as in collage.

Plastic arts Sculpting, moulding and modelling; also painting and drawing that aims to represent three dimensions.

Pointillism A dogmatic development of the impressionists' colour theories, allowing small dots of different primary colours to merge in the eye of the viewer into areas of unified colour. Seurat, the leading pointillist, called it divisionism.

Pop art Art employing the images of mass production, advertising and packaging. It began in the UK in the 1950s with a satirical edge and developed more earnestly in the USA in the 1960s.

Post-impressionism A blanket term for the modern art of the turn of the nineteenth century, ranging from Cézanne to Picasso, that broke with the impressionist outlook.

Process art Art that emphasizes the systematic process of its creation and the random process of its decay.

Purism A deliberately impersonal form of cubism, dealing in a pared-down style with machine-made utilitarian objects.

Readymade An ordinary mass-produced object exhibited as a work of art; the idea and the term are Duchamp's.

Realism Representational fidelity to life as a primary goal of art; especially the down-to-earth painting of the mid-nineteenth century in France.

Salon d'Automne An art exhibition held annually in Paris from 1903 to showcase the avant-garde.

Salon des Indépendents An art exhibition held annually in Paris from 1884 to showcase the artists who broke with the academic tradition.

Stijl, De A Dutch art and design magazine launched in 1917 by Theo van Doesburg. Its utopian aim was to establish spiritual harmony.

Suprematism A geometrical style of abstract art developed in Russia by Malevich from 1915 and concerned with the absolute emotional value of colour.

Surrealism A figurative style of art using imagery from dreams and hallucinations. The first surrealist exhibition was held in 1925 in Paris.

Symbolism A figurative style of art whose subjects were allegorical or emotional. Symbolism was influential in Europe in the late nineteenth century.

Theosophy A religious system founded by Helena Blavatsky in 1875, based on Eastern religions and the belief in a parallel, contactable spirit world.

Vorticism A dynamic kind of abstract painting in Britain around 1914–15, related to futurism.

FURTHER READING

The Grove Dictionary of Art (Macmillan, 1995).

Bowness, Alan *Modern European Art* (Thames & Hudson, 1972).

Britt, David (ed.) *Modern Art* (Thames & Hudson, 1995).

Hughes, Robert *The Shock of the New* (BBC, 1980).

Pool, Phoebe *Impressionism* (Thames & Hudson, 1967).

Read, Herbert *A Concise History of Modern Painting* (Thames & Hudson, 1974).

Stangos, Nikos (ed.) *Concepts of Modern Art* (Thames & Hudson, 1994).

Varnedoe, Kirk *A Fine Disregard* (Thames & Hudson, 1990).

Waldberg, Patrick *Surrealism* (Thames & Hudson, 1997).